She
Animates

She
Animates

Soviet Female
Subjectivity
in Russian
Animation

**Michele Leigh and
Lora Mjolsness**

Library of Congress Cataloging-in-Publication Data

Names: Leigh, Michele, author. | Mjolsness, Lora, author.
Title: She animates : Soviet female subjectivity in Russian animation /
 Michele Leigh and Lora Mjolsness.
Description: Boston : Academic Studies Press, 2020. | Series: Film and
 media studies | Includes bibliographical references.
Identifiers: LCCN 2020024595 (print) | LCCN 2020024596 (ebook) | ISBN
 9781644690345 (hardback) | ISBN 9781644690666 (paperback) | ISBN
 9781644690352 (adobe pdf) | ISBN 9781644690673 (epub)
Subjects: LCSH: Feminism and motion pictures--Russia (Federation) |
 Feminism and motion pictures--Soviet Union. | Animated films--Russia
 (Federation)--History and criticism. | Animated films--Soviet
 Union--History and criticism. | Women animators--Russia (Federation) |
 Women motion picture producers and directors--Russia (Federation)
Classification: LCC PN1995.9.W6 L445 2020 (print) | LCC PN1995.9.W6
 (ebook) | DDC 741.5/8092520947 [B]--dc23
LC record available at https://lccn.loc.gov/2020024595
LC ebook record available at https://lccn.loc.gov/2020024596

Copyright©2020, Academic Studies Press
ISBN 9781644690345 (hardback)
ISBN 9781644690666 (paperback)
ISBN 9781644690352 (adobe pdf)
ISBN 9781644690673 (epub)

Book design by Lapiz Digital Services.

Cover design by Ivan Grave. On the cover: stills from the films: *My Mother is an
Airplane* and *Terrible Vavila and Little Auntie Arina* (front); *Alter Ego, Musicians of
Bremen, Ivan Tsarevich and the Grey Wolf 3, Tale of the Boy-Kibalchish, The Cat that
Walked by Himself* (back).

Published by Academic Studies Press
1577 Beacon St.
Brookline, MA 02446, USA
press@academicstudiespress.com
www.academicstudiespress.com

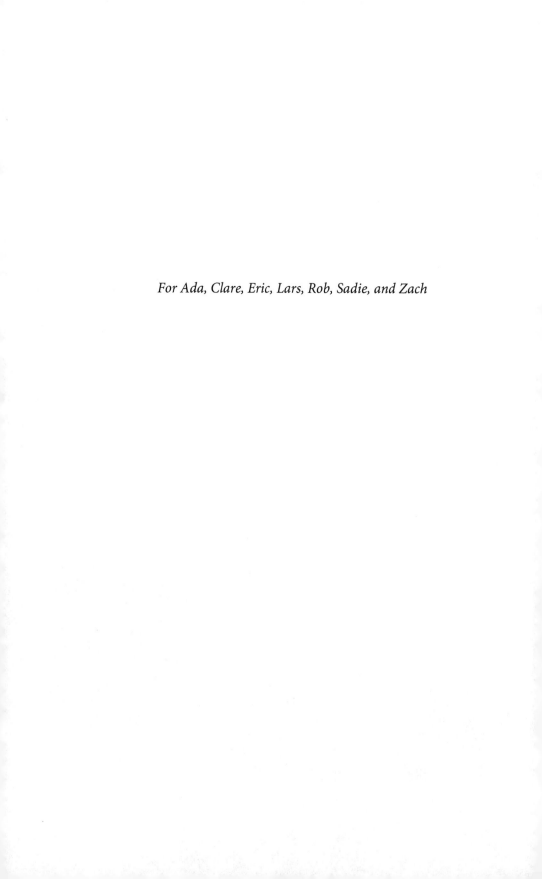

For Ada, Clare, Eric, Lars, Rob, Sadie, and Zach

Contents

Acknowledgements

We would like to acknowledge the help and support of the following people and organizations without whose assistance this book would not have been possible. Michele would like to thank the Fulbright Program whose financial support made some of the research possible. Lora would like to thank the UC Irvine non-senate faculty professional development fund for financial support. Both of us would also like to express our gratitude for the generous financial and research support from the Russian, East European, Eurasian Center at the University of Illinois, Urbana-Champaign and the US Department of State, Title VIII grants, in particular we would like to thank Stephanie Chung Porter for all her help. We would like to thank the amazing library staff at UIUC, in particular Jan Adamczyk and Joseph Lenkart who played along with our game of 'stump the librarian' with grace and laughter. The book would not have been possible without the industrious staff at the Russian State Archive for Art and Literature, Gosfilmofond and the Lenin Library, we appreciate their patience and creativity in helping us to navigate the archives. Finally, our deepest gratitude goes to the animators and studios who gave us permission for the images.

Chapter 1

Women's Cinema and the Russian and Soviet Animation Industry

"Women's cinema" is a complex critical, theoretical and institutional construction, brought into existence by audiences, film-makers, journalists, curators, and academics and maintained only by their continuing interest: a hybrid concept, arising from a number of overlapping practices and discourses. . . .

—Alison Butler, *Women's Cinema: The Contested Screen*[1]

Introduction

Imagine, if you will, a time when female directors are so prevalent that their gender is no longer an issue. Unfortunately, not only are female directors still a rarity in most of the world, their contributions have also historically been downplayed, minimized, or even omitted from the canons. In the last twenty to thirty years media scholars, the filmmaking community, and, at times, even executives have attempted to call attention to the lack of women in positions of power within the film industry and to highlight the work women have done in an effort to encourage more women to participate, and to promote parity.

1 Alison Butler, *Women's Cinema: The Contested Screen* (London: Wallflower Press, 2002), 2.

Despite the lack of parity, film scholars have illustrated that cinema has long been a place where some women have excelled and their contributions have been distinctive. One such investigation is *Women and the Cinema: A Critical Anthology*, by Karyn Kay and Gerald Peary, which points to the cinema as one site where "vestiges of 'female culture' have grown—usually unnoticed or condescendingly ignored."[2] Kay and Peary point out that even in such a male-dominated profession, women have made a place for themselves. Since that seminal work, great strides have been made to not only foreground those unnoticed and ignored women, to uncover how they helped to shape and form this burgeoning industry, but also to explore the amazing ways in which women have contributed to a uniquely female culture of filmmaking. Some recent examples include works like *The Women Film Pioneers Project* founded by Jane Gaines and Shelley Stamp's work on Lois Weber.[3] The *Women Film Pioneers Project* is an online resource of scholarly research which explores women who were working in a variety of professions during the silent era in film industries all over the world, including Russia. Stamp's recent scholarship offers groundbreaking research on Weber's career as an actress, screenwriter, and director, underscoring how she was pivotal in the development of film culture within the growing studio system in Hollywood.

By comparison, relatively few scholars have tackled the subject of women within Eastern European cinema. However, those few scholars have made important contributions on women's roles in live-action film in Russia and the Soviet Union. A noteworthy contribution is Judith Mayne's 1989 *Kino and the Woman Question*, which focuses on the issue of the woman question in Soviet montage film. Because there were virtually no female directors at the time, Mayne looks specifically at how male montage directors addressed or ignored the issue of women's emancipation in their films. Additionally, Lynn Attwood's seminal *Red Women on the Silver Screen* examines the role of women both as characters in Soviet cinema and as workers in the film industry and in particular as women who worked towards changing the industry and the representations of women.[4] More recently, Rachel Morely's 2017 *Performing Femininity: Woman as Performer in Early Russian Cinema*

2 Karyn Kay and Gerald Peary, eds., *Women and the Cinema: A Critical Anthology* (New York: E. P. Dutton Press, 1977), xiii.

3 *The Women Film Pioneers Project*, accessed June 18, 2018, https://wfpp.cdrs.columbia.edu/.

4 Lynne Attwood and Maiia Turovskaia, *Red Women on the Silver Screen: Soviet Women and Cinema from the Beginning to the End of the Communist Era* (London: Pandora, 1993).

analyzes the concept of female performance in the cinema of pre-Revolutionary Russia.[5] Works such as these are changing our understanding of film history, which until recently has been primarily a history of great men.[6]

In addition to work on female labor in cinema, in the past twenty years scholars of Russian and Soviet cinema have written on issues related to gender, especially in regard to the characterization of women in live-action film. Scholars such as Mayne and Attwood have examined characters in live-action film, revealing the ambiguities and anxieties about gender that pervade periods across Soviet and Russian history. While some of the gender issues raised by live-action cinema are also applicable to animation, many are not. For example, Rimgaila Salys in her article "Life into Art: Laying Bare the Theme in 'Bed and Sofa,'" explores the ways in which male domination and female subservience in the 1920s are conveyed directly through character development in Abram Room's *Bed and Sofa* (*Tretia meshchanskaia*, 1927).[7] Salys concludes that Room's film dramatizes and represents the full cultural complexity of the difficult question regarding female self-sufficiency and self-determination without instructing or solving these problems.[8] Beth Holmgren, when discussing the Stalinist film *Circus* (*Tsirk*, 1936) by Grigori Aleksandrov, uncovers the contradictions in the myth of Soviet gender equality during the Stalinist years.[9] Holmgren further suggests that when *Circus* undertakes the redemption of its fallen heroine, Marion Dixon, she is stripped of her eroticism and her sexuality, which liberates her as an authentic human being, falsely oppressed by capitalist culture, and naturalizes her glamour into an acceptable Soviet form.[10] This type of scholarship evaluates live-action films utilizing current feminist theories in relation to character development, attempting to recover women's struggles for self-realization while offering a more nuanced understanding of gender and power dynamics. Character analysis of live-action film does not directly

5 Rachel Morely, *Performing Femininity: Woman as Performer in Early Russian Cinema* (London: I. B. Tauris & Co. Ltd., 2017).

6 This is of course, by no means an exhaustive list of works that explore female representation in cinema, nor female industrial labor.

7 Rimgaila Salys, "Life into Art: Laying Bare the Theme in 'Bed and Sofa,'" *Russian Language Journal / Russkii iazyk* 52, no. 171/173 (1998): 294, www.jstor.org/stable/43669091.

8 Ibid., 303.

9 Alexander Prokhorov, "Revisioning Aleksandrov's 'Circus': Seventy Years of the Great Family," *The Russian Review* 66, no. 1 (2007): 4, http://www.jstor.org/stable/20620474.

10 Beth Holmgren, "'The Blue Angel' and Blackface: Redeeming Entertainment in Aleksandrov's 'Circus,'" *The Russian Review* 66, no. 1 (2007): 5–22, http://www.jstor.org/stable/20620475.

translate to discussions of Soviet and Russian animation, which rarely, if ever, focuses on interpersonal romantic relationships between men and women, fallen women, or sexuality, as these subjects would not have been considered appropriate for children.[11] While adult topics were considered taboo, we will demonstrate that on certain occasions female self-determination and the contradictions of Soviet gender equality were addressed in the animation made by women.

The scholarship on Soviet cinema shifts with the new generation of Soviet filmmakers from the 1960s onwards, who attempted to reframe the world of their films and set themselves counter to the cinema of Stalinism as they focused their films on the private lives and daily routines of Soviet citizens.[12] The 1960s were also the period that saw more Soviet women become live-action filmmakers, which in our opinion changed the way scholars analyzed these films. For instance, rather than ignoring gender, as was the official stance, scholars began to look at films directed by women, discerning their differences, and attributing them to gender. In one such instance, Susan Larsen's 2007 chapter "Kira Muratova's *Brief Encounters*," builds on Laura Mulvey's famous 1975 essay "Visual Pleasure in Narrative Cinema" and suggests that Muratova's film disrupts "the viewer's ability to identify with the male gaze (the normative identification presupposed by classical narrative cinema) at every level of the film's structure, which repeatedly locates the origin of the on-screen gaze within the memories of her two female characters."[13] In other words, it is Muratova's status as a female director which allows her to unseat the usual male gaze and the pleasure derived by male spectators by focusing on her female characters. Lilya Kaganovsky in "Ways of Seeing: On Kira Muratova's 'Brief Encounters' and Larisa Shepit'ko's 'Wings'" (2012) suggests that the women directors who began their careers during the Thaw represent a kind of Soviet "counter-cinema," one that posits the question of "seeing" differently, that is, a gendered seeing, at the center of its interrogations.[14] For scholars, like Larsen and Kaganovsky, as well as the authors of this book, women directors often

11 See section on Children's Animation later in this chapter.
12 Lilya Kaganovsky, "Ways of Seeing: On Kira Muratova's 'Brief Encounters' and Larisa Shepit'ko's 'Wings.'" *Russian Review* 71, no. 3 (July 2012): 482–483.
13 Susan Larsen, "Kira Muratova's *Brief Encounters*," in *The Cinema of Russia and the Former Soviet Union (24 Frames Series)*, ed. Birgit Beumers (London: Wallflower Press, 2007), 124.
14 See chapter 5 for more explanation of the Thaw in the 1960s.

address female spectators and issues related to women in unique ways and hence their works can be categorized as women's cinema. While only Kaganovsky engages specifically with the term women's cinema, a point we will return to, all of the scholars we have been discussing raise aesthetic and narrative particularities that relate to broader concerns of female representation and bring new insights into the discourse of gender in live-action cinema throughout the Soviet and post-Soviet period.

An issue these studies have in common is that they do not address the advances women have made in the animation industry. Soviet female directors have distinguished themselves in the animation industry despite having been largely ignored. We argue over the next several chapters that women's work in animation interacts with ideology in intricate and complex ways, often portraying females and femininity in ways that push the boundaries of ideological and aesthetic norms in the Soviet Union. Throughout this book we demonstrate how, despite dominant Soviet ideology and Russian cultural misogyny, animation made by women was and is, in fact, gendered and that gendering is crucial to understanding the impact women have in animation history. However, we do not employ a typical Western feminist approach to analyze these films, instead our approach attempts to situate these women directors and their films within the historical reality in which they lived. While there may be some theoretical overlap, our approach does not attempt to raise the same questions of gender provoked by live-action women directors. We believe that bringing the work of women animation directors together in one monograph is a necessary contribution to both feminist and animation studies, as these women deserve to have their work preserved as part of animation history. Our vision for this book is not to compare the animation of men and women, but rather point out the ways in which women imagine strong heroines, motherhood, femininity, and, at times, a more unique form of feminism than is found in the West.

Our study brings together the reconstruction of women's labor and animation history, with analysis specific to the field of animation, in order to bridge the gap between film and animation studies, Slavic studies, and gender studies. Our work is historically situated in order to accurately reassess the role of women, not only as we trace the establishment of the Soviet and Russian animation industry, but also as we attempt to understand the depictions of females and femininity in the films made by women. The three main concerns of our book are: 1) the recovery of the contributions women have made to Russian and Soviet animation over the last hundred

years; 2) the question of how the term women's cinema in Russia and the Soviet Union can be applied to animation; and 3) the complications and possible advantages posed by animation's ghettoized position as children's media. While there are many barriers to assessing women's success in the field of animation and their achievements may have been obscured over the last hundred years, our goal is to demonstrate that several female animators were able to overcome these barriers and have contributed to the shaping of animation culture and tradition in Russia.

We believe that many of the gender concerns raised by scholars of live-action cinema pose a complex set of problems when one takes into account all the relative factors of the animation industry: the medium of animation, the use of authorial point of view, the intended audience of animated work, Russian and Soviet cultural constraints in regard to animated film, and the woman question. We will discuss each of these constraints in turn in an attempt to understand the particular significance of female directors within Soviet and Russian children's animation. Only then can we explore why and how women's animation contributes to the notion of women's cinema and why studying this contribution is crucial for understanding the history of Soviet and Russian animation.

Children's Animation and Censorship

Animation was born alongside cinema, as a mostly adult form of amusement, it soon became associated primarily with children's entertainment.[15] The association of animation with children has led many to assume that it is less important and less serious than live-action cinema, and that because it is made for children it is harmless and innocent. These erroneous assumptions contributed to two significant outcomes within the Soviet Union: 1) because animation was considered less prestigious, women were allowed to reach top creative positions, especially working as directors; and 2) children's programming and animation actually became a site where artists were able to push back against dominant ideology and create changes in attitudes.[16]

15 Animation still held a place in the "grown-up" realms of experimental and art cinema, but in the American context, it was not until Ralph Bakshi's *Fritz the Cat* in 1965 that animation was again considered the purview of adults.

16 In the American context *Sesame Street* is a great example: having dealt with the death of a main character, it has also introduced a variety of characters who have challenged notions of "normal" and acceptable: a character with Down syndrome, an HIV-positive Muppet, and a Muppet with autism.

Children's animation has often been ignored by film scholars as lacking merit for scholarly investigation because of its connection to children. Jayne Pilling, in her instrumental book *Women in Animation*, admits that women have had more of an authoritative and creative role in pivotal films for children, yet she dismisses animation made for children as not belonging to her investigation because she sees it as neither an art form, nor a form of personal expression.[17] For Pilling, children's animation is too formulaic and does not tackle the personal, which is what separates the dross from the artistic. Her assessment is common among scholars of children's media, who tend to explore animation's intrinsic value as entertainment and/or as an educational vehicle, but often eschew any discussions of its artistic merit.[18] This devaluation of animation for children holds true especially within the Russian and Soviet context. Russian film scholar, Birgit Beumers, points out in her article "Comforting Creatures in Children's Cartoons" that children's animation in Russia has suffered from a lack of scholarly interest because of its connection to children.[19] Russian children's animation is further discredited because it is an area where women were working. Female directors and animators exercised tremendous creative and cultural influence, more so than their live-action counterparts.

Because children were the intended audience for most animated films during the Soviet and post-Soviet period, certain questions of gender or sexuality and some broader concerns of female representation, used by feminist scholars of live-action film, cannot be applied to animation studies in the same way. While ideas related to female self-sufficiency and self-determination do appear in animated films in the 1920s and beyond, issues of eroticism and sexuality are seen much less frequently. In the 1960s Soviet female directors did engage with different ways of seeing, yet utilizing Mulvey's psychoanalytic understanding of the spectator's gaze is not particularly helpful when discussing films that feature anthropomorphic

17 Jayne Pilling, ed., *Women and Animation: A Compendium* (London: British Film Institute, 1984), 5.
18 See L. A. Kort-Butler, "Justice League?: Depictions of Justice in Children's Superhero Cartoons," *Criminal Justice Review* 38, no. 1 (2013): 50–69, and S. M. Zehnder and S. L. Calvert, "Between the Hero and the Shadow: Developmental Differences in Adolescents' Perceptions and Understanding of Mythic Themes in Film," *Journal of Communication Inquiry* 28 (2004): 122–137.
19 Birgit Beumers, "Comforting Creatures in Children's Cartoons," in *Russian Children's Literature and Culture*, ed. Marina Balina and Larissa Rudova (New York: Routledge: 2007), 153.

cats or turtles—although it certainly can be done, we feel it does not properly explain women's representation in animated films intended for children. There are some areas of overlap in potential scholarly approaches to animation and live-action film, for example, the focus on strong female characters who overcome obstacles and the image of woman as a version of mother earth. Still, the analysis of animated films cannot mirror the analysis of live-action films due to the specifics of their intended audience and the Russian and Soviet cultural constraints in regard to animated films for children.

Recently, however, scholars have become increasingly more interested in going beyond the supposed innocence of children's animation and exploring not only the ways in which it influences children, but also how it challenges hegemony and cultural constructs. Henry Giroux, an American cultural critic, in his book *The Mouse that Roared: Disney and the End of Innocence*, examines the social, gender, and ethnic constructs espoused by the Walt Disney Corporation and the influence Disney has on popular culture.[20] Giroux argues that Disney, through films, television and radio stations, theme parks, and advertisements, invades our society to espouse Disney-centric values (which by today's standards would be considered racist, sexist, and homophobic). He suggests that we must carefully evaluate the cultural hegemony established by the corporation and view Disney films as more than simple narratives of fantasy and escape or as forms of pure entertainment. Giroux warns that it is our responsibility to find a way to insert the political back into the discussion about these films and understand the relationship between childhood and innocence. Giroux's argument is also applicable to Soviet animation, which was perhaps more consciously didactic in its hegemonic overtones. While Disney and the Soviet Union had very different ideological approaches, both aimed to educate, shape, and indoctrinate children. The relationship between childhood and innocence and the propensity to overlook messages in animated films is crucial for understanding how Russian women directors influenced not only the technical and aesthetic aspects of Soviet animation but also the espoused cultural norms and modes of behavior.

The connection between innocence and animation has been explored by Natalie Kononenko, an expert on Ukrainian folklore, in her article

20 Henry A. Giroux and Grace Pollock, *The Mouse that Roared: Disney and the End of Innocence* (Lanham: Rowman & Littlefield Publishers, Inc, 2010), 84–91.

"The Politics of Innocence: Soviet and Post-Soviet Animation on Folklore Topics." Kononenko argues that because Soviet animation was "cloaked in a veneer of innocence," that is, rendered harmless by its association with children, it was able to get away with sometimes controversial representations. For example, ethnic and gender stereotypes that would have been censored in live-action film are allowed to remain in Soviet and, now, Russian animation, because they are somehow less dangerous when they are animated.[21] Soviet animated films are not innocent, and often push alternate ideologies. While Kononenko's article focuses on Ukrainian examples and only mentions a few women animators, she comments on the types of female characters that were created during the Soviet period, "Although the Communist party had originally promised to liberate women and make them strong and equal partners to men, by the time Soviet cartoons were created, independent women were no longer desired."[22] Instead of strong independent women, Kononenko identifies examples of female characters that are "passive, gentle, self-sacrificing . . . and hardworking."[23] Besides the hardworking aspect, in general, these character traits run contrary to the official goals of the Communist party. Kononenko's scholarship uncovers negative stereotypes about women in animation, but the scope of her article is rather narrow to make conclusions about specific female animation directors. Significantly, Kononenko pinpoints the unusual censorship structure in the animation industry which helped women directors have a voice in their films, in ways that would not have been permitted in live-action cinema because animated film was deemed beyond ideology.[24]

As many animation scholars have argued, censorship worked differently in Soviet animation than in other areas of the film industry.[25] Folklorist Jack Zipes offers the most common understanding of the censorship apparatus in the animation industry in Russia: "The fairy-tale shorts were screened by state authorities and were obliged to follow the cultural policies of the Communist regimes and emphasize pedagogical and moral aspects

21 See Natalie Kononenko's discussion of *Vasilisa the Beautiful* in "The Politics of Innocence: Soviet and Post-Soviet Animation on Folklore Topics," *Journal of American Folklore* 124, no. 494 (2011): 272–294.

22 Ibid., 277.

23 Ibid., 277.

24 Ibid., 273.

25 Georgii Borodin, "V bor'be za malen'kiye mysli. Neadekvatnost' tsenzury," *Kinovedcheskie zapiski* 73 (2005): 271; and idem, "'Soiuzmul'tfil'm': Nenapisannaia istoriia," *Kinovedcheskie zapiski* 80 (2006): 149–152.

of the fairy-tale films. These policies kept changing, and the animators were always faced with arbitrary standards and censorship."[26] Zipes is correct in his basic assessment of censorship as irrational and arbitrary, yet he misses the nuances that made the system work in favor of animation directors. Censorship was at once critical because children were being influenced, but also more lax because it was innocent animation. Maya Katz, in *Drawing the Iron Curtain: Jews and the Golden Age of Soviet Animation*,[27] challenges Zipes's understanding of censorship, suggesting that the 1,200 narrative films that came out of Soiuzmultfilm in 1936–1991 cannot be categorized as simply examples of propaganda or socialist realism. Directors of animated films were not blindly forced to follow the rigid standards of the cultural policies of the Communist regimes.[28] Instead, Katz argues, directors during the production process often were presented with conflicting evaluations, that allowed directors to act on only one opinion while ignoring others that conflicted with their artistic vision. Katz's work dismisses the idea that there was a centralized, cohesive body making informed and final decisions about Soviet ideology and forcing these ideas into animated films. While there was certainly censorship and decrees passed which inhibited animation production, we highlight some of the ways in which animation directors were allowed more freedom of expression than live-action film directors.[29] In particular, women directors who despite the censors, managed to push forward films that contained their own formations of female self-realization and self-reflexivity. It is precisely because of this relative freedom and the fact that the majority of animation produced during the Soviet and post-Soviet periods was designated for children that we choose animation made by women.

Women's Contributions to Animation

Throughout its one-hundred-plus-year history, Russian cinema, like cinemas in many other countries, was and is still dominated by men. Despite

26 Jack Zipes, *The Enchanted Screen: The Unknown History of Fairy Tales Films* (London: Routledge, 2011), 79.

27 Maya Katz, *Drawing the Iron Curtain: Jews and the Golden Age of Soviet Animation* (New Brunswick, NJ: Rutgers University Press, 2016).

28 For a discussion of censorship at Soiuzmultfilm see ibid., 19–24.

29 Semen S. Ginzburg, *Risovannyi i kukol'nyi fil'm: Ocherki razvitiia sovietskoi mul'tiplikatsionnoi kinematografii* (Moscow: Iskusstvo, 1957), 164.

this, there have been times when women have helped to shape the industry, such as Antonina Khanzhonkova who served as head of production for her husband's film studio Khanzhonkov & Co. prior to 1918.[30] This holds true for animation as well, where Russian women were among the first in the world to have successful careers and to reach the coveted and prestigious position of director. For instance, Olga Khodataeva and the sisters Valentina and Zinaida Brumberg began their animation careers in 1924 in the newly established Soviet State. By 1928 they were directing their own films, and continued to direct until the 1970s.

Women in other parts of the world have had varying success at directing animated films. Lotte Reiniger, a German animator, began animating for Paul Wegener's *The Pied Piper of Hamelin* (*Der Rattenfänger von Hameln*) in 1918. Reiniger, famous for her elaborate paper cut-out silhouette animation, is often celebrated as the first woman animator, having directed her first animated short in 1919, *The Ornament of the Enamored Heart* (*Das Ornament des verliebten Herzens*), and was often credited with having made the first feature-length animated film, *The Adventures of Prince Achmed* (*Die Abenteuer des Prinzen Achmed*) in 1926. [31] Within the American context, the Walt Disney Studio is often seen as the pinnacle of the early animation industry, however they did not hire women as directors during the early years. In fact, as late as 1938 one hopeful candidate leaned that "Women do not do any creative work in connection with preparing the cartoons for the screen, as that work is performed entirely by young men."[32] The letter writer, Mary Cleave for Walt Disney Productions, Ltd., went on to inform Miss Mary Ford that the best she could hope for was to be an inker

30 Michele Leigh, "Reading between the Lines: History and the Studio Owner's Wife," in *Doing Women's Film History: Reframing Cinemas, Past and Future*, ed. Julia Knight and Christine Gledhill (Urbana, IL: University of Illinois Press, 2015), 42–52.

31 Reiniger's film is the earliest extant film. The first feature-length animated film, which was also made of cut-outs, was the now lost Argentinian film *The Apostle* (*El Apóstol*), directed by Quirino Cristiani in 1917.

32 Mary Cleave, for Walt Disney Productions Ltd., to Miss Mary V. Ford, June 7, 1938, accessed June 19, 2018, http://www.openculture.com/2013/04/no_women_need_apply_a_disheartening_1938_rejection_letter_from_disney_animation.html. It is generally understood that this is a form letter, meant to discourage young hopefuls from moving to California without a job. Mindy Johnson's book *Ink & Paint* illustrates that the letter is not an example of Disney's wholesale disregard for female artists/employees, but points to the kinds of employment where women excelled at Disney, namely the Ink & Paint department, where Cleave herself worked. Mindy Johnson, *Ink & Paint: The Women of Walt Disney's Animation* (Los Angeles: Disney Editions, 2017).

(the person who worked on quality control, tracing the outlines with india ink before color paint was added) or painter (a person who worked in the color key department—coloring in the lines created by the inker in individual frames), but she did not advise traveling from Arkansas as those positions were rare compared to the number of young women who applied for them.[33] One of the first women to work at Walt Disney and receive screen credit as an animator was Retta Scott for her work on *Bambi* in 1942.[34] The perception within popular culture of sexism and an all-boys club mentality has historically been reinforced by the fact that Disney did not employ a woman as a director of a feature-length animated film until 2013, when Jennifer Lee co-directed and wrote *Frozen*.[35]

Because Disney was so reticent to hire women as lead animator or director, one must look elsewhere in the American system in order to find one the first female animators at a major studio. Lillian Friedman Astor in 1931 was hired by the Fleischer Studios, famous for *Betty Boop* in the 1930s, to work as an inker, painter, and an in-betweener, drawing the frames of movement in between the key frames created by the senior animator. Astor was eventually promoted to an assistant animator and then finally to animator in 1933; though she never directed her own film. Astor notes, in an interview with Harvey Deneroff, that her *Betty Boop* work was shown to the Fleischers "without telling them at first that it was done by a girl," hence Astor was promoted to animator based solely on her artwork.[36] Not many women were so lucky.

33 Ibid.

34 Monique Peterson, *The Little Big Book of Disney* (New York: Disney, 2001), 303–319. Scott is also mentioned several times in Didier Ghez, *Walt's People: Talking Disney with the Artists Who Knew Him*, vol. 8 (Bloomington: Xlibris Corporation, 2009). See also Johnson, *Ink & Paint*, 155. It should be noted that Scott was most likely not the first women animator at Disney, but her case becomes an exemplar of the problems inherent in rewriting women back into film/animation history - so much of female labor has been lost without proper screen credit.

35 Terry Flores, "*Frozen's* Jennifer Lee Melts Glass Ceilings," *Variety*, June 10, 2014, accessed December 16, 2018, https://variety.com/2014/film/awards/frozens-jennifer-lee-melts-ceilings-1201216961/. While Merida is claimed by Disney to be one of their princesses, Brenda Chapman's film *Brave* (2012) was produced by Pixar and they removed Chapman as director partway through the filming of the screenplay that she wrote.

36 Harvey Deneroff, "Lillian Friedman Astor: Pioneer Woman Animator," *ASIFA-East Program*, accessed October 12, 2018, http://deneroff.com/docs/Lillian%20Friedman%20Astor%20Pioneer%20Woman%20Animator.pdf.

Generally, the field of animation has always attracted a large number of women, perhaps a holdover from the early days of cinema when droves of women were employed to paint and stencil the individual film frames of live-action film. Despite the large number of women working in the animation industry, many struggled for recognition. Anna Belonogova, a current member of the teaching collective at VGIK (All-State Institute of Cinematography) suggests in her article "Shine, Supernova," that women were attracted to the field of animation because the profession demanded great care, preservation, and creativity. Belonogova goes on to remark that women animators are always in the shadows of their male counterparts, doing a disservice to their films and their contributions, which are varied and even sometimes well-known throughout the world.[37] The authors of this book, like Belonogova, feel that it is important to not only highlight the work women were doing, but to call attention to the importance of that work.

Part of the difficulty in recognizing the work of women in animation is due to the way in which these films are made. As Eric Herhuth points out in "Political Animation and Propaganda," animation labor has been a topic for critical study especially given the capacity for animated films to conceal the condition of their production.[38] With the exception of art films, most animated films are not made from start to finish by one person, and creative input in animation cannot easily be assigned to one individual as very few animated works have been created without the hands of a great number of people. In general, directors rely on other people to help make the film and often there is a certain amount of collaboration, so that a final work bears the imprint of many people. Even when crew members are credited, identifying and researching directors, animators, camera operators, art directors, and editors of a particular film can be challenging at best, as it is often difficult to delineate how each of these individuals contributed to the final film. This concealment of labor practices can lead to exploitation and discrimination—especially in regards

37 See Belonogova's history pages on the website for VGIK (All-State Institute of Cinematography). She discusses women animators in the section "Shine, Supernova." Belonogova is a current teacher at the VGIK college, a female animator, and a member of the Filmmakers' Union. Anna Belonogova, "Gori, sverkhnovaia," accessed August 2, 2017, http://www.vgik.info/college/history_of_animation/.

38 Eric Herhuth, "Political Animation and Propaganda," in *The Animation Studies Reader*, ed. Nichola Dobson, Annabelle Honess Roe, Amy Ratelle, and Caroline Ruddell (New York: Bloomsbury, 2018), 177.

to women's labor. Within Russian animation studies, especially in the early years, it is almost impossible to identify the women who worked as in-betweeners, inkers, and colorists. These positions in the Soviet Union and throughout the world were predominantly performed by women, yet they were routinely not given screen credit, so it is sometimes impossible to know where women were working. In this respect Belonogova is correct: many women have worked on animated films, they have influenced animation and, unfortunately, for the most part their names are still unknown because their work remains uncredited.

An illustration of the unrecognized, yet clearly visible, work of women in Soviet animation in the 1940s and 1950s can be found in animator Ivan Ivanov-Vano's text *Drawn Film*.[39] Often called the father of Soviet animation, Ivanov-Vano directed over sixty films during his career and worked with the Brumberg sisters as well as with Aleksandra Snezhko-Blotskaia. *Drawn Film* analyzes animation as an art form, while introducing practical skills to new animators. The book consists of a series of chapters, which taught beginning animators necessary technical skills, outlined procedural requirements of their profession, and mapped out the history of animation. This eighty-five-page pamphlet contains only five photographs, all of which show animators at work. Women at work are visible in four of the five photos: women sitting in rows in a workshop, women tracing and painting, women drawing, and even a woman behind the camera. However, nowhere in the text does Ivanov-Vano comment on the contributions of women to the field of animation and none of the photos have names. If the male-to-female ratio indicated by the photographs is indicative of women's representation in the animation industry, then it suggests that women were an important and significant part of the field. Ivanov-Vano's book reminds us of the fact that women did not get credit for the work they did. Despite their visual presence, his book, too, serves to erase their contributions.

If we examine contemporary scholarship on Russian and Soviet animation we find that while female animators are mentioned, their films are not discussed in terms of femininity, women's issues, or women's cinema, further obscuring any connection to gender. For example, David MacFadyen in his groundbreaking 2005 *Yellow Crocodiles and Blue Oranges: Russian Animated Film since World War II* is one of the first scholars to tackle the long-ignored field of Soviet animation. While MacFayden mentions several

39 Ivan Ivanov-Vano, *Risovannyi fil'm* (Moscow: Goskinoizdat, 1950).

female animators, including the Brumberg sisters and Inessa Kovalevskaia, he is not interested in their work in terms of feminine labor; rather, he writes about the connection between Soviet animation and phenomenology.[40] Clare Kitson's 2005 book, *Yuri Norstein and Tale of Tales: An Animator's Journey*, examines one of the most widely acclaimed films of all time and one of the world's best-known and most honored Russian animators, Yuri Norstein. Kitson acknowledges Franchesca Yarbusova, Norstein's wife, and her collaborations with Norstein, but does not investigate Yarbusova's contribution, as part of female labor, nor does she discuss how Yarbusova may or may not have influenced Norstein's filmmaking.[41] Laura Pontieri's *Soviet Animation and the Thaw of the 1960s: Not Only for Children* focuses on the innovative climate of the Thaw period, which allowed animators to pull away from the didactic children's films of the Socialist Realist period. Pontieri does discuss the Brumberg sisters' adult animation, but again, she is not interested in their work as female directors.[42] Finally, in *Drawing the Iron Curtain: Jews and the Golden Age of Soviet Animation* Katz discusses the Brumberg sisters as Jewish artists, rather than as women artists. Katz, however, does highlight the fact that women and minorities, especially Jewish artists, found unparalleled opportunities in the Soviet animation industry.[43] All of these texts are quintessential for establishing the field of Russian and Soviet animation studies, yet each falls short of delineating the contributions of women's labor inside the animation industry. While these texts did not set out to discuss gender, they inadvertently support the assumed equality of Russian women within the workforce, further sublimating and obscuring the work of all the nameless women who have worked in the Soviet and Russian animation industry.

While we believe that identifying women's hidden work in animation and making it visible is important and necessary, this book will focus on a more prominent, but still relatively ignored, group of women—directors. This monograph is the first of its kind to focus on the contributions of women directors to Russian and Soviet animation. While our analysis

40 David Ward MacFadyen, *Yellow Crocodiles and Blue Oranges: Russian Animated Film Since World War II* (Montréal: McGill-Queen's University Press, 2005).

41 Clare Kitson, *Yuri Norstein and Tale of Tales: An Animator's Journey* (Bloomington: Indiana University Press, 2005).

42 Laura Pontieri, *Soviet Animation and the Thaw of the 1960s: Not Only for Children* (Bloomington: John Libbey Pub. Ltd., 2012).

43 Katz, *Drawing the Iron Curtain*.

may, at times, seem distant from traditional feminist critique, our exploration of these films identifies themes and directions that women animation directors repeatedly incorporated into their films. We are aware that our book only scratches the surface of what needs to be done. We hope that our analysis of women and their animated films opens the door for deeper and varied analysis and allows women to be added to animation history and analyzed alongside their male counterparts, prompting the inclusion of women into the broader discussion of world animation.

We discuss directors who have spanned both the Soviet and post-Soviet periods of Russian animation, including Zinaida and Valentina Brumberg, Olga Khodataeva, Aleksandra Snezhko-Blotskaia, Inessa Kovalevskaia, Nina Shorina, Nataliia Golovanova, Ideia Garanina, Anna Belonogova, Mariia Muat, Iuliia Aronova, and Darina Shmidt. These animators have all made a lasting impact on Russian animation, yet their contributions have largely been ignored by historians and film scholars. These women rose through the ranks of the Soviet and Russian animation industry, achieving what statistically few women in other countries have been able to do—become animation directors. This position requires strong leadership skills to manage different kinds of creative work, interpersonal skills to work with a variety of people with different temperaments and abilities, and management skills to deal with time constraints, budgets, bureaucracy, and of course, censors. It is the director's vision that informs the film's broad concept and esthetic style. The director must approve every aspect of the final production process. The films made by these twelve directors harnessed new technologies, proclaimed new aesthetic styles, and influenced generations of animators and viewers. The films we analyze are important not only because they allowed the twelve female directors the opportunity to innovate and to engage in the creative process, but also because they gave these women a crucial platform in the Soviet Union and Russia: a place to voice their thoughts on subjects that mattered to women, in other words, a place to create a women's cinema.

What is Women's Cinema in Russia? Why Does It Matter?

In tandem with recent scholarly attempts to unmask the roles women played in the development of film industries around the world, there has also been

a growing interest in the concept of women's cinema.[44] As the quote from Butler that opened this chapter points out, the notion of women's cinema is complicated by multiple factors and only becomes more convoluted when one is discussing Soviet and Russian animation. As we will demonstrate the notion of women's cinema within the Soviet and Russian animation industry is further complicated by its connection to children's entertainment, work collectives, Soviet decrees, the dissolution of the Soviet Union and by various industrial changes.

Perhaps the most generous explanation of the concept comes from film scholar Judith Mayne, who suggests that women's cinema can simply be understood as, cinema made by women.[45] While Mayne notes that looking at films made by women can be useful, she is far more interested in the ways in which these films "redefined and challenged some of the most basic and fundamental links between cinema and patriarchy," and perhaps most importantly, the ways in which they shifted subjectivities.[46] Maria LaPlace's exploration of women's cinema, that is, films made for and marketed to a female audience, is useful for framing the animated films we will be discussing as part of Soviet and Russian women's cinema. LaPlace notes that the films tend to focus on traditional realms of women's experience: "the familial, the domestic, the romantic, those arenas where love, emotion and relationships take precedence over action and events."[47] The attention to how female filmmakers may have dealt with the emotional aspect of women's lives can be a productive approach to women's cinema, but as Patricia White points out, some female filmmakers, like Kathryn Bigelow, do not fit that mold. White takes a broader approach to women's cinema, looking not just at authorship, thematics, or genre, but also takes into account the industrial context within which the films were made—who controlled the marketing, how the film fit within art cinema or popular cinema, and how it functioned in cultural, regional, and global context.[48] These texts offer

44 There are many excellent summaries of the evolution of the concept of women's cinema, see the books listed in subsequent citations.

45 Judith Mayne, "The Woman at the Keyhole: Women's Cinema and Feminist Criticism," *New German Critique* 23 (1981): 27–43.

46 Ibid., 1–10.

47 Maria LaPlace, "Producing and Consuming the Woman's Film: Discursive Struggle in *Now Voyager*," in *Home is Where the Heart is: Studies in Melodrama and the Woman's Film*, ed. Christine Gledhill (London: British Film Institute, 1987), 139.

48 Patricia White, *Women's Cinema, World Cinema: Projecting Contemporary Feminisms* (Durham, NC: Duke University Press, 2015), 1–22.

useful frameworks to help us address the issue of women's cinema, what it is, and why it is important within Russian animation.

The concepts of women's rights, women's issues, and more pertinently, women's cinema (*zhenskoe kino*—understood as women's or feminist film) are enmeshed with the contributions of female filmmakers to the industry. Moreover, these concepts are complicated notions within Soviet and Russian film history because of Communist ideology and how it was enacted in Soviet Russia. Women were granted the right to vote in July 1917 under the Provisional government, and the legal equality of men and women was established later by the Bolshevik regime. The Bolsheviks understood that women's liberation from bourgeois fetters could not be isolated from the liberation of the working class as a whole. Yet at the same time, the Bolsheviks also realized that women's emancipation could not be fully achieved in a backwards county and in isolation from the rest of the world.[49] This need to "catch up" with other nations industrially and economically unfortunately allowed women's issues frequently to be placed on hold while more pressing matters were handled. The Bolshevik regime attempted to fulfill this promise of women's emancipation through the formation of a party department to address women's needs, the famous Zhenotdel.

The actual liberation of women was not so easy, as the problem of women's subjugation was systemic. Leon Trotsky suggested in *Revolution Betrayed* that "The real resources of the state did not correspond to the plans and intentions of the Communist Party. You cannot 'abolish' the family; you have to replace it. The actual liberation of women is unrealizable on a basis of 'generalized want.' Experience soon proved this austere truth which Marx had formulated eighty years before."[50] In other words, woman could not be emancipated while the old family structure was still in place; she needed to be completely freed from familial obligation through the introduction of communal cafeterias, child care centers, and other resources that would ease her burden. So, while Soviet legislation in these early years gave women in Russia a level of equality and freedom that has

49 This is a very cursory discussion of Marxist and Bolshevik ideology and their understanding of the woman question. For more information see: Choi Chatterjee, *Celebrating Women: Gender, Festival Culture, and Bolshevik Ideology, 1910-1939* (Pittsburgh: University of Pittsburgh Press, 2002); Barbara Alpert Engel, "Women in Russia and the Soviet Union," *Signs* 12, no. 4 (1987): 781–796; Gur Ofer and Aaron Vinokur, *The Soviet Household under the Old Regime: Economic Conditions and Behaviour in the 1970* (Cambridge: Cambridge University Press, 1992).

50 Leon Trotsky, *The Revolution Betrayed* (New York: Pathfinder Press, 1972), 144–159.

yet to be attained by some more economically advanced "democratic" capitalist countries today, it did not translate directly into real-life emancipation for Soviet women. Most women remained too far removed from urban centers where most of the services were located and the government lacked the resources needed to fully enact the freeing of women from domestic tasks and childrearing.

By 1936, despite the fact that early Bolsheviks realized the inherent barrier to creating true equality between men and women, that is, the family, the Soviets decided to temporarily ignore the family per se and issued a decree stating that women in the Soviet Union were accorded equal rights with men in all spheres of economic, state, cultural, social, and political life. This *supposed* equality also resulted in the presumed erasure of the differences between men and women in the Soviet Union.[51] The reality of what happened is that equality was never really achieved in women's everyday lives. Soviet women were expected to work full-time outside of the home, and continue to be responsible for childcare and domestic tasks like housework and cooking, which, in turn, held them back in the workplace. Their newfound freedom meant that Soviet women were put into a double bind (meaning women were expected to still manage all household and familial tasks while also working outside the home), or a triple bind, if political activity was expected as well.

In spite of the decrees of equality, women all over the Soviet Union still struggled to gain acceptance in many fields. For women in the film industry, this equality meant that they were allowed and encouraged to join the industry, yet parity with men was never achieved. Communist decrees may have given women the chance to work in cinema, but Communist ideology also masked their feminine and/or feminist paths. In other words, the supposed equality served to erase the significance of gender, thus erasing women's contributions altogether. In fact, this may be one of the reasons female Soviet animation directors have been ignored by scholars for so long, especially inside the Soviet Union.

Women may, in theory, have had equal access to the Soviet film industry, but that did not mean the industry was fully integrated. In fact, very few women had equal access to prestigious creative positions, like that of director. Interestingly, more women became directors of animation than live-action film, though the vast majority of directors were and are men.

51 Mary Buckley, *Women and Ideology in the Soviet Union* (Ann Arbor, MI: The University of Michigan Press, 1992), 117.

Early animators in the 1920s benefited from the decrees that gave women access to employment; among them were the Brumbergs and Khodataeva. These women rose from the ranks of nameless inkers and in-betweeners and eventually became directors, while navigating an industry that had been male-dominated since its inception. As directors, these women took advantage of the creative outlet of animation to exercise their female perspective, and along the way made aesthetic innovations in the animation industry and influenced cultural models over the years.

This first wave of women animators in the 1920s had to traverse shifting political and cultural terrain, yet were still able to tackle tough subjects like women's rights while also creating some touching mother-child narratives and exalting the importance of family, even as some officials in the Communist party saw the family as a problem that needed to be fixed. From the 1930s through 1950s women's work and voices in animation became more marginalized as animation was transformed into a medium of Soviet propaganda for children. The adoption of socialist realism, cel animation, the Disneyfication of Soviet animation, and the creation of Soiuzmultfilm added further restrictions and hurdles for female expression within the industry. Despite these barriers, women animators still continued to champion mother-child relationships in films from these years and influenced Russian culture in unexpected ways. By the 1960s and 1970s women in the animation industry benefited from the more liberal political atmosphere that followed Stalin's death. Female directors in those years became increasingly invested in exploring the inequality in women's lives with satirical and counter-culture films that slowly began to move away from a children's audience.

During the almost seventy years of women working in Soviet film and animation production, there was no discussion of women's cinema among scholars, filmmakers, or critics in any of the premier Soviet film journals such as *Proletarian Cinema* (*Proletarskoe kino*, 1931–1932), *Soviet Cinema* (*Sovetskoe kino*, 1932–1936) or *The Art of Cinema* (*Iskusstvo kino*, 1936–present). An important reason is that earlier Soviet decrees of gender equality appeared to render such a thing unnecessary.[52] It was not until

52　While the exact term "women's cinema" may not have been used prior to the Revolution, the concept was evident in the labeling of pre-Revolutionary director Evgenii Bauer a "woman's director." See Michele Leigh, "Dangerous Beauty: Representation and Reception of Women in the Films of Evgenii Bauer, 1913–1917" (PhD diss., University of Southern California, 2007).

the 1980s that the first mention of the term women's cinema is made in print form by Maiia Turovskaia, theatre and film critic, as well as film historian and screenwriter. Turovskaia's article "Women's Cinema, What is it?" appeared in *The Art of Cinema* in 1981, where she writes about the subject in relation to *A Few Interviews on Personal Questions* (*Ramdenime interviu pirad sakitkhebze*, 1977), a Georgian film directed by Lana Gogoberidze.[53] Turovskaia not only sees the contribution of women as a suitable object of study, she also makes a case for Gogoberidze's film to be considered the first Soviet "women's film" of the time because of its status as a film made by a woman, dealing with women's issues and dedicated to women.[54] The term does not appear again until 1983, when Turovskaia reviews the German film *Peppermint Freedom* (*Peppermint-Frieden*, 1983) by Marianne Rosenbaum, and notes that no country has such a strong women's cinema as the Federal Republic of Germany.[55] Irina Rubanova reprises the term again in 1985 in relation to the Polish film *In Self-Defence* (*W obronie własnej*, 1982) by Beata Tyszkiewic, which, according to Rubanova, has all the hallmarks of a "women's film," that is, a film made by a woman about women's concerns.[56] These brief discussions of films that tackled problems of everyday women indicate that Soviet scholars had begun to make the case that films directed by women are distinct from films directed by men. At the same time these discussions served to highlight some of the issues that women struggled with over the years and how these issues had been glossed over or ignored by Soviet society and male filmmakers and critics in particular.

As the Soviet Union slowly fell in the late 1980s and the early 1990s, women's issues were again being raised by female filmmakers and film critics such as Turovskaia, who began to delve further into the meaning of *zhenskoe kino*. In June of 1991, just months before the collapse of the Soviet Union, the journal *The Art of Film* put out a special issue that contained a number of articles dedicated specifically to women, their trails in the film industry, and the films made about and by them.[57] The issue contains essays by both male and female critics, highlighting the crucial differences between men's perception of the term women's cinema and

53 Maiia Turovskaia, "'Zhenskii fil'm'—chto eto takoe?," *Iskusstvo Kino* 5 (1981): 34–35.
54 Ibid., 35.
55 Maiia Turovskaia, "Mentolovyi mir," in "Ekran Festivalia," *Iskusstvo Kino* 12 (1983): 155.
56 Irina Rubanova, "Golos chelovecheskii," *Iskusstvo Kino* 6 (1985): 130.
57 The journal deviates from the standard black cover with a small white Venus symbol on the bottom right-hand corner.

women's perception. Dana Tyrkich Sifer in her article "What is Women's Film?" surveyed both filmmakers and critics about the appropriateness of the term "women's cinema" or "feminist cinema" in the Soviet Union; the answers she received were, of course, varied.[58] Sifer herself felt that something was not quite right about American scholar Patricia Mellancamp's interpretation of the term, "women's cinema" as simply "cinema made by women, about women, and for women" in the Soviet context; her views are more in line with filmmaker Aleksei German, who felt there was no such thing as women's cinema, because if a film or a filmmaker was good, then gender was not an issue.[59] This attitude was popular among male filmmakers like Grigorii Daneliia, who glibly states that "If women are not people, and some suggest this is so, then, probably, this is an appropriate [term]. But if they are people, then why differentiate women's from men's [cinema]."[60] Daneliia's comment is in line with prevailing Soviet sentiments regarding gender, namely, that there is no benefit in examining women's film as a separate genre or category within cinema, a movie is a movie regardless of who made it. In other words, if you do not acknowledge the inequality in the number of female versus male filmmakers, then parity in the film industry becomes an issue that is easily obscured. Instead, cinema made by women is relegated to a concept that need not be recognized, nor is it worthy of inquiry. Sifer's response to her own survey about women's cinema clearly demonstrates the complexity of the term in the Soviet context. Even women, like Sifer, struggled to fully grasp the importance of the term for women due in part to the decades of supposed equality between men and women. The complexity of women's cinema in the Soviet context is one of the reasons that we look both to subjectivity and aesthetics as a way to determine whether a film can be designated as an example of women's cinema.

As one might expect, some women's opinions on this subject are more accepting of the concept of women's cinema. Female critics observe not only a need for the term itself as a category for discussion, but also a need for women's cinema in general, in other words, a need for more women making films. A famous live-action filmmaker from the 1960s and 1970s, Larisa Shepitko, suggests in Elem Klimov's documentary *Larisa* (1980) that "when a woman works on a film, she can observe, convey to

58 Dana Tyrkich Sifer, "Chto takoe zhenskoe kino?," *Iskusstvo Kino* 6 (1991): 42–49.
59 Ibid., 43
60 Ibid., 47.

the viewer some special nuance, a special perception of the surrounding reality of a person, of people, and of nature that is absent in the psychological makeup of a man."[61] Shepitko takes a rather essentialist approach, arguing that female filmmakers approach their subjects in a manner that is distinctly female and thus different from what a male filmmaker might create. Turovskaia, the same critic who first used the term women's cinema in 1981, expands her understanding of the concept in her article "Women and Cinema." Turovskaia remarks that for female filmmakers, "It is the fact that they are incessantly opposed, they are fighting for their place in the sun, they require attention, respect, recognition. Discrimination. Of course, it is present. It is simply assumed that genius can be created only by men. . . . In Russia, it is necessary to constantly prove, that you are not only a woman, but that you are also the director."[62] Turovskaia's comment acknowledges how Soviet women were not simply invited with open arms into the film industry by the decrees of equality. Instead, women had to constantly prove themselves in ways that Soviet men could not even imagine; women not only had to prove their worth as directors, editors, or screenwriters, they also had to prove themselves as women. For many female filmmakers the proving becomes an inherent part of the narrative of their work. This tenaciousness sets women's cinema apart from the films made by men in the Soviet Union. It is important to note that none of the critics consider the role of women in animation. Just as in live-action film, female animation directors not only offered nuances and perceptions that could be argued to be unique to women, but they also proved themselves with dogged determination, long before the term women's cinema could be used to define their work.

This discussion about women's cinema in the Soviet Union also raises the question about how femininity, feminism, and sexism are different within the Soviet context. Turovskaia notes the difference between sexism in Russia and sexism in other countries in an anecdote that she heard while at a meeting of the International Association of Women Filmmakers.[63] According to Turovskaia, a female Dutch filmmaker recalled that on the eve of an award presentation, the directors of the festival suggested that she wear an evening gown. If she did not have one, they would provide it. The Dutch filmmaker felt that this was sexist, as such an offer would not have

61 Ibid., 43.
62 Maiia Turovskaia, "Zhenshchina i kino," *Iskusstvo kino* 6 (1991): 131–137.
63 For Turovskaia's discussion of this anecdote see ibid., 133–134.

been made to a male director. Turovskaia, however, suggests that a Soviet woman would be happy to receive such a proposal; in a Soviet woman's everyday life there simply does not exist a suitable space and time for such a dress. Soviet women, who had little opportunity for femininity, were not thought of as women who would enjoy the luxuries of a gown, makeup, and finery. Soviet women existed with a double burden: career and domestic servitude, hence the trappings of femininity were a luxury few could afford. Turovskaia continues "That's why 'our' sexism is not when they give a coat or give a ball gown (this is from 'their' life), but when a man cuts in front of a woman in a queue; when women are dragging string-bags (full of groceries), and the men are walking with the newspaper; when HE sits down to watch soccer, and SHE goes to the bathroom to do the washing by hand. This is sexism in the Soviet way."[64] Soviet sexism takes place when a man assumes it is his right always to come first, to not perform household duties, nor in any way lessen the burden of the women around him; in other words, it happens all the time.

The sexism Turovskaia describes is one of the byproducts of Soviet gender equality, which placed women firmly in a subservient position within the familial and domestic space. In many ways this domestic servitude left women in Russia far behind their Western counterparts. Seventy years of Soviet ideology, combined with a long history of misogyny in Russia prior to the revolution, contributed to the lack of basic respect for women as people. As a result, female directors had to employ subtle forms of feminism and femininity that are significantly different from Western models. But despite the gender strictures imposed by Soviet ideology, female animation directors were able to add an essential women's voice and issues related to women's rights to Soviet animation.

The question that comes to hand then, is how best to discuss the animation made for children by women in Soviet and post-Soviet Russia in order to make a case for women's cinema within the field of animation. Two concepts in particular will shape our discussion of the animated films made by Russian women: the notion of a female aesthetic and female subjectivity. Paul Wells's discussion of the female aesthetic in *Understanding Animation* has become a key theoretical approach to understanding the differences between male- and female-directed animation. Wells notes that the field of animation has long attracted women and

64 Ibid., 134.

that female filmmakers have used animation to create a specific feminine aesthetic which resists the inherently masculine language of the live-action arena.[65] Wells suggests that within a Western context, this type of filmmaking is often outside the more conventional industrial arena and inevitably becomes both personal and political, because it is self-evidently opposed to orthodox, male-dominated animation. Women's animation, Wells argues, shifts the representation of women from object to subject; it mistrusts language as an agent of masculinity and instead expresses itself in visual terms; it abandons conservative forms and demands more from the viewer; and, finally, it seeks to reveal a woman's perception of either private or public roles.[66] Wells contends this aesthetic has become more recognizable since the 1970s, especially in the United States, although he admits that female animation pioneers should not be overlooked. Wells offers an assessment of women's contributions to animation that recognizes their accomplishments and highlights how women have been able to distinguish their work from men's.

Wells's distinction between male- and female-directed animation is one of the reasons we do not use the same line of feminist questioning in examining women's animation, as other scholars have utilized in discussing live-action film. However, Wells's framework for discussing women's animation is complicated within the Soviet and post-Soviet context. For seventy years, Russian animation made by women existed within the Soviet industrial confines, and often as part of children's education and entertainment production, so its study requires new ways of contextualizing how those films function within a male-dominated system. While Wells asserts that women's film-making is often outside the more conventional industrial arena, in the Soviet Union this was clearly not the case: virtually all animation was part of the state-planned economy and made within the Soviet animation industry. In the Soviet context, since women were involved in the very beginning of Soviet animation and advanced much more quickly up the cinematic ranks than in the live-action arena, women's representation both behind and in front of the camera is distinctive. Yet Wells's notion that women's animation is self-evidently opposed to male-dominated animation and seeks to reveal a woman's perception of private and public life is particularly useful when examining women's work within Soviet animation.

65 For a more complete and detailed description of the feminine aesthetic in animation see Paul Wells, *Understanding Animation* (London; New York: Routledge, 1998), 198–201.

66 Ibid.

His argument about women's animation inadvertently reinforces our assertion that female-created animated films for children require a slightly different framework for feminist critique than live-action cinema, as this approach would ignore the shift in representation in animation. Although there have been many insightful and complex studies on gender issues in Soviet cinematic productions, gender in animated films directed by women cannot be evaluated solely on already established criteria.

While Wells's notion of the female aesthetic provides us with a useful framework for discussing some of the films made by Russian women, it is not sufficient for understanding the full scope of female animation directed under strict industry standards and state-sponsored censorship; for that we turn to the concept of female subjectivity. Subjectivity aims at revealing the perspective of the individual self, rather than some perspective from outside the self's experience.[67] Coupled with feminist theory and the understanding that much of history, philosophy, psychology, and cinema studies focuses on the male experience, the study of female subjectivity is the investigation of the selves of individual women and their lived experience, not just their connections to the experience of men.[68] The concept of female subjectivity raises the experience of women as human beings and individuals to the same level as that of men. Within cinema studies, female subjectivity explores the aesthetic, theoretical, and ideological implications of women in cinema in order to identify female power and subject formation in the narrative structure of cinema and in the cinema itself.[69] While female subjectivity in cinema has been extensively explored, there has been scant research done on female subjectivity in animation for children.[70] Our use of this concept is made complex but not impossible by the totalitarian Stalinist state's constraints on women's subjectivity, which requires reading women's labor as a possible expression of that subjectivity.

67 Andrea Strazzoni, "Subjectivity and individuality: Two strands in early modern philosophy: Introduction," *Societate si Politica* 9, no. 1 (2015): 5–9.

68 Gill Jagger, "Dancing with Derrida: Anti-essentialism and the Politics of Female Subjectivity," *Journal of Gender Studies* 5, no. 2 (1996): 191–199.

69 Kate Ince, *The Body and the Screen: Female Subjectivities in Contemporary Women's Cinema* (New York: Bloomsbury, 2017).

70 Chloe Feinberg, "Articulating Interiors of Longing and Desire: Asparagus (1979) by Suzan Pitt," *Animation Studies 2.0*, November 11, 2015, 15–19, https://blog.animationstudies.org/?p=1303#comments.

Throughout this monograph we will explore how female subjectivity differs from the feminine aesthetic, as identified by Wells, especially when women contributed to the field of animation under Stalinist repression.[71] The totalitarian Stalinist regime pushed women animators away from simply utilizing a female aesthetic towards a more encompassing notion of female subjectivity. This switch from a focus on female aesthetics to subjectivity during the Stalinist years is crucial to understanding the effect of the totalitarian state on female animation directors, especially during the years when women directors assumed a more influential role in defining the trajectory of the Soviet animation industry.

While the concept of female subjectivity has largely been connected to Western second-wave feminism and with the slogan "the personal is political," which has its origins in an article with the same name written by Carol Hanisch in 1970, the recognition that female individualisation appears as a central feature of late modernity demonstrates the importance of researching how the formation of female subjectivity functions in other countries outside the West, including Russia.[72] As we argue in this book, judging Russia by Western feminist standards is not entirely fruitful given that femininity, feminism, and sexism have been different within the Soviet and Russian context. However, female subjectivity focuses on women's lived experiences, and this concept is fundamental in all societies in which men and women are still unequal.

Finally, we are intrigued by the way the slogan "the personal is political" encourages the notion that these practices, undertaken in places and spaces not conventionally defined as political, would in fact contribute to the development of new female political subjectivities that would enable women to speak as political subjects.[73] The animation industry, during Joseph Stalin's reign, was just this type of unconventional space, which could not be defined as strictly political, but allowed women to speak as autonomous individuals through their films. Hence the personal *is* political

71 For a more complete and detailed description of the feminine aesthetic in animation see Wells, *Understanding Animation*, 198–201.

72 Carol Hanicsh, "The Personal is Political," http://www.carolhanisch.org/CHwritings/PIP.html. See also Ulrich Beck and Elisabeth Beck-Gernsheim, *Individualisation: Institutionalised Individualism and Its Social and Political Consequences* (London: Sage, 2002); and Shelley Budgeon, *Choosing a Self: Young Women and the Individualization of Identity* (Westport: Praegar, 2003).

73 Frances Rogan and Shelley Budgeon, "The Personal is Political: Assessing Feminist Fundamentals in the Digital Age," *Social Sciences* 7, no. 8 (2018): 1–8.

in these animated films directed by women throughout the Soviet period. So while motherhood and traditional female roles are portrayed on the screen during the Stalinist era, it is important for scholars to pay attention not only to how female roles are characterized, but also to how women were changing the industry and influencing cultural norms as part of the formation of the female subject. In order to fully comprehend the films and filmmakers we discuss within this monograph, we will frame and put forward the concept of a Soviet female subjectivity, one that takes into account the desires of Russian women and the challenges those women faced to become animators. This Soviet female subjectivity is not tied to a particular time frame, but rather was born of the contradictions of female equality that were formed during the Soviet era, but which continued on into the post-Soviet period and shaped the lives of generations of Russian women.

Because of the unique relationship between ideology and censorship in Soviet and Russian animation, examining the ways in which women contributed to and complicated a notion of women's cinema in animation is a fraught but productive idea. The specific brand of censorship in animated films in the Soviet Union facilitates the discovery of a surprising wealth of films which deal with issues important to Russian women, or which allowed them to directly challenge the status quo. Women wove their own voices, styles, and experiences into their animated films and in the process helped to change both the animation industry and cultural modes of expression in Russia. Through the exploration of these women's directorial voices, in conjunction with feminine aesthetics and female subjectivity, this book takes animation out of the children's playground, where it has long been placed in Russian film history and criticism, and moves it to the larger global context of women's cinema and film history.

Chapter 2

In the Beginning: The First Wave of Soviet Women Animators

Early Russian and Soviet Animation

Indigenous film production in Russia began in 1908 with the public screening of *Stenka Razin* by the Aleksandr Drankov film company, and it was not long before animation reached the screens as well. The origins of Russian animation prior to the revolution in 1917 were grounded initially in scientific study by two men from very different backgrounds, ballet master Aleksandr Shiriaev and Wladyslaw Starewicz, whose career in animation grew out of his interest in entomology. Despite the fact that his films were never screened publicly in a theatrical setting, Aleksandr Shiriaev can be considered the first Russian animator. As a principal dancer, choreographer, and ballet master with the Imperial Russian ballet in St. Petersburg, Shiriaev was interested in studying and preserving folk dances for the ballet. From 1906 to 1909 he made a variety of films including documentary films, trick films, and paper and ink animation, in addition to his seminal stop-motion puppet films where he painstakingly recreated folk and other dance sequences from various ballets. His interest in stop-motion animation originated from his thousands of sketches of various character dances, which he then turned into animation, usually staged using hand-made

puppets in a studio that he built in his apartment. When he offered to film the dances at the Mariinksii, provided the theater purchase a camera and film stock, he was told by the management that the still photography they had used for the last fifty years was more than adequate; in other words, Shiriaev was being a "troublemaker" and he should not waste his or the ballet's time.[1] Despite this setback, Shiriaev purchased a camera and continued to work making stop-motion puppet films of folk dances as a private, personal affair, and while he showed them to close friends and colleagues, they were never screened publicly.[2] Shiriaev's work stands out as a testament to the usefulness of animation as a serious tool for studying movement, and also reinforces animation's early connection to adult pursuits and interests.

While animation is now usually identified as primarily a medium for children's entertainment or education, early in its history, animation was more aligned with the interests of adults, as is evident in the work of Shiriaev and his contemporary, Wladyslaw Starewicz.[3] Starewicz was born in Russia to Polish parents; like Shiriaev, he began making animated films based on his private interests, but from the start of his career, his films were intended for public consumption. While working at the Museum of Natural History in Kovno, Lithuania, Starewicz began making documentary films. During an attempt to film live male stag beetles battling over a female, he encountered a problem: each time he turned the lights on to film, the normally active beetles stopped moving. His solution to the problem was puppets and stop-motion animation. With embalmed beetles, supported by wires, Starewicz was able to recreate the stag beetle battle for his film *Lucanus Cervus* (1910).[4]

Starewicz's first commercially successful stop-motion animation, *The Beautiful Lucanidae* (*Prekrasnaia Liukanida*, 1910), was a fairy-tale love-story about beetles. Subsequently, he was hired by the Khazhonkov studio

1 Birgit Beumers, Victor Bocharov, and David Robinson, eds., *Alexander Shiryaev: Master of Movement* (Pordenone: Le Giornate del Cinema Muto, 2009), 20, 81.

2 Urbanora, "Daily Archives: October 22, 2008," *The Bioscope*, accessed June 27, 2018, https://thebioscope.net/2008/10/22/. See also "Russian Dance Film Selections 2004," *St. Petersburg Dance Film Festival "Kinodance,"* accessed June 27, 2018, http://www.kinodance.com/russia/films_russian_selection.html.

3 For more discussion of these early years see Sergei Asenin, *Volshebniki ekrana* (Moscow: Iskusstvo, 1974), 17–20.

4 Giannalberto Bendazzi, *Animation: A World History* (Boca Raton: CRC Press, Taylor & Francis Group, 2016), 72–73 and Yuri Tsivian, "The Case of the Bioscope Beetle: Starewicz's Answer to Genetics," *Discourse: Theoretical Studies in Media and Culture* 17, no. 3 (Spring 1995): 119–125.

in Moscow where he directed both live-action and animated films. Of the dozen or so stop-motion puppet films he made, today his most famous pre-revolutionary animated film is *The Cameraman's Revenge* (*Mest' kinomatograficheskovo operatora*, 1912). The film playfully tackles adult themes of marital infidelity, jealousy, and retaliation. It also offers a sophisticated vision of the power of moving pictures; at the same time it calls attention to some of the tropes of early cinema, such as cinema's connection to voyeurism through the use of the keyhole matte shot and the flammability of early nitrate film.

In 1909 Shiriaev left his animation pursuits to focus on the ballet, and after the 1917 revolution Starewicz moved to France to continue his career as an animator and filmmaker. Animation in Russia was halted for several years after the revolution, for numerous reasons including Starewicz's emigration, as well as lack of equipment and materials, and, of course, a civil war. While women were working in other areas of the pre-revolutionary film industry, no woman had yet had the opportunity to try her hand at animated film.

Women and the Birth of the Soviet Animation Industry

The 1920s were a turbulent and volatile time in Soviet animation in terms of industrial challenges, shifting target audiences, aesthetic styles, changing technology, and the disputes about ideological control. In the first decade after the revolution, animation struggled to find its footing within a film industry that had been devastated by wars, emigration, and material shortages. Early Soviet animation also began its shift from adult-centered animation towards child-centered, dual-purpose entertainment and educational animation. For the most part, early pre-revolutionary animators were really filmmakers dabbling with animation. However, the 1920s saw the first filmmakers, who were trained as artists first before taking on various roles within the growing animation industry. Animators during this time experimented with different techniques and aesthetic styles as they learned the art of animation. Animation styles varied from the avant-garde aesthetic, adopted by artists of the early 1920s, to aesthetics influenced by printed cartoons, and to the incorporation of classical painterly styles learned in Russian art schools.

New techniques needed to be mastered, as animators veered away from Starewicz's puppet animation towards pen and ink drawings and,

eventually, to cel animation. The introduction of sound technology in the late 1920s created additional challenges for animators in terms of rhythm synchronization and narrative approaches. In the first part of the 1920s, Soviet animated films were political in nature, introducing audiences to and harnessing the new Communist ideology. By the end of the 1920s, the Communist party was taking a more active role in overseeing and regulating the media industries, and, as a result, it was decided that animated films should be targeted specifically to children as a way to indoctrinate them into the new Soviet state. The first ten years of Soviet animation were also marked by the inclusion of women into the ranks of animators, inkers, in-betweeners, production designers, and directors. These women helped to shape animation as a growing industry separate from the live-action film industry. Among the first wave of women animators in the Soviet Union were the Brumbergs, Khodataeva, and Mariia Benderskaia.[5] Each of these women not only mastered the technical difficulties of representing movement on the screen, they also managed to move beyond the nameless ranks of in-betweeners, inkers, and painters to direct their own films. More importantly, their very presence pushed the animation industry to accept women as equals in the newly evolving Soviet society.

The new Soviet state and its leaders saw cinema as a tool of propaganda, agitation, and education, and thus as a simple way to bring Communist ideology to the illiterate masses all over Russia.[6] Vladimir Lenin dictated his now famous statement "that of all the arts the most important for us is the cinema" to the Soviet Minister of Education, Anatolii Lunacharskii, setting into motion a massive shift in the types of films that would or could be made.[7] In February of 1922, among Lunacharskii's duties was to draw up a plan of action for the future of Soviet cinema and to oversee that new cinema, which included an expansion of animation.

5 We mention Benderskaia here, but do not delve further into her career at this time, as she only directed one film, *The Adventures of the Little Chinese* (*Prikliucheniia kitaichat*, 1928).

6 The Russian literacy rate was roughly forty percent just prior to World War I, with rural areas being decidedly lower at about twenty-five percent, and literacy rates among young girls being significantly lower than that of young boys. See Jeffrey Brooks, *When Russia Learned to Read: Literacy and Popular Literature, 1861–1917* (Princeton: Princeton University Press, 1985), 4.

7 For the cultural importance of this statement in the 1920s see Richard Taylor, "Soviet Cinema as Popular Culture: Or the Extraordinary Adventures of Mr Nepman in the Land of the Silver Screen," *Revolutionary Russia* 1, no. 1 (June 1, 1988): 36–56.

The first Soviet animation was conceived at the Russian Telegraph Agency (ROSTA), where stop-motion technology was repurposed to create moving posters, an innovative approach to invigorate the agency's original static political posters and to bring ideas about Communism to the non-Russian populations.[8] Documentary filmmaker Dziga Vertov's *Soviet Toys* (*Sovetskie igrushki*, 1924) is recognized as the first narrative animation of the new Soviet industry. The film was produced at Goskino and animated by Ivan Bushkin and Iurii Merkulov. This heavily propagandistic film is a pen and ink and cut-out animation (images drawn on individual sheets of paper), which focuses on the harmful behavior of the NEPman—a member of a new wealthy social class of the 1920s, an unwelcome result of Lenin's New Economic Policy—who consumes everything and everyone in sight. The film also celebrates the positive advancements of the new Soviet state as a worker and a soldier defeat the NEPman.[9] *Soviet Toys*, like many animated films made in the 1920s, was an experimental film influenced by ROSTA, the artists of the Russian avant-garde like Vladimir Tatlin, Aleksandr Rodchenko, and Vladimir Maiakovskii, illustrators like Vladimir Lededev, and political cartoonists like Viktor Deni.[10]

In addition to its overt criticism of NEP, *Soviet Toys* also inadvertently comments on the role of women during NEP, with the inclusion of only one obviously female character: a promiscuous dancer.[11] She transforms from a floating leaf into a simple line drawing of a dancer, with her cleavage clearly demarcated. Her interest in more than dance is made evident with the close-up of her face, framed in a matte iris shot as she alluringly winks, shakes her head, and smiles. Her French cancan-style dance, which shows off her undergarments, serves to arouse and excite the NEPman, also shown in the matte iris shot. Many women faced hardships with the adoption of

8 Katz, *Drawing the Iron Curtain*, 32.
9 For a more in-depth discussion of Soviet Toys see Lora Mjolsness, "Vertov's *Soviet Toys*: Commerce, Commercialization and Cartoons," *Studies in Russian & Soviet Cinema* 2, no. 3 (2008): 247–267.
10 For example, Pontieri discusses the link between early Soviet animation and the avant-garde graphic artist, Tsechanovskii. She suggests that Tsechanovskii's book illustrations display the directness of poster style, including elements of journal graphics and advertising, and maintains that he was the first animator to use these styles in film. See Pontieri, *Soviet Animation*, 22–29. *Soviet Toys* draws on the style of Viktor Deni and other newspaper cartoonists of the 1920s. See Mjolsness, "Vertov's *Soviet Toys*," 247–267.
11 Mjolsness, "Vertov's *Soviet Toys*," 255–257.

NEP as both women's unemployment and prostitution increased.[12] This promiscuous dancer is representative of certain women who distanced themselves from proletarian culture by associating with NEPmen as a relatively easy path to gain entrance into a more luxurious lifestyle. While not the familiar flapper stereotype commonly associated with loose women at this time, this dancer is performing a service like a prostitute and is paid in luxuries. In order to reward her, the NEPman motions to the sky and fancy shoes, hats, and jewelry fall to his hand and then to her feet. In the end, she dives willingly into the NEPman's stomach, allowing him to consume her both literally and figuratively. The only woman, in this film, is, first and foremost, an object bought and manipulated by a powerful bourgeois man. However, Vertov's dancer does not exhaust the types of women who existed during NEP. As we will see, women directors distanced themselves from Vertov's dancing woman and instead chose to animate positive representations of women in their films, helping to shape the future role of women in the Soviet state.

In 1924, the same year that *Soviet Toys* was released, women were invited to participate in the formation of a working group that would become the first experimental Soviet animation studio, organized at the State Technical School for Cinema (GTK) by Nikolai Khodataev, Merkulov, and Zenon Komissarenko.[13] The workshop they created was a low-budget program to produce animated film, which welcomed both women and minorities, as dictated by Lunacharskii and by the proletarian principles of the new state to use art to inspire revolutionary action.[14] Due to the lack of funding to train animators these workshops drew their students mainly from the Russian State Art and Technical School (VKhUTEMAS) and served to professionalize future animators. Among the first participants in the workshop were Olga Khodataeva (Nikolai Khodataev's sister), Valentina and Zinaida Brumberg, and Liudmila Blatova; all but Khodataeva were trained artists at VKhUTEMAS.[15] Ivanov-Vano and Vladimir Suteev frequented the stu-

12 Marceline Hutton, *Incorporated Russian and Western European Women, 1860–1939: Dreams, Struggles and Nightmares* (Lantham: Rowman & Littlefield, 2001), 130–232.

13 For a discussion on the early formation of the workshops at GTK in see Katz, *Drawing the Iron Curtain*, 32–36. Also see Nikolai Khodataev, "Iskusstvo multiplikatsii," in *Mul'tiplikatsionnyi fil'm*, ed. Grigorii Roshal' (Moscow: Kinofotoizdat, 1936), 15–100.

14 Lynn Mally, *Culture of the Future: The Proletkult Movement in Revolutionary Russia* (Berkeley, CA: University of California Press, 1990), 4–5.

15 Blatova worked as an animator on only two films, *China in Flames* and *Start* (*Start*, 1925), which has been lost.

dio later that same year.[16] Each member was instructed in all aspects of animation including script writing, shooting, editing, and graphic design, while mastering the technique of stop-motion animation using pen and ink to create paper cut-outs.[17] The workshop format allowed these women a chance to learn alongside some of the most talented artists in the field and propelled several women into directorial positions by the end of the 1920s.

While women participated in the first Soviet animation studio, they often did not receive recognition for their work in terms of the actual screen credits in these early films. The first film made by the GTK workshop, *Interplanetary Revolution* (*Mezhplanetnaia revoliutsiia*, 1924), offers an example of the disparity in how film credits were assigned. *Interplanetary Revolution* tells the story of a Red Army soldier, who flies to Mars and vanquishes all the capitalists on the planet; it also serves as a parody of Iakov Protazanov's film *Aelita: Queen of Mars* (*Aelita*, 1924) which was being made at the same time. *Interplanetary Revolution*'s style is influenced heavily by the Russian avant-garde posters of artists like Maiakovskii. Redolent with an obsession for mechanization and industrialization, lack of depth perception, heavy lines, and dependence on geometric shapes, this was the most common style of early Soviet animation. The founders of the GTK workshop, Komissarenko, Merkulov, and Khodataev, are credited on the film as being the artists responsible for writing the scenario and directing the film. However, Khodataeva also worked as an animator on the film, but did not receive recognition in the film credits. It is only because her brother listed her as an animator on the film in an article he wrote ten years later that her contribution was recorded and can be acknowledged today.[18]

According to Khodataev, after the completion of *Interplanetary Revolution* the collective brought the Brumberg sisters into the experimental workshop in order to work on a much longer narrative film, *China in Flames* (*Kitai v ogne*, 1925).[19] *China in Flames*, an animated film which warns of the dangers of capitalist pillaging of China's natural resources, was

16 Nikolai Khodataev, "Khudozhniki i mul'tipikatory," *Sovetskoe kino* 10 (1934): 28–34.

17 The workshop also produced *How Avdotia Became Literate* (*Kak Avdot'ia stala gramotnoi*, 1925) but this film did not survive.

18 Khodataev, "Khudozhniki i mul'tipikatory," 28–34.

19 Ibid. Iurii Merkulov discusses the beginnings of Soviet animation and Khodataeva's role in his "Sovetskaia mul'tiplikatsiia nachinalas' tak," in *Zhizn' v kino: Veterany o sebe i svoikh tovarishchakh*, vol. 2, ed. O. T. Nesterovich (Moscow: Iskusstvo, 1971), 122–140.

ordered by the United Committee for Hands Off China and released in 1925. It is also recognized as one of the first Soviet animations and the first animation to be completed on such a grand scale. *China in Flames* was originally three ten-minute films, each completed by a different director, and then joined together to form a thirty-two-minute full-length feature. The group had to contend with a complicated theme, the lack of a dramatic basis to carry the plot of the film, and the absence of a unified creative direction. Khodataeva, the Brumbergs, and Blatova worked as animators on this film, but were not given proper credit in the film's title sequence. Even though these women did receive some recognition for their contribution in various after-the-fact publications, the lack of credit on the screen still erodes the recognition of their true place in film history.[20]

Fig. 1. *China in Flames* (*Kitai v ogne*, 1925)

The stylistic differences found in *China in Flames* are an indication of the women's creative stamp on the film. There are two obvious aesthetic styles in this film: the popular avant-garde poster style and a more classically informed, painterly style. Like many other animated films of

20 Khodataev, "Khudozhniki i mul'tipikatory," 15–100.

this period, *China in Flames* took its inspiration in part from avant-garde revolutionary posters. In fact, the film is subtitled "A Cinema Poster" (*Kino-kartina*), reinforcing the connection to the early animated posters produced at ROSTA. This film was almost exclusively made using hinged paper and ink puppets and stop-motion animation, creating an impression of primitiveness enhanced by limited movement of the characters. Drawing on their classical artistic foundations, the women's style is distinguishable from the avant-garde style used both in this film and in *Interplanetary Revolution*. Instead of stark, geometrically informed backgrounds, the women use a painterly style represented by the landscape scenes, buildings, cars and ships of the foreign imperialists, as well as certain faces. For example, this style is found in the landscape of China (see Fig. 1), which is depicted with attention to detail—from its rounded hills, which are shaded to give the appearance of three-dimensionality, to gradations on the scrubby pine trees where individual needles stand out, and to the soft reflection of the sun and the moon on the water; all of which the Brumberg sisters drew in charcoal.[21] This style is also used in the intricate detailing on the faces of Lev Karakhanov, Lenin, and Sun Yat-sen, which is in stark contrast to the monstrous caricature and sharp lines of the capitalist who hopes to plunder and consume China's riches. The emphasis on the roundness of the drawings and the shading, whether it is a face or a tree, adds not only softness to the imagery but also a sense of realism, which makes the women's contribution to this animation remarkable for the time period.

The examples of *China in Flames* and *Interplanetary Revolution* demonstrate how Soviet ideology and directives allowed women the chance to participate in the first animation studio, and yet their stories and specific achievements have been almost forgotten. Bolshevik power gave women opportunities they did not have in pre-revolutionary Russia, and yet their contributions remained marginalized in these very early years. Women's representational exclusion stemmed, at least in part, from the inability of the new Soviet society to completely liberate women from the deeply ingrained patriarchal culture.

21 Ibid., 41.

The Woman Question in the 1920s

Little progress was made in the early 1920s in terms of women's rights despite the laws and proclamations that removed all barriers to women's equality. In theory, collective organizations were to take over the menial tasks like childcare, cooking, and cleaning, which took women out of the workforce and limited their participation in political life. Founded in 1918, the Young Communist League (Komsomol), which admitted youth between the ages of fourteen and twenty-three, reflected the same attitudes towards women's equality as the Communist party. The Komsomol member was expected to help liberate women from the supposedly "oppressed and enslaved" conditions they had suffered under the capitalist system and to "devote special effort" to drawing young women "into League and Party activities."[22] Regardless of these lofty ideas about women's equality and attempts to draw young women into the party, practical matters took precedent, namely the struggling economy. Lenin created the New Economic Policy, or NEP, after the end of the Civil War in order to give temporary incentives to private industry to jumpstart the suffering economy. The NEP period, which lasted from 1921 to 1928, was a definitive step away from the realization of emancipation, as women were hit particularly hard by the realities of NEP and made up disproportionate numbers of the unemployed. There was certainly resentment of the NEPmen, the entrepreneurs who became rich from this sidestep back to a capitalistic system, because while NEPmen were making money, they were not putting their money into collective organizations like canteens and daycares, which would have allowed women to enter the workforce as equals to men. The hostility felt by the average worker towards the NEPmen was demonstrated in Vertov's *Soviet Toys*.

So, while official Soviet policies called for the elimination of gender-based inequalities, the reality was that those policies were being undercut by NEP. For instance, Anne Gorsuch argues in her article "'A Woman is Not a Man': The Culture of Gender and Generation in Soviet Russia, 1921–1928" that much of the language and the actual practice of the Komsomol served to emphasize the differences between young men and women, rather than

22 Ralph Fisher, *Pattern for Soviet Youth: A Study of the Congresses of the Komsomol, 1918–1954* (New York: Columbia University Press, 1959), 67.

to promote equality, especially in the period of NEP.[23] On paper women had achieved equality with men, yet much of the practice of the early Soviet state continued to put women at a disadvantage. This was particularly true after the death of Lenin in 1924, which, as Attwood suggests, also signaled the death of what he saw as the two prerequisites for women's equality: mass participation in the work force and liberation from the private work of family.[24] Thus, while the Soviet Union was well on its way to realizing many of its goals for stabilizing the country and the economy, its promise to women remained unfulfilled.

With Joseph Stalin's rise to power in the late 1920s, NEP came to an end, and there was yet another attempt to ensure equality for women. Organizations like the Komsomol noted gender inequality between men and women, and came to the realization that "despite the fact that much has been said and decided" about the need to have more women in leadership positions, the situation was "still very poor."[25] Public campaigns against the exploitation and mistreatment of women increased in 1927 and 1928. As Eric Naiman explains with reference to a related campaign against corruption, "the Party began to increase its control over potentially 'apolitical' areas of social activity [in the final years of NEP], 'personal life' was no longer accepted as an autonomous region, and the Komsomol organs launched a concerted effort to penetrate privacy and organize leisure."[26] Despite the government intrusion, these efforts failed to transform the daily lives of women. In the late 1920s women were once again encouraged to "organize separate [club] circles for girls as a means of improving [their] psychological and cultural level," and to use International Women's Day as a way to pull in women who were not party members.[27]

The reality of the situation, Gorsuch correctly argues, was that relatively few successful efforts existed to provide special activities just for

23 Anne E. Gorsuch, "'A Woman is Not a Man': The Culture of Gender and Generation in Soviet Russia, 1921–1928," *Slavic Review* 55, no. 3 (1996): 636–660, http://www.jstor.org/stable/2502004.

24 Attwood and Turovskaia, *Red Women*, 53.

25 Gorsuch, "A Woman is Not a Man," 354. For more information on problems of promotion in rural areas, see Isabel A. Tirado, "Komsomol and the Krest'ianka: The Political Mobilization of Young Women in the Russian Village, 1921–1927," *Russian History* 23, no. 1 (1996): 345–366.

26 Eric Naiman, "The Case of Chubarov Alley: Collective Rape, Utopian Desire, and the Mentality of NEP," *Russian History / Histoire Russe* 17 (Spring 1990): 7.

27 Gorsuch, "A Woman is Not a Man," 349

young women and there was little to encourage them to fight for equality.[28] However, one attempt to encourage women's participation in International Women's Day and the struggle for equality was the 1928 animated film *Terrible Vavila and Little Auntie Arina* (*Vavila groznyi i tetka Arina*, 1928) co-directed by Olga and Nikolai Khodataev. The film illustrates how animation was not exempt from the call to encourage women to participate in Soviet life, as a way to ensure their equality.

Olga Khodataeva in the 1920s

In 1927 Khodataeva joined her brother and the Brumberg sisters to form their own animation collective. As the period of rapid industrialization began with Stalin's first Five-year plan, the semi-private, German-Soviet Mezhrabpom-Rus film studio absorbed GTK as a production department. Animators at this point formed collectives for the duration of a project. During the late 1920s, the collective continued to use mostly paper and ink cut-outs in the graphically avant-garde style, inspired in part by newspaper political cartoons. Although scholars such as Giannalberto Bendazzi in *Animation: A World History* refer to this group as being directed by Nikolai Khodataev, the credits of the films made by the group during this period demonstrate that the women began to share the credit for directing the films.[29]

As mentioned earlier, Khodataeva is a prime example of how women's labor among men was, and continues to be, historically overlooked. In 1918, she graduated from the Moscow School of Painting, Sculpture, and Architecture and worked as a graphic artist. She joined her brother Nikolai in 1924 when he organized the animation course at the GTK and from 1927 to 1932 she worked alongside her brother and the Brumberg sisters as part of an animation collective. Her earliest films were co-directed with her brother and Valentina Brumberg, but by 1930 she was directing her own films. She would later work at various studios including Mezhrabpom-Rus, Sovkino, Soiuzkino, Mosfilm, and Soiuzmultfilm on numerous animated films. From 1927 to 1960, Khodataeva directed thirty-two films. While not all of her films are propaganda, many of her most well-known titles fall in this category.

28 Ibid., 654.
29 Bendazzi discusses the formation of early Soviet animation and the work of Nikolai Khodataev in his *Animation: A World History*, 79.

One such propaganda film, which is also a pro-woman, feminist manifesto, is *Terrible Vavila and Little Auntie Arina*, made at Mezhrabpom-Rus by order of the Central Union of Consumer Societies, an organization concentrated on rural social infrastructure. While Khodataeva's contributions may be difficult to identify in co-directed films, her influence should be acknowledged, especially considering that Khodataeva's name is often listed first in the credits for this film, implying that she took on a leadership role in directing the film.[30] More importantly, the subject matter of the film is one that was important for women of the day. The film covers the significance of International Women's Day, and was in line with the principles of the Central Union of Consumer Societies, which was particularly concerned with the position of rural women in the Soviet Union. *Terrible Vavila and Little Auntie Arina*, a paper and ink cut-out stop-motion film, was the first Soviet film to tackle the woman question and to deal directly with women's issues, in order to encourage rural women to become involved in politics and to take advantage of their equal status.

Mayne brilliantly asks how Soviet montage films addressed the woman question in *Kino and the Woman Question*, but no one has really investigated how issues related to women and the new Soviet ideology have been addressed in animation.[31] With that in mind, an analysis of *Terrible Vavila and Little Auntie Arina* is fundamental for understanding the relationship between the woman question and animation. As MacFadyen notes, despite its crude nature and the fact that it was filmed on an outdated "museum piece" camera, this film was one of the first animated films to garner significant popularity and remained popular with viewers long after its release.[32] Its subject matter and the fact that no other film addressed the issue so openly is undoubtedly one of the reasons for its success.

In *Terrible Vavila and Little Auntie Arina*, Auntie Arina is liberated from the drudgery of housework by the anthropomorphized tools of her enslavement: water buckets, oven tools, pots, pans, and other kitchen utensils. These tools of women's subjugation encourage Auntie Arina to take a day off and to attend the women's meeting in honor of International

30 See the program notes for Retrospective at the Deutsche Kinemathek 2012, accessed November 2, 2018, https://www.deutsche-kinemathek.de/en/retrospective/2012/films, and International Filmfestspiele 2012, accessed November 2, 2018, https://www.berlinale.de/en/archiv/jahresarchive/2012/02_programm_2012/02_programm_2012.htm.

31 Judith Mayne, *Kino and the Woman Question: Feminism and Soviet Silent Film* (Columbus: Ohio State University Press, 1989).

32 MacFadyen, *Yellow Crocodiles*, 70.

Women's Day. In the opening of the film, the sun smiles and then transforms into a shining March 8th emblem, as Auntie Arina walks carrying her water buckets. One of the sun's rays streaks down in front of Auntie Arina, blocking her path, and transforms again into the words "March 8th," causing Arina to stop and put down her buckets, which then develop faces, arms, and legs. They run away from Auntie Arina, in protest, because it is International Women's Day and they do not want her to do any more work.

Fig. 2. *Terrible Vavila and Little Auntie Arina* (*Vavila groznyi i tetka Arina*, 1928)

Auntie Arina chases the errant buckets home. She consults the calendar to prove them wrong, only to find out, with a close-up shot, that it is actually March 8th, an international day for working women. Other pots, pans, and kitchen devices join the buckets to dance around Auntie Arina in celebration of Women's Day. The ember rake and tongs hang a banner telling Auntie Arina "You are free today, we give you leave" (see Fig. 2).[33] However, despite the enthusiasm of her pots and pans, Auntie Arina is still unwilling to leave her housework to attend

33 Note that they use the familiar forms of you, *ty* and *tebia* in Russian, to address Auntie Arina, testifying to her daily contact with them, but also equating her with the tools of domestic labor.

the women's meeting. At the proding of the buckets, Auntie Arina's neighbor convinces Arina to attend the Women's Day meeting. The film acknowledges that celebrating International Women's Day is a new, unfamiliar concept for rural women and that women may need encouragement and support from other women in order to truly be liberated from the drudgery of everyday life.

Men, on the other hand, occasionally offer resistance to women's organization. In order for Soviet society to move forward men often needed to be educated to accept women's liberation. Auntie Arina's husband loudly objects to her taking a day off from her domestic responsibilities, worried about who will make him cabbage soup. He throws her to the ground and ends up in a tug-of-war over Arina with the woman who has invited Arina to the meeting. The meeting and the women prevail, and Arina drags her husband on the ground to the meeting, suggesting that women need to lead their backward husbands towards political change and women's equality. But Arina, with her pots and pans, is unsuccessful at changing her husband's point of view. He is able to escape Arina's grip and runs back to the house only to be attacked by kitchen implements that he once used to terrify his own wife. Despite her inability to convince her husband, Arina's real power comes from speaking up at the meeting. At the end of the film the collect power of the women becomes visible. The women march together, Arina is holding a banner, proclaiming that women will build a new way of life and reiterating that women's cooperation and political involvement is the only true path toward liberating women from the kitchen.

The rather cute anthropomorphized kitchen objects in this film are in stark contrast to the aesthetics inspired by the avant-garde poster style and more painterly style utilized by women animators in *Interplanetary Revolution* and *China in Flames*. While Wells notes that metamorphosis, the ability of an animated object to change into something completely different, is a quintessential technique in animation, this method held little sway in early Soviet animation as it was too fantastical for Soviet tastes.[34] However, if we consider anthropomorphic transformation as a branch of metamorphosis, then this film is an exception to the rule. The film is about changing society, and it is only natural that this is accomplished through transformation: specifically, transforming objects of women's subjugation into anthropomorphized helpers so that Auntie Arina can fulfill her duty as a good Soviet woman. While

34 Wells, *Understanding Animation*, 68–69.

certainly an agitprop film, a specimen of official political propaganda, it is noteworthy that this film remained popular and through its popularity managed to fill one of the goals of International Women's Day—uniting women on more than just one day. As Gorsuch suggests, there were relatively few official efforts to encourage women to come together and advocate for themselves, and often women were outwardly discouraged from doing so.[35] This film is an exception. Gorsuch goes on to quote Comrade Goldina, "The 8th of March [International Women's Day] is a good thing, but it's a shame that it happens [only] once a year; if it took place five times a year that would be better."[36] Through repeated viewing, this animated film directed by a woman encouraged and moved viewers one small step towards the realization of equality for women.

Today this film stands as one of the most powerful examples from the 1920s of an animator tackling the woman question, creating a benchmark for female characters who fight to be heard and to change their world. As the film demonstrates, the life of peasant women, unlike their urban counterparts, had changed little since the revolution and proclamations of equality took considerable time to reach the countryside. Both men and women had to be educated about women's newly acquired equality. Auntie Arina and the anthropomorphic tools of women's subjugation enter into a visionary dialog about Soviet feminism and the role of women in Soviet society. The transfiguration of women's household tools, which in former times had bound her to the past and to tradition, facilitates the transformation of the woman into a political activist who demands equality with men. This film demonstrates the metamorphosis in peasants' real lives as well, for while it is certainly idealistic in its representation of both women and Soviet society, it gave peasant women hope and reassurance of equality with men, which was still far from their reach.

Making Animation for Children

Soviet animation shifted its attention to children in the late 1920s in response to the changing political climate. After Lenin's death, the Soviet Union turned inward, looking for ways to strengthen itself as a nation, and, according to MacFadyen, by 1925 the doctrine of "Socialism in one

35 Gorsuch, "A Woman is Not a Man," 654.
36 Ibid.

country" became official policy.[37] In other words, there was a shift away from global Communism and efforts were made to combat the negative effects of NEP and strengthen Communism at home. With this policy shift, resources were centralized, and new methods were developed for shoring up the ideological education of Soviet citizens, resulting in the first Soviet films made specifically for children.

The question of cinema for children became one of the central tenets of the All-Union Party Congress in the Spring of 1928. Its participants noted that "children's films are almost completely lacking" and advised filmmakers to "make consistent political and pedagogical-artistic, cultural, and newsreel films for child audiences."[38] The ideological education of children became one of the key components for realizing socialism in the Soviet Union, and film became an essential tool in that process. As animation was still a marginalized art form, the Soviet ideologists spoke predominantly about live-action films. Yet, their recognition of the cinematic needs of young audiences became instrumental for the development of animated film as a new Soviet art form. That same year, Sovkino, a film organization run by the state, gave permission to organize an animation department at Mezhrabpomfilm in Moscow and, for the first time, the Soviet government allowed animators to have their own dedicated studio space.[39] With the ideological support for children's animation and the funding of the new animation studio, Soviet animators began to create films aimed specifically at young audiences.

In the animation industry's transition towards children as its new target audience, its relationship with the young viewer was framed by the Soviet state's vision of the child. As Catriona Kelly notes in "Shaping the 'Future Race': Regulating the Daily Life of Children in Early Soviet Russia," "Bolsheviks' determination to . . . construct a radically different, new society meant that, from the first, children were pushed to the forefront of ideological discussion."[40] Indoctrinating children was the surest way of realizing this new society, and animation, with its reliance on humor and non-verbal cues,

37 MacFadyen, *Yellow Crocodiles*, 71.
38 Richard Taylor and Ian Christie, *The Film Factory and Soviet Cinema in Documents, 1896–1939* (New York: Routledge, 1994), 210–211.
39 Borodin, "Soiuzmul'tfil'm," 14–152.
40 Catriona Kelly, "Shaping the 'Future Race': Regulating the Daily Life of Children in Early Soviet Russia," in *Everyday Life in Early Soviet Russia: Taking the Revolution Inside*, ed. Christina Kiaer and Eric Naiman (Bloomington: Indiana University Press, 2006), 256.

became a logical location for this indoctrination. Authors, film directors, actors, and animators were tasked with ideologically instructing the young, rather than indiscriminately entertaining them. Mass education through animation was one of the early thematic components and structural principles of Soviet animation in the late 1920s. Often touted for their aesthetic and technical advances, animation made by women during this early period of Soviet history conformed to these ideas, but also opened a dialog with Soviet ideology and pushed more positive female representations on the screen.

The Brumberg Sisters in the 1920s

Two women who pushed such boundaries during the early years of Soviet animation were Zinaida and Valentina Brumberg, known collectively as the Brumberg sisters. During their almost fifty-year careers, the sisters directed over forty films, and they are best remembered today as directors of animated films for children with heavily didactic themes. According to the Brumberg sisters' account of their school days, they were interested in making images move from an early date, and they filled the margins of their textbooks with small pencil drawings of various fairy-tale heroes who came to life when the pages of the textbook were flipped.[41] With a passion for art, the sisters entered the Higher State Art and Technical Studios (VKhuTEMAS) in the early 1920s directly after completing high school. At VkhuTEMAS, they studied with some influential artists of the early twentieth century, such as Ilia Mashkov, Piotr Konchalovskii, Aristarkh Lentulov, and Robert Falk.[42] The Brumberg sisters volunteered to join other students at the experimental animation studio at GTK to learn the art of animated films. Thanks to Khodataev, they gained their first experience working as animators on the film *China in Flames*.

Due to their art school education, the sisters had exposure to both traditional artistic movements of the past, as well as revolutionary and experimental tendencies inspired by the avant-garde, and their animation highlights this connection between the past and present. Like their contemporaries, by the late 1920s the Brumberg sisters turned their attention

41 O. Abol'chik, "Valentina i Zinaida Brumberg," in *Mastera sovetskoi mul'tiplikatsii*, ed. I. Lishchinskii (Moscow: Isskustvo, 1972), 56.

42 "The Brumberg Sisters Against the Background of their Time," *Leading Figures in Russian Animation*, film 6, MIR Studios, 2013, accessed January 11, 2018, https://www.youtube.com/watch?v=pyds1GYc2LU&list=PLn5Aci4kkiv4FQaRr9Qsgx7_mWnj PM7h.

to animation for children, an area they would concentrate on for most of their careers. This dedication to children's animation should not imply that their work is inferior or without artistic merit; quite the contrary. The Brumberg sisters, who worked together as a team, began their careers as directors with two films at Sovkino, *You Give a Good Lavkom* (*Daesh khoroshii lavkom*, 1927, no longer extant) and *Samoed Boy* (*Samoedskii malchik*, 1928). These are films that the sisters directed, wrote, and animated, alongside Khodataevs, as part of an animation collective.[43]

The *Samoed Boy* was one of the first Soviet animated films created to be a contemporary folktale and intended specifically for children. This was a particularly interesting choice, given that in the 1920s and the early 1930s, Soviet pedagogues and party leaders were especially hostile towards the fairy-tale and fantasy, which explains the lack of fantasy and whimsy in animation for children during these years. As Marina Balina points out in *Politicizing Magic: An Anthology of Russian and Soviet Fairytales*, the Soviets were slow to realize the influential pedagogical advantages of the fairy-tale and saw enthusiasm for folklore and fairy-tales as part of the bourgeois mind-set.[44] In other words, the fairy-tale was connected to the past, something to be avoided, an idea that was reinforced in the collectively authored volume, *We are Against the Fairytale* (*My protiv skazki*, 1928), which was edited by leading Soviet pedagogues, Ivan Sokolianskii and Aleksandr Zaluzhnyi. Sokolianskii and Zaluzhnyi strove to create regulations in children's literature by championing class-oriented content and chastising those authors who "polluted" the imagination of young readers by exposing them to fairy-tales.[45] This movement had some powerful allies, including Lenin's widow, Nadezhda Krupskaia, who instigated the removal of fairy-tales because of her belief that

43 Although certain Gosfilmofond documents list Nikolai Khodataev as the general supervisor of this film, the Brumberg sisters are often listed first as both animators and scriptwriters with Khodataevs in second position. These differences may have been a result of who filled out the paperwork. See Gosfil'mofond, F. A op. II d. b-2, Belye stolby, Russian Federation.

44 For a more detailed analysis of the early Soviet fairy-tale discourse and of Soviet pedagogues, including Nadezha Krupskaia's and Maksim Gorkii's involvement, see Marina Balina, introduction to *Politicizing Magic: An Anthology of Russian and Soviet Fairy-Tales*, ed. M. Balina, H. Goscilo, M. Lipovetsky (Evanston, IL: Northwestern University Press, 2005), 105. For more on this period in Soviet animation see Lora Mjolsness, "Under the Hypnosis of Disney: Ivan Ivanov-Vano and Soviet Animation for Children after World War II," in *Brill Companion to Soviet Children's Literature and Film*, ed. Ol'ga Voronina (Leiden: Brill, 2019), 393–420.

45 Ivan Sokolianskii and Aleksandr Zaluzhnyi, eds., *My protiv skazki* (Kharkov, 1928).

the fostering of imagination through fantasy directly opposed the utilitarian upbringing necessary for future builders of Communism.[46] Soviet critics, pedagogues, and ideological workers continued to fear magic, animism, and anthropomorphism—the devices that make the fairy-tale so attractive to both children and animators.

The Brumberg sisters were no exception to the attraction. They utilize several fairy-tale devices within the plot of the *Samoed Boy*, which, while set up as a folktale, uses magic and animism to illustrate the backwardness and danger of the deceptive shamans of the world, and to establish socialist ideals as the more desirable traits one should emulate. Only boys with real, practical knowledge of the world can build a future for themselves and for their nation. The *Samoed Boy* stands out as one of the most successful animated films for children in these early years because of its theme, its fluid movement, and the aesthetic look of its artwork. On the surface, *Samoed Boy* displays the proper ideological content necessary to educate the children of the Soviet Union. However, within the pro-Soviet story line and the advancements in technical competence, the Brumbergs engage with Soviet ideology in a complex way, producing an artful film that is both pro-woman and pro-family.

The sisters had more creative control over this film than any of their earlier works. Aesthetically, *Samoed Boy* marks a shift away from the picturesque backgrounds and moveable cut-out puppets of the earlier Soviet cut-out stop-motion films. Instead, the animation is created with individual paper and ink drawings, with scant graphics and limited details, but with rich, smooth movement of the characters across the frame. *The Samoed Boy* offers a plot that is more linear in nature and hence more suitable and accessible to children. The film features an Inuit boy, Chu, who not only saves himself from a bear attack, but also outsmarts and uncovers the shady practices of the Shaman in his village. Fleeing the corrupt Shaman, Chu is rescued by a Soviet ship and taken to Leningrad where he joins a technical college to study and becomes a productive member of Soviet society. This film is explicit in its political nature and points to the desire of the Soviets to manipulate the plot of folk and fairy-tales for ideological purposes.

While the main character Chu is male, the film also briefly introduces a strong female character, Chu's single mother, who takes up a gun to

46 Ben Hellman, *Fairy Tales and True Stories: The History of Russian Literature for Children and Young People (1574–2010)* (Leiden: Brill, 2010), 354–362.

defend her child when his reindeer and sled come home without him. The power of the mother figure is underscored with the use of the flashback, a technical advancement long used in live-action film, which enhanced the clarity of the film and provided more narrative capabilities. Since the film was originally released as a silent animation and the target audience was children, who may not yet have been able to read, the clarity of the narration was extremely important and vital to the success of the film. The use of the flashback stands out especially since it is not necessary for plot development but is placed in the film to relieve the suspense.

The film opens with a medium long shot of Chu on his reindeer-pulled sled, followed by his dog. Next, we see Chu in a long shot, almost dwarfed by the immense frozen tundra, which is accentuated and given depth with a separately drawn background and foreground which moves along with Chu as he traverses the snow. The film then cuts away to a polar bear looking out over the snowy landscape. It is not until the camera follows the bear down from his vantage point on the hillock that the viewer realizes that the bear has spotted Chu and will attack. Chu falls off the sled as the reindeer swerves to avoid the polar bear. The viewer is left with Chu on the ground, perhaps unconscious, as the bear towers over him, and before the viewer can see what happens next, the film cuts away to the reindeer running with the empty sled back to Chu's village. The Brumberg sisters utilize framing and editing techniques from live-action cinema to build suspense in this scene.

Fig. 3. *Samoed Boy* (*Samoedskii malchik*, 1928)

Chu's mother grabs a rifle, prepared to do anything to rescue her son. Along the way, she is met by Chu's trusty dog, who, reminiscent of *Rescued by Rover* (Lewin Fitzhamon, 1905), leads the distraught mother to her son. When she finds Chu, he is sitting on top of the polar bear. Chu tells his mother in the intertitles not to be afraid, he has killed the bear. The directors employ a flashback as a means to allow Chu to visually inform the viewer and his mother how he regained consciousness and killed the bear with a knife. The warm embrace Chu's mother gives him demonstrates not only her love for her child, but also her pride in him (see Fig. 3). While Chu did not need his mother to rescue him, she was armed and ready to protect him. More importantly, she raised him to be brave and resourceful. Children and their mothers, as nurturers, are celebrated in this film, as this relationship will bring about the future of Communism. The moment is bittersweet; Chu has proved himself to be a man capable of protecting himself, yet he still wants to be embraced and loved by his mother.

Motherhood and feminism have a complicated relationship in both the West and Soviet Russia. Radical versions of feminism argue that women will never be truly free of patriarchy until they are free not just from the responsibility of child rearing, but from the yoke of reproduction itself. In this line of thinking, the Bolshevik feminist Aleksandra Kollontai envisioned a society where the nuclear family would no longer be a social necessity and the state would assume child-rearing capabilities—only then would men and women be truly equal.[47] Representations of motherhood in both film and literature of the 1920s demonstrate the complexity of the problem with the woman question. According to Kaganovsky in *How the Soviet Man was Unmade*, the desire to eliminate woman altogether from a future masculine utopia is a staple of the 1920s' works by male writers. She notes that as Stalinist culture was established, women in literature and film were treated with suspicion and were described either as young men or mothers.[48] Women couldn't be just women in literature and live-action film. While the concept of woman was problematic, Stalinism privileged the family and a return to more traditional notions of maternity and reproduction, so mothers were ideologically desirable, even necessary. As an animated film, motherhood in the *Samoed Boy* functions in a thought provoking space. *Samoed Boy* is a transitional film that straddles the avant-garde twenties and the Stalinist period.

47 Mally, *Culture of the Future*, 174–175.
48 Lilya Kaganovsky, *How the Soviet Man Was Unmade: Cultural Fantasy and Male Subjectivity Under Stalin* (Pittsburgh: University of Pittsburgh Press, 2008), 73–74.

The Brumbergs' film does not treat the mother with distrust, and she is not depicted as a young man, though she does wield a rifle in protection of her family. Chu's mother is loving and heroic, yet, she gives him the space he needs to become a man. Hence, she is a strong and positive representation of woman. Chu's strong relationship with his mother distinctly emphasises the absence of good men and male role models in Chu's life, but it is the confidence and resourcefulness she instilled in him that allow him to strike out and find his own role models.

For Chu, his resourcefulness is especially important as he faces his biggest challenge, not against an animal, but against the perfidy of the male bourgeoisie. The villain in the film is the village Shaman, the only other male depicted in the village. The Shaman is the only possible father figure in the film despite his nefarious status. Not surprisingly, an exaggerated form of the technique of squash and stretch is used repeatedly to depict the Shaman, giving him a humorous and ridiculous appearance in the film. These transformations are designed to make him more commanding and are coupled with the idol which appears to the villagers to move in response to the Shaman. The viewer of the film, however, sees the Shaman instruct Chu on how to make the idol move. The Shaman's performance invests him with power and placates the villagers, who continue to languish under his rule. In this instance, the technique of squash and stretch is used to intensify the political message of the film and discredit the folk beliefs and superstition, revealing it all as a sham. While this man, the Shaman, is the only character with the appearance of political power, he is depicted as holding back and corrupting society. It is young Chu who uncovers this deception, in retribution for the Shaman's theft of his bear. Chu escapes the Shaman's wrath, floating out to sea on an ice floe.

The second flashback takes place at the end of the film when Chu has moved to Leningrad and has joined a Rabfak, a technical workers' university. In this final scene Chu is seated at a desk studying, with portraits of Lenin and Marx on the wall, two powerful men, which establish Chu as a good young Communist. Lenin's image fades out and in his place in the upper right-hand corner are scenes we have previously seen from Chu's village life, replayed as Chu's memories, but also to remind the viewer of Chu's origins. The insert shot is a narrative technique borrowed from live-action filmmaking which allows the Brumbergs to reinforce the importance of Chu's mother and his past. Chu has given up his rural connections, especially with his mother, to become part of the new Soviet family, yet as he

becomes a new Soviet man he still dwells on his past and his homeland. While one may argue that Marx and Lenin have become male role models and possible father figures for Chu, in this flashback Chu remembers his past dominated by his mother. While Soviet critics of the time may have interpreted this flashback as Chu not forgetting his past, the scene is ideologically ambiguous, as it also depicts Chu looking to the past, to the life he left, instead of imagining a new Soviet future of greatness.[49]

In *Samoed Boy* the Brumberg sisters, as directors, began to solidify their commitment to animated films for children. More importantly, this film addresses the significance and complexity of the bond between mother and child and establishes motherhood as not just a simple return to traditional roles for women. Instead, motherhood speaks of the need to raise future Soviet citizens and the importance of mother figures, especially in the case of missing or absent fathers.[50] In the 1920s women in animation collectives worked to depict a variety of positive roles for women—from a political activist to a proud mother of a future Communist. These early years of Soviet animation and the structure of the animation collectives placed women like the Brumberg sisters and Khodataeva in positions to become animation directors and lead their own teams in the 1930s, overcoming the political turmoil and contributing to the technological advances of the next decade.

49 Gosfil'mofond, F. A op. II d. b-2, Belye stolby, Russian Federation.

50 In this sense, the film is in line with Abram Room's 1927 film *Bed and Sofa* (*Tret'ia Meshchanskaia*), where the heroine Liuda decides not to have an abortion and instead the film ends with her on a train to the provinces, the future of the new Soviet state growing in her womb.

Chapter 3

Female Creativity in the Wake of Censorship, Consolidation, and Disney

The 1930s were a time of turmoil in the Soviet Union, marked by the solidification of Joseph Stalin's reign and the proliferation of his cult of personality; there was no sector of politics, labor, culture, or private life that was not affected by Stalin and his policies.[1] Stalin's control over the Soviet Union and the Soviet people was supported by this personality cult in which artists, writers, and filmmakers were expected to glorify Stalin, his past, present, and his future. The result of Stalin's repressive policies were the Great Purges, in which writers, artists, and animators, as well as average Soviet citizens were accused of being counterrevolutionaries, "enemies of the people," and were imprisoned or killed. In a totalitarian regime in which citizens are state employees and are therefore under direct state control, the manifestations of women's voices and of female subjectivity often become subsumed within the system. In Stalin's Soviet Union, with increased censorship and a general atmosphere of fear, women were no longer able to pursue films that overtly expressed their own identities, how they lived their lives, and how they saw their roles in society. However, women were still animating and directing films; and their contributions are still important to the history of animation. In this period we must consider the alternate routes women

1 The cult of personality refers to the widespread popularity and acceptance of Stalin created by extensive propaganda, media campaigns, and outright lies.

took to express themselves, namely through aesthetic changes, especially in the creative use of anthropomorphism. While their films often reverted back to more traditional plots about male heroes, the female directors who worked under Stalin changed the direction of the Soviet animation industry with new aesthetic paths, quietly challenging the status quo.

The 1930s in particular brought significant transformations to many industries, but for the Soviet animation industry these upheavals were especially turbulent and served to create more restrictions for Soviet animators. In the animation industry the changes that would affect decades of filmmaking included the introduction of new technologies such as sound and cel animation, the assumption of sociaist realism, the creation of Soiuzmultfilm, and, finally, the adoption of a Disney-styled aesthetics. Each of these, in turn, created special challenges to the fledgling industry and to the women animators who worked there.

Innovations: Sound Changes Everything

At the end of the 1920s, the film industry experienced a revolution of its own; a revolution in sound, heralded by Al Jolson crooning "Toot, Toot, Tootsie, goodbye" in the *Jazz Singer* (Alan Crosland, 1927), a Warner Brothers film that utilized the sound on disc technology developed by Vitaphone. The popularity of sound film spread like wildfire across the globe, and by 1930 the sound on film process had taken over as the predominant, more reliable, technology. In 1929 Mezhrabpomfilm and Sovkino began producing sound films, though only two theaters in the Soviet Union were equipped for sound, one in Leningrad and one in Moscow. The transition to sound production in the Soviet Union was slow, with silent films still being made as late as 1935, and it was not until 1936 that one hundred percent of the films produced were sound films, even though not all Soviet cinemas had yet been equipped for sound exhibition.[2]

As the film industry transitioned to sound in the early 1930s, Soviet animators were starting to think about its role in animation. Sound presented a new series of challenges for animators who now had to set the characters' movements to different rhythms based on sound and, in essence, "teach" their animated characters to lip-sync words. It called for an entirely new

2 For more information see Birgit Beumers, *A History of Russian Cinema* (New York: Berg, 2009), 79–82; and Jay Leyda, *Kino: A History of the Russian and Soviet Film* (Princeton: Princeton University Press, 1983), 277–300.

way of thinking about the animated image. Valentina Brumberg ruminates in her 1931 article "Sound Animation" that animation is unique in its use of sound, as opposed to live-action cinema. She elaborates on the relationship between the animated image and the creative use of sound, "With the development of sound cinema, in animation sounds can be very diverse, from the real to the most unnatural, there are great opportunities for using the most eccentric instruments and sound devices. Incredible adventures of animated drawn 'heroes' can be illustrated with incredible sounds and noises."[3] In other words, unlike live-action cinema, which is tied to a sort of realism that predicates that the sound accompanying an image must also be "realistic," animation does not carry the same connection to realism and has more creative license to explore the ontological relationships between the drawn or animated image and sound. Valentina Brumberg and other Soviet animators recognized the vast potential offered by sound technology and explored the possibilities inherent in the disconnect between sound and image in animation; at the same time they also saw sound as a means to flesh out both character and narrative.

Valentina Brumberg notes that the first experiments with sound and animation were not truly sound film. Instead, they utilized a post-synchronization process, in which the sound was added over the filmed images after the animation was completed. By adding sound to already completed and sometimes even already released films, studios were able to quickly and inexpensively meet the growing demand for animated sound film. Valentina Brumberg preferred the more technologically challenging method, that of recording the sound first and then drawing and filming the images to synchronize with the sound.[4] This method offers the animator better synchronization of sound to moving image. Regardless of this advantage, for the most part, Soviet animators and studio leaders initially preferred the post-synchronization method. The addition of sound and the synchronization of sound to the image in older films not only created new technical issues, but also changed the way in which interior meaning appeared, and was understood, on the screen.

Sound was added to a number of previously released silent films in the early 1930s, for example *Post (Pochta)* by Mikhail Tsekhanovskii, originally released in 1929 and re-released in 1930 with a musical score

3 Valentina Brumberg, "Zvukovaia mul'tiplika," *Proletarskoe kino* 2 (1931): 63.
4 Ibid.

by V. Deshevov. *Post* had the honor of being the first Soviet animation with a sound score to be viewed by an international audience and was quite successful within the Soviet Union long after is re-release.[5] *Samoed Boy,* as previously mentioned, was also originally screened in 1928 as a silent film, but it was re-released in 1931 with a soundtrack written by Nikolai Brovko. One of the reasons for adding sound to *Samoed Boy* was to make this already succesful silent film even more accessible to Soviet children. Valentina Brumberg, based on the parameters set forth in her article, did not consider either *Samoed Boy* or *Post* to be examples of true sound animation.[6]

The addition of sound to *Samoed Boy* does help to clarify some of the ideological ambiguities apparent in the silent version; yet it also raises other issues.[7] The new version of the film also calls into question the choices made by officials, not only in releasing the original film, but also in the decision to add sound and to release the film a second time. As part of the decision-making process to re-release the film with sound, the silent version of *Samoed Boy* was reviewed on March 20, 1930, and was signed for release by T. Akhmanov. However, a typed review was included with the release form, stating an unknown reviewer's less than positive opinion: "This film is very outdated. I saw this film in January of this year (1930) and since this time our Soviet filmmakers have come very far and the films that are appearing now are significantly better than those that were made in the Spring or the Fall. . . . These films should be taken to Red Square and burned so that eventually step by step or blow by blow these films will not be shown on the screen."[8] The reviewer's comments point to the extent to which not only technology, but also political rhetoric, had changed in two years' time. In a way, this assessment is correct: animated technology advanced very quickly, rendering films from only a few months back, let alone almost two years, as antiquated.

Regardless of the reviewer's negative recommendation, the film was chosen to be re-released with sound. The new sound track included

5 Leyda, *Kino*, 281.
6 See the analysis of *Samoed Boy* in chapter 2.
7 The 1930s brought changes to the industry which resulted in many of the founding Soviet animators leaving the industry, including Merkulov, Kommisarenko, and Khodataev, who left animation to become a full-time sculptor sometime between 1934 and 1936 when Soviet animation turned itself away from more experimental animation and more towards Disneyesque animation.
8 Gosfil'mofond, F. A op. II d. b-2, Belye stolby, Russian Federation.

narration of the intertitles, well-placed dog howling, and what is listed as "northern music" interspersed throughout the film. At the end of the film, as Chu sits in his room and he remembers his past, the sound version ends with a voice over of a radio announcer: "Hello . . . Hello . . . Moscow is speaking, and now listen to a news report about the wintery Inuit. From the state radio waves information flows to fill everyone up and to spread evil on all shamans. Knowledge is necessary to all!"[9] Unlike the ending of the silent film, which is ambiguous, the voiceover on the film leaves the audience with a strong ideological message about the need to channel everyone into state-controlled knowledge. Only then can the evil of primitive religion be defeated.[10] The ending of the sound version also erases the strong bond between the boy and his mother, as it creates a distinct difference between his past and present life. The audience is left with only negative impressions of the shaman, the only father-like figure in the village, and the positive role of Soviet knowledge as savior. The more pro-mother and pro-woman message that the Brumberg sisters created in their original film is completely erased in the sound version. While depictions of motherhood were both complex and politically charged by the 1930s, as we will discuss, the ending of the sound film serves to erase the importance of motherhood altogether, taking with it women's agency to tell their own stories.

The Woman Question in the 1930s

Lynn Attwood argues in *Red Women on the Silver Screen* that women's lives in the 1930s under Stalin experienced an unwelcome transformation that resulted in a step backwards away from equality.[11] Stalin brought NEP to a complete halt and quickly instituted plans that would industrialize the entire nation at rapid speed. These changes resulted in both men and women entering the industrial workforce, and the number of women workers doubled between 1928 and 1932.[12] However, one

9 V. Brumberg, Z. Brumberg, Khodataeva, Khodataev, dirs, *Samoedskii mal'chik*, Tret'ia fabrika Sovkino, 1931.

10 It is interesting that the passage of time has made the ultimate call about the worth of these two versions of the *Samoed Boy*. The silent version of the film has been subtitled in English and released by Jove to an American-speaking audience. Anyone can pull it up on Youtube or a number of other sites. The sound version can only be watched at Gosfilmofond in Moscow.

11 Attwood, *Red Women*, 51–70.

12 Ibid.

of Lenin's prerequisites for women's emancipation—the elimination of private, domestic work, such as cleaning, cooking, and childcare—was ignored. Instead, resources were funneled away from domestic services and into heavy industry, thus increasing the double burden on women. Stalin announced preemptively at the Eighteenth Party Congress that "in every branch of the economy, culture, science and the arts—everywhere stands an emancipated woman alongside man, equal with him, performing great tasks, moving socialism forward. Women in our country have become a great force."[13] Despite Stalin's rather hyperbolic enthusiasm, the situation was much more complicated.

The Zhenotdel, or women's department, which was set up in 1919 to bring women into the party, was dissolved in 1930, with the government claiming that the woman question had been solved when class struggle ended and the functions of the department were absorbed into the Communist party. The result was that women's equality was ignored once again during the 1930s, and policies and laws enacted during these years made women's lives more difficult, not easier. With women virtually absent from political arenas, quotas were established in certain professions, which relegated most women to traditional female employment that had lower wages and less prestige.[14] A woman's career advancement was also complicated by policies that encouraged her to have children, to increase the population, and by the prohibition of abortion in 1936. These setbacks to women's equality affected the animation industry as well, with women who were unmarried and childless, like the Brumberg sisters and Khodataeva, being more likely to advance their careers to become directors of their own animation collectives; while women like Aleksandra Snezhko-Blotskaia, who was married and had a daughter, spent many years co-directing before finally being permitted to direct films. Policy changes enacted in the 1930s not only affected women's work and home lives, but also determined the types of female representation that were permitted on screens for decades.

13 Buckley, *Women and Ideology*, 117.

14 Janet Evans, "The Communist Party of the Soviet Union and the Women's Question: the Case of the 1936 Decree 'In Defense of Mother and Child,'" *Journal of Contemporary History* 16, no. 4 (1981): 757–775; and Wendy Z. Goldman, *Women at the Gates: Gender and Industry in Stalin's Russia* (Cambridge: Cambridge University Press, 2002).

Socialist Realism, Soiuzmultfilm, and the Effect of Disney on Soviet Animation

The year 1932 saw another major change that would affect not just the film and animation industry, but all the arts: the adoption of socialist realism as the official method of artistic production. The requirement of the arts to portray and promote the ideals (not the reality) of socialism severely limited the creative directions animators could follow. The imperative to portray Soviet society in upbeat and politically relevant ways was a challenge for many artists to say the least.[15] The strictures of socialist realism resulted in a serious loss of creative control for filmmakers in the Soviet animation industry. It is not surprising that several artists and film directors, such as Nikolai Khodataev, could not tolerate the restrictions on their creativity and left animation to pursue other careers. And yet there were many animators, including the Brumberg sisters and Khodataeva, who continued to work in the animation industry. In order to thrive, these women had to adapt to the new requirements, including the need to produce new politically charged content, ever-increasing party control, and other bureaucratic reforms.

The last two significant challenges to the industry were the creation of Soiuzmultfilm, due to bureaucratic centralization under Stalin in the 1930s, and the subsequent decision of the studio to adopt the successful stylings of the Walt Disney Studio. The the reorganization of film studios and the creation of Soiuzmultfilm brought animators together and changed the dynamics of animated film production. In the years prior to the formation of Soiuzmultfilm, animators had heated discussions about the future direction of their art, during which the question of creating a large animation studio or union was repeatedly raised.[16] Regardless of dissenting voices, Soiuzmultfilm was created in 1936, as the Mezhrabpomfilm studio was reorganized, splitting it into two entities. Soiuzdetfilm was to create live-action film for young viewers, and Soiuzdetmultfilm, later renamed Soiuzmultfilm, was to focus on all types of animation. The creation of Soiuzmultfilm meant the disbanding of all of the small and relatively independent studios that had

15 Mjolsness, "Under the Hypnosis of Disney," 405–406.
16 Georgii Borodin, "Kinostudiia 'Soiuzmul'tfil'm': Kratkii istoricheskii obzor," https://web.archive.org/web/20160305111609/http://new.souzmult.ru/about/history/full-article/5.05.2016.

previously been part of Mosfilm, Sovkino and Mezhrabpomfilm.[17] As animators regrouped, with the majority of them joining Soiuzmultfilm, they experienced a loss of creative control and a strict curtailing of artistic initiative.

Under the guidance of Soiuzmultfilm many animators turned to producing an ever-growing number of children's animation in the form of educational shorts and features, and much of the experimental mood of the first years of Soviet animation was lost. Women in the animation industry had to adapt as well, and many, like Aleksandra Snezhko-Blotskaia, found the role of director out of reach. Feminist-leaning films like Khodataeva's *Terrible Vavila and Little Aunt Arina* did not have a place in the Stalinist 1930s, yet the Brumberg sisters and Khodataeva continued to champion the family and mother-child relationships, to pioneer aesthetic changes at the studio, and to influence cultural norms in the Soviet Union.

Soizmultfilm was to become the premier Soviet animation studio, and while it encouraged new technologies and new aesthetic styles, it also limited animators' independence. At that time, animators discussed the need to adopt the Disney studio's favored cel technology as the most promising method for producing hand-drawn films. Opinions, however, were divided about the degree to which they should borrow from the American studio. Nevertheless, Soiuzmultfilm took the official decision to adopt Disney-style aesthetics. More importantly, the decision of Soiuzmultfilm to emulate the success of Disney led the studio to focus on both the newest techniques of cel animation, which brought with it the stratification of labor, and the Disneyfication of aesthetic style.[18]

In the 1920s and 1930s, Disney's innovative techniques and a demonstrated aesthetic style earned broad popularity around the world. Not only Soviet animators, but also average Soviet citizens were enamored with Disney films. Soviet citizens had opportunities to view many Disney films that utilized both color processing and sound. For example, at the 1935 American Color Film Festival in Leningrad the program prepared viewers for the visual treat of Disney's *Silly Symphonies* while

17 S. L. Bogdanova, "Ocherki o zhizni i tvorchestve Aleksandry Gavrilovny Snezhko-Blotskoi," *Kinograf* 19 (2008): 210.

18 Ivan Ivanov-Vano, often called the father of Soviet animation, suggests that Soviet animators fought against "cheap vulgar disneyfication." Ivanov-Vano, "Risovannyi fil'm," 17.

warning them of the danger of American ideology.[19] According to the program Soviet animators should emulate the drawing, movement and sound techniques and especially the synchronization of Disney's animated films, but not the empty storylines. The *Silly Symphonies* were musically inspired short animated films, they were not designed to be plot-driven and did not feature continuing characters. The program focused on the *Silly Symphonies'* lack of narrative complexity as a way to encourage Soviet animators to create Disney-style films with Soviet plots.[20]

Soviet animators felt the pressure to emulate Disney's style if they wished to compete on the world market. In the Soviet Union, Disney's overwhelming success led to a demand to "Give us a Soviet Mickey Mouse."[21] This imperative, announced at the All-Union Conference on Comedy (1933), forced Soviet animators to respond to Disney both stylistically and technologically. After Victor Smirnov, the director of AmKino, a New-York-based Soviet film distribution company, led an official trip to the Walt Disney Studios, the decisive step was made to create a single animation studio and pursue cel animation.[22] Lucille Kramer, an employee of Disney and a Russian emigré, was invited to Moscow to share Disney's technology. Film production was suspended for two months in 1936 to retrain all the workers in this new technology. Soiuzmultfilm at this time created a sound studio and updated studios with light tables, new cameras, and equipment for color film as well.

The Soviet artists' exposure to Disney's smooth, colorful, child-like exaggerations of realistic characters, be they human or animal, made the Soviet animators' dedication to the adult-centered, avant-garde, graphic poster style, as well as the paper cut-out and pen and ink drawings from the 1920s appear dated. That smoothness of movement was achieved through cel animation, which, apart from producing a more

19 N.Sekundov, ed., *Amerikanskie fil'my* (Leningrad, 1935), 2–3.

20 Mjolsness, "Under the Hypnosis of Disney," 409–410.

21 Pontieri, *Soviet Animation*, 39.

22 Amkino Corporation was created in 1922 with the Motion Pictures Producers and Distributors to foster the exchange of films between the United States and the Soviet Union. See E. A. Ivanian, *Entsiklopedia rossiisko-amerikanskikh otnoshenii XVIII–XX veka* (Moscow: Mezhdunarodnye otnosheniia, 2001), 48; and Lana Azarkh, "Mul'tiplikatory," *Iskusstvo Kino* 9 (2010): 137. Azarkh was an animator who worked under the Brumbergs until the 1970s; she wrote at length about how Disney was adopted at Soiuzmultfilm.

life-like, convincing visual effect, was also more efficient and cost-effective. While cel animation was first invented by Earl Hurd and John Bray in 1915, it was Disney who streamlined the process, running an animation studio like an automobile factory. This revolutionary process used clear flexible sheets known as cels which could be created in an assembly line and permitted a large number of people to work on drawing, inking, and painting the thousands of images that would then be layered and individually filmed. The hope was that the Disneyesque division of labor would allow Soiuzmultfilm to create longer and more elaborate animated films in a shorter period of time. To the disappointment of Soviet animators, who were introduced to cel animation between 1933–1934, the outcome of the process could not compare with American animation partially due to the inferior quality of Soviet cels which were thicker and became opaque after reuse.[23] Animators now needed to draw differently as well as adopt animation techniques that would permit their characters a greater synchronization of sound and movement—walking, running, and jumping—in a more nuanced Disneyesque manner.[24] The method, undoubtedly, encouraged productivity. But, due to its conveyer-belt efficiency, it also impacted animators' individual creative style, made centralized control more possible, and tended to keep women from easily advancing within the ranks.

There is some debate among scholars over how the Disney aesthetic was adopted at Soiuzmultfilm. The history page on the Soiuzmultfilm website states that the Disney aesthetic was embraced because Stalin personally made the choice for this direction of development.[25] However, animation scholar Anatolii Volkov asserts that Stalin did not have a direct influence on the adherence to the Disney aesthetic style at Soiuzmultfilm, even though it is well known that Stalin liked Disney films. Instead, the adoption of Disney realism was more of an attempt to compete with the West.[26] By Disney realism, we are referring not to verisimilitude, but primarily to the fluidity of movement perfected by Disney, and aided with the use of rotoscoping, a technique developed

23 Ivan Ivanov-Vano, "Graficheskaia mul'tiplikatsiia," in *Mul'tiplikatsionnyi fil'm* (Moscow: Kinofotoizdat, 1936), 170.

24 Mjolsness, "Under the Hypnosis of Disney," 405.

25 Borodin, "Kinostudiia."

26 A. Volkov, *Mul'tiplikatsionnyi fil'm* (Moscow: Znanie, 1974), 71.

by Max Fleischer where animators traced over film footage, frame by frame, to achieve realistic movement for their characters, regardless of their humanity.

In the late 1930s and on into the 1940s the aesthetic style of Soviet animation continued to favor the natural realism of Disney movement, moving further away from Russian artistic experiments of the 1920s, to please their audiences.[27] Yet, according to Khodataev, there was some resistance to blindly imitating Disney even in the 1930s.[28] Later, during the Great Purges, there was a price for this love of Disney. Victor Smirnov, the Amkino director who helped to usher in the age of Disney, was convicted as an American spy for his work in bringing this new technology to the Soviet Union.[29]

The Fairy-Tale in Animation

While Soviet animators were "encouraged" to animate like Disney, they also found comfort in a genre frequently embraced by the Disney studio—the fairy-tale. Despite the early Soviet animosity towards the fairy-tale, in the 1930s the genre held special appeal because of its accessibility to younger audiences, its capacity for nationalist and class indoctrination, and other propaganda potentialities.[30] The Decree of the Party's Central Committee on September 9, 1933 pronounced the fairy-tale a necessity for the education of Soviet children.[31] A year later, Maksim Gorkii fully rehabilitated the fairy-tale at the First Soviet Writers Congress, when he emphasized the ability of folklore and fairy-tales to influence social change and insisted on the importance of Soviet readers' familiarity with folklore.

This acceptance of the fairy-tale, with its magic, animism, and anthropomorphism, came just in time to breathe new life into the animation

27 Disney style can be seen in many Soviet animated films of the 1930s, 1940s, and 1950s, including those produced by Ivanov-Vano, Lev Atamanov, Leonid Amalrik, Vladimir Polkovnikov, and even Tsekhanovskii.

28 Nikolai Khodataev, "Puti mul'tfil'ma," *Sovetskoe kino* 4 (1935): 46–48.

29 Kirill Maliantovich, "Kak borolis' s 'kosmopolitami' na 'Soizmul'tfil'm' (rasskaz-vospominanie)," *Kinovedcheskie zapiski* 52 (2001): 191–196.

30 Beumers, "Comforting Creatures," 160–164.

31 "Postanovlenie TsK VKP(b) ot 9 sentiabria 19233 g. 'Ob izdatel'stve detskoi literatury,'" in *Resheniia partii o pechati* (Moscow: Politizdat, 1941), 158–159.

industry, as other areas of creative freedom were shut down. Although the fairy-tale could be used as a heavy ideological tool, it could also serve as a foil for subtler artistic endeavors. Drawing from the relatively safe topic of the fairy-tale, animators were able to avoid explicit socialist realist themes, and instead focus on moral instruction of a universal timeless type, promoting such values as loyalty, courage, and honor. Soviet animators, including the Brumberg sisters, Ivanov-Vano, and Tsekhanovskii, all worked on animated adaptations of fairy-tales in these years in order to skirt the issue of overt ideology during the height of the Stalinist terror.[32] As a medium that invited the young viewers' full immersion in the morally valuable story, animated fairy-tales had a chance to survive and even flourish within the Soviet ideological guidelines. Choosing fairy-tales and their underlying narratives allowed female animators to push the boundaries of the doctrine of socialist realism and use moral codes not prescribed directly by the government. Women harnessed the fairy-tale genre and utilized it to present strong heroines in a time that was less committed to the equality of men and women.

The Brumberg Sisters in the 1930s

Despite the many obstacles of the early Stalinist period, the Brumbergs continued to develop a personal style which focused on creating human likenesses and positive female characters in the 1930s. The sisters worked on a number of fairy-tales and fables for children before they joined Soiuzmultfilm, including two films they co-directed with Ivanov-Vano, the *Tale of Tsar Durundai* (*Skazka o tsare Durandae*, 1934) and *The Dragonfly and the Ant* (*Strekoza i muravei*, 1935). The Brumberg sisters were hired together at Soiuzmultfilm in a single work order on July 7, 1936 and, as a rare example of female power in animation, they were permitted to build their own director's group.[33] Zinaida Brumberg asserted that her success in these years was based on the strong collective that she formed. "In the beginning of our careers we did a lot ourselves. We were at once scriptwriters and artists and directors. . . . I think that when you gather up a group of people who think in the same manner and who are talented and enthusiastic, only then can true

32 Mjolsness, "Under the Hypnosis of Disney," 406.
33 Katz, *Drawing the Iron Curtain*, 83.

success be reached."[34] With the help of this collective, the sisters directed *Hare-Tailor* (*Zaiats-portnoi*, 1937), *Little Red Riding Hood* (*Krasnaia shapochka*, 1937), *Ivashko and Baba Yaga* (*Ivashko i Baba Iaga*, 1938) and *Puss in Boots* (*Kot v sapogakh*, 1938). The Brumbergs continued to create characters, especially female characters, who displayed agency and strong voices, while highlighting qualities that did not contradict the policies of socialist realism.

Their version of *Little Red Riding Hood* is a particularly useful example of their commitment to character development, the advancement of technology, and aesthetics in animation. The film utilized cel technology, which allowed for increased speed in production and greater precision in terms of the flexibility of character movement and synchronization of the images and sound. Hence, the movement is smoother, and the Brumbergs were able to create a more realistic sense of depth reminiscent of the Disney style with its use of the multiplane camera. In comparison, in the *Samoed Boy*, the Brumbergs created scenes that highlighted animation's ability to create a sense of depth: for example, when the boy is traveling through the frozen tundra, the Brumbergs were able to create a fore-, middle, and background in order to accentuate the vastness of the landscape. However, there is a sense of flatness with the pen and ink on paper technique, as the boy never interacts with the scenery, but simply moves along it. The new cel technology and the ability to layer the cels on multiple planes allowed the Brumbergs to create a more realistic sense of depth throughout *Little Red Riding Hood*, but especially in the forest scenes, when the Cat is running through the forest to deliver Grandmother's letter to Little Red. The Cat weaves around the trees in the fore- and middle grounds and is often covered by their shadows, which is something that would not have been possible with pen and ink on paper.

The Brumberg sisters offer their own interpretation to *Little Red Riding Hood*, a simple tale that lends itself well to feminist re-interpretation.[35] The story of *Little Red Riding Hood* has a long history of evolution as an oral tale starting sometime around the tenth century and was first written down in the seventeenth century by Charles Perrault and then

34 Zinaida Brumberg, "Liubimaia rabota," in *Zhizn' v kino. Vypusk 2*, ed. O. T. Nesterovich (Moscow: Iskusstvo, 1979), 20.

35 Jack Zipes, *The Trials and Tribulations of Little Red Riding Hood* (London: Routledge, 1993), 17–89.

again in the nineteenth century by the Brothers Grimm. The various versions of the tale all have in common a cautionary nature. Zipes notes that Little Red Riding Hood is "an imaginary character who is used as a warning to children, particularly girls, a symbol and embodiment of what might happen if they are disobedient and careless."[36] Zipes argues that rape and violence are at the core of this tale, which has shaped the regulation of sexuality in modern Europe and contributing to the reinforcement of stereotypical gender roles.[37] Yet, its various versions differ in their ending and the extent to which they conform to gender stereotypes. In Perrault's version, one of the most popular, both the grandmother and Little Red are eaten by the wolf due to the Grandmother's gullibility and Little Red's predilection for talking to strangers. In the Grimms' version, the Grandmother and Little Red are both eaten, but are saved by a huntsman who cuts them from the belly of the wolf. Other editions of Grimms' tales have Grandmother and Little Red learning from their mistakes and tricking a second wolf who tries to eat them, thus allowing them agency over their own lives.[38]

The Brumberg sisters had the chance to shape the characters in ways that both fit the original model and deviated from it, to adhere to 1930s Soviet Russia, and in doing so offer a new variation of the classic tale. In the Brumbergs' version, Grandmother and Little Red are not eaten by the wolf, nor are they saved by a huntsman. Instead, they hide from the wolf and later capture him with the help of Grandmother's cat and some household objects. It is precisely the ending of the film that Soviet critic, V. Garin criticized in 1939. He suggests that while the Brumbergs' artistic style is high quality, their reworking of the ending is of low cinematic style, depicting nothing more than a cat fight with a wolf.[39] Yet, the revised ending of the tale allows the Brumbergs to weaponize the domestic sphere, reminiscent of Khodataeva's *Terrible Vavila and Auntie Arina*, and ultimately gives power and control of the tale to the female characters.

Certainly, the Brumbergs' version reinforces some standard gender roles. For example, while there is no mother in the Brumbergs' tale,

36 Ibid., 17.

37 Ibid., 34.

38 Jacob Grimm and Wilhelm Grimm, *The Complete Fairy Tales of the Brothers Grimm*, translation and introduction by Jack Zipes (New York: Bantam Books, 1987), 104–105.

39 V. Garin, "Novye raboty mul'tfil'ma," *Iskusstvo kino* 5 (1939): 34–36.

Little Red wears an apron, which suggests her participation in traditional female activities, cleaning, cooking, caregiving, and keeping an attractive appearance. Grandmother is shown performing domestic tasks, such as getting the milk and knitting. Although they do not live in the same house, Grandmother also takes on the traditional mother's role and cautions Little Red to avoid the forest because of the dangers that lurk there. Later, the Wolf chases Grandmother around the cottage and does not eat her; he eschews her in favor of the young and tender Little Red. The Wolf's treatment of Grandmother illustrates the lack of value that a male-dominated society places on older women. These are just a few of the stereotypically gendered representations contained within the basic plot of the reworked fairy-tale. The representation of universal morals linked to female subjugation in this tale did not directly work against the doctrine of socialist realism, so it would not have caught the eye of the censors, yet elements of the tale can be read as reactionary: the untrustworthiness of a powerful male; the confiscation and reading of private mail; and even the weaponizing of the domestic sphere.

However, the animated version also allows the female characters more agency. While the two women do initially hide from the Wolf, they work together with the Cat to vanquish the Wolf, causing one to wonder if they had not planned the whole escapade. The Wolf learns that Little Red will be going to Grandmother's house when he intercepts Grandmother's letter to Little Red that was dropped by the Cat.[40] The next day, as Little Red heads off to Granmother's house, she encounters the Wolf twice. Both times he is in disguise—first as Grey Goat and then dressed as Grandmother. Little Red appears to trust the Grey Goat/Wolf—perhaps the only male character, who is later shown to be her enemy, and allows him to give her a ride through the forest, despite warnings from Grandmother.

40 This element of the Brumbergs' tale has a very specific meaning for Stalinist Russia, perhaps as unintentionally it speaks to the fact that average citizens were having their mail read by the NKVD, Stalin's Secret Police, in the 1930s as part of the Great Purges. See Central Intelligence Agency, Soviet Postal Intelligence: May 1962, 78-02646R, Box 005, Folder 009, 1–64. https://www.cia.gov/library/readingroom/docs/CIA-RDP78-02646R000600090001-2.pdf.

Fig. 4. *Little Red Riding Hood* (*Krasnaia shapochka*, 1937), courtesy of Soiuzmultfilm.

Fig. 5. *Little Red Riding Hood* (*Krasnaia shapochka*, 1937), courtesy of Soiuzmultfilm.

The Brumbergs' digressions from the basic fairy-tale place their female characters in more powerful positions than most versions of the story. Zipes suggests it is not by chance that new versions of *Little Red Riding Hood* since 1983 have been written by feminists in an attempt to reclaim the tale from its sexist past.[41] The Brumberg sisters were decades ahead of their time, creating characters who challenge and push back against the gendered stereotypes. It is significant that the defeat of the Wolf takes place within the cottage. The domestic space is no longer a space that contains and controls women; the female characters instead use the home to vanquish the malicious invader.

Grandmother and Little Red are able to save themselves with the help of two anthropomorphized sidekicks of sorts, the Cat and, to a lesser extent, the Clock;[42] a narrative trope borrowed from the Disney model and another way in which this version differs from the original tale. While the Wolf is only just a wolf as he slinks through the forest in search of prey, he is anthropomorphized during most of the film, but never loses his predatory nature. The Clock and the Cat are anthropomorphized in some scenes where they are helping Grandmother and Little Red, but not in others. This sliding in and out of anthropomorphized behavior operates differently than in earlier Brumberg films; in *Samoed Boy* it grounds the hero in reality, whereas in *Little Red Riding Hood* it helps the Brumbergs to create a more fluid opposition between the real and the fantastic on the screen. In *Little Red Riding Hood* the use of these sidekicks demonstrates that the Brumbergs choose not to have a human male rescue the women, allowing the characters more control in their own rescue. In fact, it is when the Cat dons Little Red's signature cap and boots, that the Cat is able to defeat the Wolf. Little Red's clothing transforms the Cat into a hero, a surrogate for Red, and serves as an anthropomorphic talisman of Red's feminine power. In this way, Little Red helps to save herself and Grandmother from the Wolf. After Grandmother, Cat, and Little Red push the barrel containing the trapped wolf down the hill and into the lake, the Cat returns Little Red's cap and basket with a bow as a formal thank you to Little Red for her help (see Fig. 4) and then reverts back to cat

41 Jack Zipes provides numerous examples, see his "A Second Gaze at Little Red Riding Hood's Trials and Tribulations," in *Don't Bet on the Prince: Contemporary Feminist Fairy Tales in North America and England*, ed. Jack Zipes (New York: Taylor and Francis, 2014), 227–260.

42 In Russian this clock is not called a grandfather clock. It is called *vysokie stoiachie chasy* (high standing clock) or sometimes *napol'nye chasy* (floor clock).

nature, on all fours, and rubs herself against Little Red hoping to get some milk. With the Wolf vanquished, domestic harmony is restored.

The Brumberg sisters also follow another popular American-influenced narrative technique in animation—the gag structure, which Disney and other American studios employed very successfully. The Brumbergs' interpretation of the gag is female-centric, centered around the domestic space. The film utilizes a series of comical gags, including the ball of yarn tripping up the Wolf; the Clock using its weights as fists to hit the Wolf; the Cat sprinkling pepper on the Wolf's snout; the dishes flying out from beneath the Cat's feet to hit the Wolf; and, finally, the Wolf falling into the conveniently placed barrel of tomato sauce. The gags function to create humor, which helps to keep the film from being too scary, but more importantly, the gags signify the centrality of the feminine domestic space and its ability to defend itself from the male intruder. The final gag takes place when Little Red, the Grandmother, and the Cat roll the barrel containing the Wolf into the lake and pieces of the barrel pop up onto the water but not the Wolf. The film ends with a shot of the Cat, Grandmother, and Little Red Riding Hood laughing and reveling in their ingenuity (see Fig. 5). It took female agency and the domestic space to vanquish the villain.

The Brumbergs incorporate two popular 1930s animation tropes in their reworking of the tale: the addition of musical numbers and the reliance on sound to carry the narrative plot. It was Disney's *Silly Symphonies* and the *Three Little Pigs* in particular that led Soviet animators to embrace the importance of not only the synchronization of movement and sound in animation, but also the musical numbers. Disney produced original music for *Three Little Pigs* creating an overwhelming success with the song "Who's Afraid of the Big Bad Wolf?" In *Little Red Riding Hood* the Brumbergs demonstrate their ability to utilize sound and songs in meaningful ways that flesh out the characters and the story. They use sound quite literally to give voice to women's strength and knowledge. In *Little Red Riding Hood* our main character not only sings a catchy little tune on the way to Grandmother's house but the words she sings are important as she sings about her knowledge of the story that she is acting out in the film. She sings that she must be careful, "So the terrible Grey Wolf does not drag me into the forest, as it happens in fairy-tales." The self-reflexivity speaks to Little Red's knowledge of the dangers of the forest. She also seems aware of how fairy-tales function and that she is part of the tale. If she knows she is in a fairy-tale, perhaps her trip to Grandmother's is not all that innocent. In other words, rather than the Wolf creating a trap for Little Red, perhaps, this is all a trap for the Wolf.

This film relies on sound not only for narration, but also for humorous effects and character development. For example, the Wolf alters his voice several times in an effort to trick both Little Red and Grandmother into thinking that he is each of them, as well as the Grey Goat (also a higher register than his usual baritone). The Wolf's attempt to feminize his voice and speak softly signifies his attempt to lure both women into his dominating male grasp by using "female" voices, implying safety. He is not always successful, which allows the Brumbergs to create moments of humor. For instance, when the Wolf pretends to be Little Red, he has to cough first because he cannot get his voice high enough. Also, when he pretends to be Grey Goat at Grandmother's, as he sings the final refrain, "Is that so? Is that so? A Grey Goat?," his voice becomes deeper and deeper to remind the audience of his evil intent and is punctuated by his turning towards the camera with an evil smile on his goat face. Like other animators of the time, the Brumbergs also use sound as a means of insight into the nature of their characters. The Wolf is accompanied by deep tones of the oboe that hint at his sinister nature, while Little Red is accompanied by the light airy notes of a flute, implying her youth and innocence. The music and the animation work together to create a provocative and moving tale that plays with tradition.

Advancement in film technology allowed the Brumberg sisters to add these sound features to their animation and demonstrate their increasing technical competence as the art of animation continued to evolve. Instead of allowing the strictures of socialist realism and Soiuzmultfilm to become obstacles to their creative potential, the sisters were able to flourish within the system and reimagine a fairy-tale with greater female agency. The Brumbergs used the medium of animation to simultaneously straddle the real and the imaginary, facilitating a subversion of reality, and hence through their reworking of the tale they were able to infuse the domestic space and the women within with the agency to rescue themselves in a time when women had less power.

Olga Khodataeva in the 1930s

Not all female animators during the 1930s were able to incorporate female-centered narratives into their fairy-tales and some chose to create films with heavy propagandistic slants. Khodataeva, for instance, worked frequently within the confines of what can be considered propaganda.

Unfortunately, many of her early films, like *Happy Life* (*Veselaia zhizn'*, 1932), a film about maintaining cleanliness in communal apartments, co-directed with Valentina Brumberg and made at Soiuzkino, have not survived. By the 1930s she solidified her position as the director of her own collective. Khodataeva was able to direct her next film on her own, *Happy Moscow* (*Veselaia Moskva*, 1934), made at Moskinokombinat. In 1936, she began to direct films at Soiuzmultfilm, with *The Returning Sun* (*Vozvrashchennoe solntse*, 1936), a Chukchi and Nenets folktale.

Her second film at Soiuzmultfilm, *Father Frost and the Grey Wolf* (*Ded Moroz i seryi volk*, 1937) was a New Year's tale for children, and her image of Father Frost has since become a cultural icon in Eastern Europe. Khodataeva's film tackles the controversial subject of the New Year after a long prohibition against the religious Christmas holiday by Soviet authorities. According to Grigorii Borodin in his article, "The Image of Father Frost in Russian animation," Khodataeva's film was the first Soviet attempt to imagine a human form for this magical being.[43] Borodin suggests that Khodataeva's Father Frost is mediocre and crude in terms of its animation, but that her film gave children throughout the Soviet Union the first classical image of Father Frost and set in motion a tradition of Soviet New Year's films. Khodataeva's animation is not nearly as smooth and fluid as the Brumberg sisters'. Her use of sound is limited and not as creative as in *Little Red Riding Hood*, though she does include a catchy little tune about the New Year, which could have had audiences singing along like "Who's Afraid of the Big Bad Wolf?" Regardless of its artistic merit, Khodataeva's version of Father Frost with his floor-length fur-trimmed coat and hat, mittens, and cold nose became the template upon which all other versions were based for generations.

Khodataeva's film lays the foundation for Father Frost as a magician, a ruler of winter, and a friend to children and animals.[44] The film is very loosely based on the Brothers Grimm's *The Wolf and the Seven Kids*, with the addition of Father Frost and a New Year's setting. In the opening of the film, Father Frost sings of bringing toys to children and decorating the New Year's tree—setting the expectations for this new Soviet holiday that combined New Year's and Christmas traditions. With a wave of his arms, he covers trees with white snow and later in the film he also magically blows a

43 Georgii Borodin, "Obraz ded-moroza v rossiiskoi animatsii," *Prazdnik* (October 2001), http://www.animator.ru/articles/article_255.htm.

44 Ibid.

strong wind that freezes the Grey Wolf's hut at will. Clearly, he commands winter to do his bidding.

The film is set in a magical forest, where Father Frost arrives to bring the New Year's celebration to the little forest animals. While Khodataeva's Father Frost may not be as realistically drawn as characters created in Disney films, and his movements not as smooth, she still includes many realistic details in both the background and foreground of the animation to give children a new version of the holiday. Like the Brumbergs, Khodataeva uses a multiplane setup to create a sense of depth, as her characters weave in and out of the forest trees during the chase scene. Another example of her attention to detail is the New Year's tree and celebration at the end of the film (see Fig. 6). The table is laden with all sorts of cakes and jellies to eat. The children each receive a toy from Father Frost. The New Year's tree is shaded to emphasize its plentiful boughs and is decorated with candles, garlands, intricate dolls, stars, and bobbles. Each of these elements became an integral part of the Soviet New Year's celebrations.

Fig. 6. *Father Frost and the Grey Wolf* (*Ded Moroz i seryi volk*, 1937), courtesy of Soiuzmultfilm.

Father Frost is the only human in the film, and with the exception of the peg-legged Grey Wolf, all the other characters are anthropomorphized animal children with the main characters being Sister rabbit and her two

brothers. Anthropomorphism in this tale functions differently than in Khodataeva's films from the 1920s. Instead of the domestic accoutrements that come to life in *Terrible Vavila and Little Aunt Arina*, in *Father Frost and the Grey Wolf* Khodataeva uses anthropomorphism to create an entire enchanted and magical world, in order to replace the old Christmas tales. The anthropomorphic rabbits interact with a mythical, but seemingly more human, Father Frost. The rabbits take on the gendered personalities of Soviet boys and girls. All the animal children are working and playing as Father Frost arrives. When Brother rabbits see Father Frost, they ask for a tree and toys. Father Frost agrees to bring them a beautiful New Year's tree, but only with their help. Sister rabbit is left at home to guard the house and is warned by her brothers not to let anyone enter.

Interestingly, Khodataeva manages to weave into the tale a strong female character, in the form of Sister rabbit. Sister is initially deprived of adventure, left to domestic chores and setting up the feast. Soon, however, she demonstrates that she is a bright little rabbit. When the Wolf knocks on the door and says he is Father Frost, she looks out the window and sees it is the Wolf and denies him entry. It is only when the Wolf knocks again, dressed like Father Frost, that Sister is fooled. She notices that he has a peg leg, but it is too late and the Wolf puts her in the sack along with the feast. Sister's cries for help are overhead by Father Frost and her brothers.

At first glance, this fairy-tale appears to reinforce female characters as victims, but Sister is far from helpless. She opens a hole in the bag and throws out the New Year's treats to create a trail for Father Frost and her brothers to follow. She also manages to escape from the Wolf's bag, while her bumbling brothers tie up the real Father Frost. In a heroic move, Sister then leads the others to the Wolf, who is forced by Father Frost to help cut down and carry the New Year's tree. In the end, Sister expresses empathy and is willing to let the Wolf in to celebrate the New Year. Despite her attempt to forgive him, the Wolf grabs her and tries to run away with her, kicking and screaming. Father Frost steps out and freezes the Wolf to his death in the river.

This new tale is certainly not as strong as the Grimms' tale in terms of female empowerment, in the original version the mother cuts open the wolf's stomach to save her children whereas Khodataeva's version has Father Frost stepping in at the last minute to overpower the Wolf. That said, Sister illustrated time and time again that she is resourceful, and for the most part she did not need rescuing. One might assume that she would

again escape from the Wolf's clutches. More importantly, she represents Soviet little girls who are just as smart, resourceful, and heroic as the boys, allowing girls to see themselves as heroes. Even though Khodataeva's New Year's tale is remembered today for her cultural contribution to the creation of the canonical Soviet Father Frost, rather than for a strong female character, this film creates a Soviet female subjectivity that is reflected in the resourcefulness of the female heroine, while influencing the cultural norms of the Soviet Union in the 1930s and beyond.

Chapter 4

The War Years, Stalinist Repression, and Women Navigating the Animation Industry

In the 1940s and 1950s Soviet animation and women animators struggled to find their niche within the educational and entertainment industry and within Soviet culture. While there was the potential for more women to assume creative positions when World War II forced many men into active duty, women's work in animation was, in fact, even more marginalized than it had been in the 1920s and 1930s. By the 1940s animation was drastically transformed into a medium of propaganda for Soviet children. Women had more difficulty asserting female agency in their animation as a result of external pressures, including the silencing of the woman question, World War II, and Stalinist repression.

The Brumbergs and Khodataeva continued to direct films and to push animated film in new aesthetic directions, contributing to the creation of a Soviet female subjectivity within Soviet animation. During this period women directors, like Snezhko-Blotskaia, were finally given the opportunity to direct. Unlike Khodataeva and the Brumbergs, who began directing their own films early in their careers, Snezhko-Blotskaia worked as both an assistant director and a co-director for almost two decades before she was allowed to independently direct her first film in the late 1950s.

Snezhko-Blotskaia is an example of how the second generation of women animators, and, more particularly, those married with children, had to work harder in the 1940s and 1950s in order to attain the top creative positions in the animation industry.

World War II and Evolution of Soiuzmultfilm

The 1940s and the early 1950s were dominated by the Great Patriotic War and its aftermath. In 1941 the Soviet Union was invaded by Germany after Stalin failed to recognize the warnings. The cost of the war to the Soviet Union was incalculable. Fifteen million people lost their lives fighting in the war, but another ten million were indirect casualties.[1] Many employees of Soiuzmultfilm fought on the fronts of the Great Patriotic War or were involved in filming instructive war films. During the war, few animated films were produced due to lack of funds.[2] Instead of films for children, animators concentrated more on satirical and propagandistic films. For example, in 1941 the Brumbergs, Khodataeva, Ivanov-Vano, and Aleksandr Ivanov co-directed *Journal of Political Satire No. 2* (*Zhurnal politsatiry No. 2*, 1941), which was about the inevitable destruction of fascism. This heavy propaganda film contained sections like: "What Hitler Wants," "Beat Fascist Pirates," and "Beat the Enemy at the Front and the Rear."[3] Khodataeva co-directed several anti-war propaganda films including *Kinocircus* (*Kinotsirk*, 1942) with Leonid Amalrik and *Song about Chapaev* (*Pesnia o Chapaeve*, 1944) with Piotr Nosov.

In October 1941, Soiuzmultfilm was divided into two branches, one located in Central Asia and the other in Moscow, as a way to protect the industry.[4] When part of Soiuzmultfilm was evacuated to Samarkand, along with important heavy industry, sixty employees were resettled from Moscow. Film production in Samarkand began in early 1942 and attempts were made to finish films that had been started before the war. However, construction for the Samarkand studio was not fully completed until 1943, shortly before the reevacuation back to Moscow. Few films were produced

1 Wolfgang Lutz, Sergei Scherbov, and Andrei Volkov, *Demographic Trends and Patterns in the Soviet Union before 1991* (London: Taylor and Francis, 2002).
2 Borodin, "Kinostudiia."
3 *Zhurnal politsatiry No. 2*, 1941.
4 Borodin supplies more specific details of Soiuzmultfilm during the war, see Borodin, "Kinostudiia."

due to lack of resources, poor working conditions, hunger, and the fact that studio was engaged in the production of consumer goods—combs and buttons—in order to aid the war effort. The most notable films made were not war-inspired adult propaganda films, but rather fairy-tales for children. In Samarkand, the Brumbergs completed two out of the five most significant films for this period, *The Tale of Tsar Saltan* (*Skazka o tsare Saltane*, 1943) and *Sinbad the Sailor* (*Sindbad-morekhod*, 1944).[5] Khodataeva completed her *Fox, Hare, and Rooster* (*Lisa, zaiats i petukh*, 1942) and *Teremok* (1945) as part of the Moscow branch of Soiuzmultfilm. Both the Brumbergs and Khodataeva managed to remain active during the war, despite the fact that productivity and creativity were greatly curtailed.

After returning from Samarkand in 1943, Soiuzmultfilm received its Moscow premises back and engaged actively in recruiting new staff. In 1944, the studio organized the first post-war courses to train new animators. From 1945 to 1949, four groups of young animators were trained, many of whom became famous in subsequent years, including Roman Kachanov and Viacheslav Kotionochkin. Women also participated in these courses, yet only one woman is listed as a notable by Soiuzmultfilm: Renata Mirenkova.[6] Mirenkova attended the animation courses in 1945–1946, and was employed at Soiuzmultfilm between 1946 and 1982. She worked on more than a hundred films, however, she never became an animation director. Soiuzmultfilm also regularly organized courses, including evening courses, for in-betweeners and colorists, as well as staff development. These positions were not prestigious; hence, many women were employed in them.[7] While these courses were successful at bringing more women into the animation industry, the majority of the women did not rise to positions of creative power.

When Soiuzmultfilm returned to Moscow, despite the focus during the war on adult-centered propaganda films, animation aimed at adult audiences was still quite rare. The studio began to dedicate itself, again, to the production of films exclusively for children. There was also a push towards unifying art, animation, and ideological content. A decree was passed by

5 This film was co-directed with Tatiana Basmanova. This was the only film she directed. Basmanova worked as an animator and screenwriter for other films including the Brumbergs' *Little Red Riding Hood* (1937) and *Puss in Boots* (1938).

6 Borodin, "Kinostudiia."

7 At the present, tracking the work of these women is complicated and too large an undertaking for our current project.

the Soviet Ministry of Cinematography in 1948 to accelerate this unification, attesting to the importance of animation. In addition, the Communist Party's Ideological Committee set forth two important goals in the late 1940s: attain international recognition and form a link between the art inspired by Western prototypes and Russian national heritage.[8] Animation turned to Russian literature, folklore, and representational art as a way of interpreting Russian cultural heritage and translating it into the language of Soviet ideology and culture.

Children's animated films during the 1940s and 1950s often focused on a more national approach, including values that were ideological, but also humanistic. According to Birgit Beumers in her article "Comforting Creatures in Soviet Cartoons," children's animation and specifically animated fairy-tales were ideologically subversive because they reinstituted the moral value system that the Soviet state had previously replaced with little-meaning propaganda slogans.[9] We believe, as Beumer suggests, that animated fairy-tales directed by women are certainly worthly of scholarship, not only due to their moral value system, but also the way in which these tales allowed women to express their subjectivity and further a feminine aesthetic.

The Art Council and Censorship

In addition to the imposed emphasis on national heritage and Russian literature, Soviet animators also experienced new types of censorship after the war. In the 1940s the Ministry of Cinematography began to regulate the footage of animated films, increasing their control over the approval of scripts and the production of films.[10] Hence, animators had less control over both the length and the content of their films. The Art Council was founded in 1946 under the guidance of the Ministry of Cinematography and tasked with censorship oversight. The Art Council was initially a collective of ten eminent figures from animation, filmmaking, and theater, as well as select composers, artists, teachers, journalists, and representatives

8 Ivanov-Vano cited these goals in his monograph *Sovetskoe mul'tiplikatsionnoe kino* (Moscow: Znanie, 1962), 44–47.
9 Beumers "Comforting Creatures," 161.
10 Borodin, "Kinostudiia."

of the Komsomol Central Committee.[11] The chairman of the Art Council was also the appointed director of Soiuzmultfilm, and his deputy (since the 1960s) was the Editor in Chief. The first chairman of the Art Council was Aleksandr Ptushko, the famous puppet animator. The Art Council solidified the connection between the arts and censorship, and directly impacted the creativity of artists in all fields at Soiuzmultfilm.

The Brumberg sisters became all too familiar with censorship under the Art Council, while following the mandate to connect animated films to national content. Some of their most notable animated classics from this period include Nikolai Gogol's *The Lost Letter* (*Propavshaia gramota*, 1945) and *The Night Before Christmas* (*Noch pered Rozhdestvom*, 1951). The Brumbergs bring Gogol's tales to life by applying one of the most important attributes of animated film to his work—the interweaving of the real world with the fantastical, which becomes a hallmark of their animation. The Brumbergs' *The Lost Letter* was the first full-length feature film made at Soiuzmultfilm. According to Zinaida Brumberg, both the length and the choice of Gogol were risky, "but the interweaving of the fantastic with the everyday, the humor and the poetry we felt was very close to our art."[12] *The Lost Letter* certainly follows the mandate to draw from Russian national heritage, but the story depicts an animated descent into hell and is not your usual children's tale. The Brumbergs' film depicts the underworld and the deceitful ways of its inhabitants, using anthropomorphism and metamorphosis. The film was not well received; perhaps, the depictions of hell and the power of God were too realistic and too far from proscriptive Soviet ideology. Following the film, the Art Council decided that Soviet animators should refrain from making full-length films and should concentrate on shorter animations, limiting animators to one-reel films, about twenty minutes long.

Do We Need a Soviet Disney?

Under the guidance of Soiuzmultfilm in these years many animators turned to producing an ever-growing number of shorts and features in the Disney

11 By the early 1960s it had grown to thirty members and remained so in the 1970s and 1980s.

12 Irina Margolina and Mark Liakhovetskii, dirs., *Kollektsiia Animatsiia ot A do Ia*, episode 47: "Brumberg, Valentina i Zinaida" (Moscow: Ren TV, 1996).

style.[13] However, Disney's hold over Soviet animation began to wane after the war, and a new struggle against Disney realism and the direct borrowing of techniques from the Disney corporation began to emerge. For example, in 1947, Sergei Eisenstein commented, "Our animators use Disney's style. Meanwhile, in the images of our animals and in the tracing style of our sketches we can follow our own Russian animal folklore and epic."[14] In suggesting that Soviet animators dedicate themselves to Russian culture, Eisenstein recognized an essential feature of Soviet animation, the intent to make Russian fairy-tales both a literary and a visual core of animated films.[15] He also emphasized the need for Soviet animators to distance themselves from Disney's appealing style in spite of their shared interest in the fairy-tale as a genre. For Eisenstein, Soviet animators were obligated to find their own artistic language to translate Russian fairy-tales and literature for the screen.

Animators responded to this nationalistic call by focusing on traditional values inherent in Russian cultural heritage and emphasizing the growing patriotic spirit that began in the 1930s but continued after the war. The trend towards incorporating fairy-tales in animation coincided with the Soviet government's decision to export more animated films.[16] The post-war invasion of Eastern European countries and the bombardment of the Eastern Bloc with Soviet propaganda, as well as the increasing cultural competition with the West on the Cold War's global stage were critical factors behind this reorientation towards a broader international audience. The competition on a worldwide scale also challenged Soviet animators to perfect their technical competence and outshine American and European studios with their amazing fairy-tales.

Another reason that most animators during the 1940s and early 1950s were in favor of the fantastic worlds of fairy-tales, simply put, is that fairy-tales allowed them to avoid the reality of the difficult Stalinist years and socialist realism. Pontieri suggests that, just like works of Disney that target both children and adults, socialist fairy-tales also provided a

13 While the Art Council limited animators to one reel, there were exceptions. A few features were made during these years, for example, Ivanov-Vano's *Little Humpbacked Horse* (*Konek-gorbunok*, 1947), which runs fifty-seven minutes.
14 Sergei Eizenshtein, "Iskusstvo," in *Izbrannye proizvedeniia v shesti tomakh*, vol. 3 (Moscow: Iskusstvo, 1964), 500.
15 Mjolsness, "Under the Hypnosis of Disney," 109.
16 Ibid., 407–408.

diversion for adults who wanted an escape in the form of a story during these years.[17] Animated films based on Russian literary classics also offered such a diversion. The connection to escapism is also supported by MacFadyen's phenomenological idea that all Soviet animation from the 1930s to the 1990s is fundamentally "emotional" and not propagandistic as might be expected.[18] The escapist nature of the fairy-tale also offered respite from the realities of everyday life and the drudgery of the domestic space for female animators.

The Woman Question in the 1940s and 1950s

Discussions of the woman question from the 1930s through the 1950s were sparse, because it was argued that women had been emancipated in the 1920s. Scholar Vera Bilshai's comment from 1956 that, "The solution to the woman question occupies one of the top places among the great achievements of Soviet Socialist construction," attests to the assumption that the woman question was resolved during Stalin's regime[19] Nevertheless, many of the early advancements in women's rights were lost due to the emphasis on the nuclear family which resulted in bans on abortion and stricter divorce laws. Women's lives were more challenging while Stalin was in power.

Historian Mary Buckley argues that the restrictions on women were further complicated by the requirement for internal passports, labor books, and labor discipline; all part of Stalin's efforts to tighten control of Soviet society and force rapid industrialization.[20] While the Soviet Union had its largest increase of female labor during the period of forced industrialization in the 1930s, and World War II did bring more than three million previously non-wage earning women into the workforce, these gains did not bring Soviet women the same types of opportunities as women had in other countries where female employment was low.[21] Instead, the Slavicist Olga Voronina argues that women were forced into employment outside the house during these years and hence took on the low-prestige

17 Pontieri, *Soviet Animation*, 49.
18 MacFadyen, *Yellow Crocodiles*, 8–27.
19 Vera Bil'shai, *Reshenie zhenskogo voprosa v SSSR* (Moscow: Gospolitizdat, 1956), 3.
20 Mary Buckley, "Soviet Interpretation of the Woman Question," in *Soviet Sisterhood*, ed. B. Holland (London: Fourth Estate, 1985) 38–40.
21 Sheila Fitzpatrick, "War and Society in Soviet Context: Soviet Labor before, during, and after World War II," *International Labor and Working-Class History* 35 (1989): 37–52, http://www.jstor.org/stable/27671803.

and low-paid work which men avoided. Since no cultural policy existed to combat sexism or discrimination against women, the patriarchal ideology that held women as second-class citizens did not disappear.[22] The result was that women were pushed to the background, kept in menial jobs, and deprived of opportunities to make substantial changes in their lives. In the animation industry, women also experienced a lean time during the 1940s and 1950s. Rather than hiring more women to fill the positions left vacant by men serving during the war, the animation industry got smaller and produced fewer films. Those women that were working during and after the war pushed themselves to expand the aesthetic and thematic goals of Soviet animation, thus leaving their mark on the animation industry by pushing beyond Disney, privileging anthropomorphism, and a sense of "Russianness" as a way to express their uniquely Soviet female subjectivity.

The Wartime Creations of the Brumberg Sisters

Of all the female animators discussed in this book, the Brumberg sisters have had the most extensive and prolific careers. This enables scholars to look at the various subjectivities they created in their films. Katz, for instance, suggests that the Brumberg sisters frequently used ethnic characters to represent Jewish subjectivity through exploitation, migration, and acculturation of Jews, and in this way they recreated the mystical Old World and the Jewish conception of "olden times" in their films.[23] While this assessment of the Brumbergs' films is insightful, it is only one of the subjectivities present in their films. Manifestations of Soviet female subjectivity also become apparent over the course of their careers. Katz identifies one overlapping area in terms of women's labor and Jewish studies: the Brumberg sisters formed their directors' collective outside the usual channels at Soiuzmultfilm. In this way, the Brumberg sisters provided work for many Jewish actors and playwrights at a time when it was very difficult for them to find employment.[24] While the Brumbergs did not go out of their

22 Ol'ga Voronina, "Mythology of Women's Emancipation in the USSR as the Foundation for a Policy in Discrimination," in *Women in Russia: A New Era in Russian Feminism,* ed. Anastasia Posadskaya (London: Verso, 1994), 46–47.

23 See Katz's discussion of the Brumberg sisters as Jewish animators, *Drawing the Iron Curtain,* 75–95.

24 Ibid., 88–89.

way to hire women in the same way they hired Jewish artists, the fact that these women were able to accomplish such a feat during the Stalinist era attests to their strong leadership skills as well as the fact that they were in demand as animators.

During World War II, while evacuated in Samarkand, the sisters worked on Aleksandr Pushkin's *The Tale of Tsar Saltan* (*Skazka o tsare Saltane*, 1943). Following the trends in animation that focused on Disney-like realism of movement, the Brumberg sisters used rotoscoping, in which actors were filmed and the film was used as a guide for animators to create smooth, realistic movement for the animated characters.[25] Utilizing the rotoscoping effect in *The Tale of Tsar Saltan*, the Brumbergs were following the mandate of the Communist Party's Ideological Committee both to connect animated films to national content and to attain international recognition by imitating Western animated fairy-tales.

Pushkin's *The Tale of Tsar Saltan*, originally published in 1831, seemed an obvious choice for an animated film during the war. A classic of Russian literature, the poem avoided realities of Soviet life and had the potential to appeal to international audiences. Pushkin wrote his fairy-tales after the failed Decembrist Revolt to overthrow Tsar Nicholas I in 1825. The Tsar exiled Pushkin for his controversial poems but eventually allowed the poet to return, feeling Pushkin had reformed his revolutionary attitude. However, when the political context of Pushkin's time is considered, the fairy-tales themselves demonstrate only that Pushkin learned to be more discreet in his political views.

In the tale, the Tsar weds the youngest of three sisters causing jealousy among her family members. The young Tsarina gives birth to little prince Gvidon while the Tsar is off to war. The Tsarina's mother and sisters hatch an evil plot which ends with the Tsarina and the baby sealed in a barrel and cast into the sea to drown. Through several magical interventions, the Tsarina and prince are not killed. Rather, he grows to manhood, builds a kingdom, reunites his mother and father, and falls in love with a swan who becomes a beautiful princess.[26]

25 Sergei Kapkov, "Valentina i Zinaida Brumberg," in *Nashi mul'tfil'my: litsa, kadry, eskizy, geroi, vospominaniia, interv'iu, stat'i, esse*, ed. M. Margolina and N. Lozinskaia (Moscow: Interros, 2006), 28–33.

26 One possible reading of this tale is as political satire regarding an ineffectual and gullible tsar.

Fig. 7. *The Tale of Tsar Saltan* (*Skazka o tsare Saltane*, 1943), courtesy of Soiuzmultfilm.

Fig. 8. *The Tale of Tsar Saltan* (*Skazka o tsare Saltane*, 1943), courtesy of Soiuzmultfilm.

As noted earlier, in Brumberg films from the 1920s, like the *Samoed Boy*, the Brumbergs often emphasize the relationship between mother and child. The mother-child bond is also heavily accentuated and contrasted in *The Tale of Tsar Saltan*. The film portrays two types of mother-child bond: one founded in greed and jealousy (the Tsarina's mother and sisters) and one that is pure of heart and nurturing (the Tsarina and Prince Gvidon). The negative mother-child bond is enacted by the woman known in Pushkin's poem as "baba babarikha," who is aptly described by Louis Zellikoff's translation as "mother, sly deceiver."[27] She fills the frame and is masculine in her drawing, cold, domineering, and dark. She is behind the attempt to destroy the Tsarina and her son and urges the sisters to lie in an effort to keep the Tsar under her control. The Tsarina is the opposite of her mother. She is light and diminutive, feminine in her drawing, and devoted in her service to the country (her desire to produce an heir), her husband, and her child, whom she protects with her life. The film clearly establishes her mother-child bond as the desirable one with several touching moments that are drawn out visually. For example, when the boyars enter the nursery, the toddler Prince runs to his mother's lap for protection; and when sentenced to death by sea, the Tsarina embraces her child, protects him, and holds onto him for dear life (see Fig. 7). The magic of a mother's loving embrace, combined with the magic of the fairy-tale, saves Prince Gvidon and facilitates his growth into a young man within the barrel.

Pushkin's tale also contains a transformative Swan Princess, who performs astounding miracles.[28] She creates a magnificent city, a squirrel who cracks nuts of gold with gem centers, an army of bogatyrs from the sea. She also transforms the Prince into a mosquito, a fly, and a wasp, in order to bring about an everyday miracle—the reuniting of a sundered family unit and the creation of a new family unit. The plot of Pushkin's tale easily complements the Stalinist anti-independent women agenda which placed its focus on family and emphasized motherhood and wifehood as goals for women. The visual components of the Brumbergs' interpretation of the tale challenge this agenda.

The women in the tale are also central to the usage of anthropomorphism and metamorphosis, visually setting the animation apart from Pushkin's famous tale. The Brumberg sisters do not utilize anthropomorphism in

27 See Pushkin, "Skazka o tsare Saltane, o syne ego slavnom i moguchem bogatyre knyaze Gvidone Saltanoviche i o prekrasnoi tsarevne lebedi," in *Izbrannye Proizvedeniia*, vol. 1 (Moscow: Khudozhestvennia literatura, 1968), 223. See also Pushkin, *The Tale of Tsar Saltan*, trans. Louis Zellikoff (Moscow: Progress Publishers, 1978)

28 Maria Mikolchak, "Misogyny in Alexander Pushkin," in *Misogynism in Literature*, ed. Britta Zangen (Frankfurt: Peter Lang, 2004), 99–110.

scenes related to life before Gvidon and his mother are sentenced to death. Those scenes are grounded in a sort of realism, devoid of the fantastical, and devoid of magic. The first instance of metamorphosis and magic takes place in the barrel when, protected by his mother's love, Gvidon transforms from a toddler into a grown man. Later, it is through the Swan Princess's power that Gvidon is transformed into various insects and then back again into human form so he can travel to his father's land. The anthropomorphism in the film is connected to magic and is used to define the Swan Princess's power. The Princess occupies a liminal space between animal and human: she is a swan, yet she is wise, she talks, bats her long eyelashes, and acts like a human. She also has the most spectacular metamorphic transformation, lasting a full twenty seconds, as she transforms from the swan into the princess; a process which includes fireworks, stars, and shimmering lights. The closing scene of the Princess, all in white with a gown reminiscent of her swan shape, yet dancing with her arms stretched out and close-ups of her face, leaves the viewer with a sense of a powerful woman, who has orchestrated changes in her life and the lives of others, and speaks to the metamorphosis of women, from young girl to woman and eventually to mother (see Fig. 8). The anthropomorphism in this film is attributed to the most powerful female in the film and her own final transformation is the most stunning visually. This power of transformation is the power all women hold. It is also an acknowledgement of the power the Brumberg sisters had managed to accumulate as directors at Soiuzmultfilm and their ability to transform the lives of younger animators and artists.[29]

The Brumberg Sisters after the War

After World War II Soviet animation began to explore new stylistic directions and innovative content, despite the increased pressure from the Communist party to clearly illustrate Communist ideology in animated films. The Brumberg sisters decisively filled this demand and expanded their vision as artists with the film *Fedia Zaitsev* (1948). The Brumbergs stepped away from the safety of Russian fairy-tales and literary adaptations and turned their attention to contemporary Russian life—the very topic that animators avoided because of the bleak reality of life in the Stalinist

29 Katz argues that the Brumberg sisters' films and specifically *Fedia Zaitsev* were a rehabilitation project for the waning Moscow theater world and also for waning Jewish actors and actresses. The Brumberg sisters gave struggling intellectuals of the MAT, the Moscow Arts Theater, a place to work. See Katz, *Drawing the Iron Curtain*, 75–95.

era and the restrictions of socialist realism. *Fedia Zaitsev* highlights one of the most important attributes of animated film—the ability to interweave the real world with the fantastic. This is the same quality that attracted the Brumbergs to the fairy-tales of Gogol, Pushkin, and other authors.

Fig. 9. *Fedia Zaitsev* (1948), courtesy of Soiuzmultfilm.

The stick-figure Little Man in *Fedia Zaitsev* is the antithesis to Disney-style realism and the height of the Brumbergs' aesthetic style (see Fig. 9). The Little Man not only inspired other animators to begin to break away from the Disney aesthetic, he also became the symbol trademark for Soiuzmutlfilm and was used as an identifying logo on each film.[30] *Fedia Zaitsev* is also a key example of how the Artist Council and directors vied for creative control during the production process. The plot of *Fedia Zaitsev* was planned to be even more controversial and anti-Western, extending beyond its challenge to Disney aesthetic. The original script, written by Mikhail Volpin and Nikolai Erdman, called for a feature-length film and included a plot about Fedia's journey to the Kingdom of Lies, a capitalistic

30 This became the eighth logo for Soiuzmultfilm and was used in 1967–1974. "Soiuzmultfilm—Russia," CLG Wiki, The Motion Graphics Museum, accessed August 12, 2018, http://www.closinglogos.com/page/Soyuzmultfilm+(Russia).

Western fairy-tale kingdom, where Fedia must be rescued by Little Man.[31] The Kingdom of Lies is also clearly an imaginary world, in great contrast to the realistic world of Moscow depicted in the first part of the script.

The Brumbergs repeatedly attempted to circumvent the Artist Council's censorship of this film. For instance, the original script was split into two parts in response to the Art Council's decision to support only non-feature length animated films.[32] The Brumbergs also received permission directly from the Ministry of Cinematography to complete their feature in an attempt to bypass the Art Council.[33] Regardless of the promise of approval, the Brumbergs were denied permission to film the second part based on the inability to reeducate Fedia in a convincing way. The Art Council also denied the second part due to the depiction of the Kingdom of Lies alongside modern Moscow and the portrayal of capitalists that did not correspond to Soviet ideology.[34]. In the end, the Art Council censored the Brumberg's film and only one part was made.[35] The process behind the film highlights some of the problems that animators had when attempting to make animated films about contemporary reality, instead of fairy-tales.

The final version of *Fedia Zaitzev* does not contain feminist forward content, it illustrates how the Brumbergs as powerful women directors continually pushed the boundaries of acceptable themes, political messages, and aesthetic styles, and tested the acceptable limits of animation and imagination. With this film, the Brumberg sisters critically reoriented the animation industry and provided a framework for the everyday enactment of a Soviet feminist subjectivity that challenged structures of the male-dominated animation industry and demonstrated how women changed the trajectory of Soviet animation.

Who the Brumbergs were as women and animators became apparent in one of the few personal accounts of the sisters that emphasizes the ways

31 For a more detailed analysis of the original script see Georgii Borodin, "Nikolai Erdman i animatsiia," *Kinovedcheskie zapiski* 61 (2002), http://www.kinozapiski.ru/ru/article/sendvalues/687.

32 However, in practice, these restrictions on film length were not applied. At the time Soiuzmultfilm has a fairly wide range of metric standards—from one part to four, with the occasional release of full-length pictures (five parts or more).

33 Borodin, "Nikolai Erdman i animatsiia."

34 Ibid.

35 This article also explains the relationship of *Fedia Zaitsev* to the film *I Drew a Little Man* (*Chelovechka narisoval ia*), which was produced in 1960. See Borodin, "Nikolai Erdman i animatsiia."

in which their physical characteristics were mirrored in their directorial styles. Through comments made by Lana Azarkh, an animator who worked with the Brumbergs in 1950s–1970s, we are able to establish a connection between female subjectivity and their lived experiences as women, offering insight into how the sisters saw themselves as individuals, and as animation directors. Azarkh first met the Brumbergs at Soiuzmultfilm in the 1950s when they were already, in her opinion, advanced in age. With almost twenty years' experience in the industry, the Brumberg sisters were established and well-respected directors. Azarkh characterized the older sister Valentina as short, lively, easily excitable, with beautiful blue eyes and dyed hair (sometimes quite exotically). Zinaida, the younger sister, was taller, never bothered to dye her hair and sported unsophisticated bangs. Azarkh claims the sisters had the same physical build: high waist, sloping shoulders, with massive lower bodies and full legs. While Azarkh's comments center mostly on their physical appearance, she also comments on how their strong personalities influenced their directorial roles at the studio. Her recollection is important in understanding one of Valentina Brumberg's favorite quotes connected to her appearance: "A woman with thin legs does not have the right to exist."[36] Brumberg's quote, which was well known at the studio, gives the impression that her solid build was not only part of her strong identity or her personality; it also contributed to her confidence and her successes behind the screen.[37]

While the Brumbergs are often grouped together as if they were a cohesive working group, Azarkh's recollections also remind us that Valentina and Zinaida Brumberg were two separate directors, with opinions that did not always align. Azarkh often witnessed their differences of opinion at the studio, which resulted in unpleasant arguments because, as the sisters liked to say, "the mouth is full of words."[38] The sisters did not blindly agree with each other, but worked together to solve their creative differences. Azarkh believed that Zinaida was the more stubborn of the two, and that Valentina took great efforts to convince Zinaida to change her opinion. When they were in agreement, the union of these two sisters became a force to be reckoned with in Soviet animation. As a woman and as a fellow animator, Azarkh's comments are revealing about how women themselves regarded other women in the animation industry. Azarkh, for the most part, limited her comments and understanding of the Brumbergs to their physical appearances and their personalities, and not

36 See Azarkh, "Mul'tiplikatory," 138.
37 Ibid.
38 Ibid.

to their contributions to animation. It is hard to imagine a situation in which men would have been described in similar ways. This desire to delvalue the work done by women by focusing on appearances and personalities solidifies the complicated nature of female subjectivity in Soviet animation.

Olga Khodataeva in the 1950s

Khodataeva emerges as another powerful woman, who during the last years of the repressive Stalinist regime became a champion of the rare female-centered animated film. Khodataeva spent the early 1940s dedicating herself to the war effort, and as film production came back up to speed after the war, she dedicated herself to films featuring female characters. While her films in the 1950s do not have the same political fierceness and do not champion women's rights in the same way as her earlier films, they do showcase women as mothers and adventurers. Her films continue to have some similarities with the aesthetic of Disney realism, but they also push Soviet animation into new thematic and stylistic directions.

Both *Sarmiko* (*Sarmiko*, 1952) and *The Flame Burns in the Yaranga* (*V iarange gorit ogon*, 1956) are tender films about children from Northern Russia, which feature female heroes who struggle with proper behavior, but transform their ways. Working within the accepted conventions of the 1950s, Khodataeva made films for children inspired by fairy-tales but set in a contemporary world like many of the Brumbergs' films.[39] Her film *The Flame Burns in the Yaranga* won two international awards, meeting the mandate to reach a wider audience. In 1956 it won first place at the Eighth International Festival of Films for Children and Youth in Venice, Italy and in 1957 it won a gold medal at the International Film Festival under the auspices of the Sixth World Festival of Youth and Students in Moscow.[40]

The script for *The Flame Burns in the Yaranga* was written by Zhanna Vitenzon, which she based on the folktales of the peoples of the North. At the time, Vitenzon was a student at Moscow State University, and she was fascinated by the North, where she often went on folklore expeditions. *The Flame Burns in the Yaranga* was her first film script, but Vitenzon went on to work at Soiuzmultfilm as a screenwriter until 1990. She also wrote

39 Khodataeva's films were subject to the 1950s state policy which restricted the length of animated films to approximately twenty minutes.

40 "*V iarange gorit ogon*," accessed November 23, 2018, http://animator.ru/db/?p=show_film&fid=3071.

children's literature. The plot of *The Flame Burns in the Yaranga* highlights the mother-child relationship between a widow and her children, a son and a daughter, Iatto and Teiune. In the beginning of the film, her children are self-absorbed, lazy, and disobedient; Iatto refuses to help his mother collect firewood and Teiune is more concerned with protecting her hands and admiring her long beautiful braids. Because their mother was not able to collect enough firewood on her own, the fire gets low, and an ember escapes and burns a hole in the snow veil of Purga, an evil personification of winter. In retribution, Purga turns the mother into a bird and carries her away. The children are forced to cast off their laziness and go in search of their mother. Through their bravery, perseverance, and sacrifice they are able to save their mother: Iatto uses his bow and arrows to help them along in their journey and Teiune cuts her beautiful braids in order to extend a rope to make the final climb to Purga's ice castle. While the script may have been based on a northern folktale, the reeducation of the children into contributing members of the family unit fits the general model of socialist realism.

Fig. 10. *The Flame Burns in the Yaranga* (*V iarange gorit ogon*, 1956), courtesy of Soiuzmultfilm.

Life in the far North of the Soviet Union was very different from other regions; the average Russian knew very little about the character of northern

people, their customs, or their "exotic" way of life. However, as folklorists began to collect and to publish folklore and music from the provinces in the 1950s, many screenplays were written based on these collections. Leonid Aristov, the art director for the film, spent time in the Lenin Library in Moscow researching materials for this film and loosely based his designs on the Chukchi reindeer herders, who are the indigenous people inhabiting the Chukchi Peninsula on the shores of the Bering Sea near the Arctic Ocean.[41] Khodataeva's film is a more positive portrayal of the Northern people and their beliefs than the *Samoed Boy* released eighteen years earlier.

At first glance Khodataeva's film employs many of the features of Disneyesque realism. For example, in the opening scene the children's shadows jump lively with every move the children make in front of the fire, which is reminiscent of the naturalistic details employed by Disney. Additionally, the shape and curves of the fawn, who is reunited with his mother, are rendered in a manner strikingly similar to Disney's *Bambi* (1941), although the color palette is not as diverse.[42] However, the film, which was grounded in archival research, utilizes realistic aspects of Chukchi life such as the *yaranga*, a cone-shaped or rounded reindeer-hide tent. The characters in the film are also dressed in traditional Chukchi clothing such as knee-length coveralls, made from reindeer hide and trimmed with fur, and robe-like dresses of fawn skins beautifully decorated with stripes of embroidery (see Fig. 10).[43]

Verisimilitude to traditional Chukchi life is also manifest in Khodataeva's use of anthropomorphism and metamorphosis, which again is connected to shamanism: the Chukchi religious practices and beliefs that all animals, plants, rivers, forests, and other natural phenomena are considered to have their own spirits.[44] The white witch Purga is the personification of winter, drawn in blues and whites; she appears and disappears when the snow is blown over the landscape as she travels on white skis, accompanied by three white wolves. Day also appears as a red man, who guides the sun across the sky on a sled pulled by

41 Sergei Kapkov and Leonid Aristov, "Kinematografom ia zarazilsia, kak infektsiei," *Gazeta* 16 (August 16, 2004), http://www.animator.ru/articles/article.phtml?id=50.

42 This may be due in part to shortages after the war, but stylistically it helps to reinforce the foreignness and coldness of the location.

43 Virginie Vaté, "Maintaining Cohesion through Rituals: Chukchi Herders and Hunters, a People of the Siberian Arctic," *Senri Ethnological Studies* 69 (2005): 45–68.

44 Nadezhda I. Vukvukai, "Chukchi Traditional Clothing as Historical Source of Cultural Transformation," *Études/Inuit/Studies* 31, no. 1/2 (2007): 311–315.

bright white reindeer. While the sun itself does not transform, he gifts the children magic arrows that they need to defeat Purga and save their mother. However, the most interesting metamorphosis takes place when the mother, attempting to protect her children, is transformed by Purga into a white glaucous gull, indigenous to the Bering Sea region. As a gull, the mother continues to protect her children, but is eventually swept up in the snow flurries as Purga flees with her. This transformation from mother to bird and back to mother not only employs the Chukchi belief that natural phenomena have their own spirits, but also demonstrates a mother's power to protect her young. While Khodataeva depicts women and girls in more traditional roles, she emphasizes their bravery and enhances it with metamorphosis.

Khodataeva ran into difficulties with the Art Council regarding the representation of women in this film. The Art Council had no problem with Purga, the female villain, who splits families apart, both animal and human. However, it had difficulties with the representation of the mother and how that framed her relationship with her children. The Art Council took issue specifically with the words for the song, written by Mikhail Svetlov, that the mother sings to her children. The film opens with the mother singing as she performs household chores and wakes her children. The song reoccurs when the children are in danger trying to rescue their mother. When the mother hears Purga is sending Drema, a sleep-inducing henchman to put her children to sleep in the snow storm, she calls upon a nearby bird, teaching it a special song which will wake her children. Having been recently transformed into a gull, the mother is able to speak with the bird, and with the song, she transfers the power of a mother's love to the bird. The bird sings to the children, "Let young blood never get cold, even in the terrible hour of danger. Let bravery never leave you. And your heart will not falter." According to the Art Council, the song sounded too much like a religious hymn.[45] Mikhail Svetlov defended his song, and in the end, the Art Council approved it, but reluctantly.[46] The song helps to establish that the bond between a mother and her children is stronger than sleep, the darkness of night, and the winter cold. As the words in the song imply, the women in this film are brave and adventurous, but they put family and love first. Traditional motherhood is a central theme in this animated film, but the

45 Kapkov and Aristov, "Kinematografom ia zarazilsia."
46 Ibid.

reliance on Chukchi beliefs and the transformational power of a mother's love, combined with the adventure story plot, which includes the daughter making a heroic sacrifice, makes this film a powerful female-centric film.

Khodataeva's directorial presence and the manifestations of femininity in her films were, in fact, quite different from the Brumberg sisters, providing viewers with additional notions of Soviet female subjectivity. While all three women were strong, confident directors, according to Azarkh, Khodataeva brought exotic and adventurous settings to Soiuzmultfilm, not only in her films, but also in the way she dressed and ran her animation collective.[47] Azarkh comments that Khodataeva was an extraordinary force, who wore homemade robes with shell necklaces. She adds that Khodataeva's animation collective was known as a "special country," marking its difference from the Brumbergs, but also noting the exotic and adventurous flavor that her films and her presence brought to the studio. Khodataeva's predilection towards the exotic, whether in her everyday life or in her approach to animated films, distinguished her work not only from the prevalent Disney aesthetic, but also from other women animators at Soiuzmultfilm.

Aleksandra Snezhko-Blotskaia in the 1950s

Another renowned female animator, Snezhko-Blotskaia, began her career at Mosfilm in 1934, working alongside the Brumbergs and other animators. Like the Brumbergs, Snezhko-Blotskaia worked her way up from animation artist to director, directing more than twenty films during her career at Soiuzmultfilm. However, unlike the Brumbergs, who managed to begin directing their own films early in their careers, Snezhko-Blotskaia worked for two decades under Ivanov-Vano. Snezhko-Blotskaia, whose career was perhaps hindered by the fact that she was married and had a daughter, exemplifies how the repressive Stalinist regime hindered women's success and achievements within the animation industry.

Snezhko-Blotskaia's daughter, Siuzanna Bogdanova, notes that while attending school, her mother worked in a library and learned to love fairy-tales.[48] Snezhko-Blotskaia entered the animation industry after she studied painting at the the Moscow Architectural Institute in the studio of Ivan Rerberg. She began working in animation at Mezpabpomfilm as

47 Azarkh, "Mul'tiplikatory," 138.
48 Siuzanna Bogdanova chronicles her mother's career. For her own words see Bogdanova, "Ocherki o zhizni i tvorchestve," 207–212.

an assistant animator to Vladimir Suteev and Dmitrii Babichenko, then in 1936 she began working at Soiuzmultfilm under Ivanov-Vano and later became his co-director. Bogdanova states that her mother was content to work with Ivanov-Vano for all those years, to have her name always appear below Ivanov-Vano in the credits.[49] While Bogdanova claims that Snezhko-Blotskaia was satisfied with her lesser role, Azarkh suggests a different scenario. Azarkh remembers Snezhko-Blotskaia as a strong capable director, who did not have the title she deserved.[50] Azarkh argues that Ivanov-Vano was the only animator allowed to hold two positions, one a VGIK as a professor and one at Soiuzmultfilm, because Snezhko-Blotskaia was second in charge and had control of his films. Azarkh also remarks that Snezhko-Blotskaia was intelligent, talented, and politically uncommitted, which is also insightful in regards to her adaptation of the political children's tale *The Military Secret* (*Voennaia taina*, 1935) by Arkadii Gaidar, which became her *Tale of the Boy-Kibalchish* (*Skazka o Malchishe-kibalchishe*, 1958). One of Azarkh's most revelatory observations about Snezhko-Blotskaia is that the director needed a lot of courage to defend her right to work independently and break away from her male colleagues.[51] While veiled as a statement about Snezhko-Blotskaia's personality, this comment also corroborates the difficulty in advancing that most women in the animation industry experienced.

In 1956 Snezhko-Blotskaia became a director in her own right, forming her own animation collective. Many of the films directed by Snezhko-Blotskaia were international in nature and were based on fairy-tales from all over the world: Russian, Lithuanian, Burmese, Chukchi, and Kazakh. Like her predecessors, Snezhko-Blotskaia's films continue to have some similarities with the aesthetic of Disney realism, but her films also advance new thematic and stylistic directions as was common for women in these years. For the most part, Snezhko-Blotskaia was interested in stories that only loosely followed the requirements of socialist realism.

That said, one of her most successful films, and one that was most socialist realist in nature was the *Tale of the Boy-Kibalchish*. Gaidar wrote the story to prepare young Communist readers for the grave trials ahead, as they fought against the bourgeois. Snezhko-Blotskaia worked on the

49 Bogdanova, "Ocherki o zhizni i tvorchestve," 211–212.
50 Azarkh, "Mul'tiplikatory," 139.
51 Ibid.

script for the film with Gaidar's widow, Liia Solomianskaia.[52] In this story, the peaceful Soviet motherland is subjected to a sneak attack by bourgeois forces and as Soviet fathers and older brothers are injured and killed, little children want to join the battle in order to save the Soviet Union. Snezhko-Blotskaia was literally exhausted from the onslaught of Liia Solomianskaia, who was trying to ensure that every word out of Gaidar's story was in the script, but Snezhko-Blotskaia held true to her own aesthetic goals.[53]

Fig. 11. *Tale of the Boy-Kibalchish* (*Skazka o Malchishe-kibalchishe*, 1958), courtesy of Soiuzmultfilm.

In *Tale of the Boy-Kibalchish* Snezhko-Blotskaia resurrected the avant-garde style, inspired by agitational posters that had previously been considered too experimental.[54] The main character, dressed in a red shirt and a white budenovka hat with a red star—a distinctive type of Communist military hat from the Russian Civil War (1917–1922)—is visually reminiscent of Dmitrii Moor's agitational poster asking people to volunteer for the Red Army in 1920. The Head Bourgeois behind the war, as the most hideous villain is called, reminds viewers of Maiakovskii's Okna ROSTA from 1921—his head is a flat round circle dominated by a toothy mouth and large round eyes, topped with a top hat (see Fig. 11). The film also draws inspiration from

52 Ibid.
53 Ibid.
54 Snezhko-Blotskaia's resurrection of the avant-garde style is due in part to the death of Stalin in 1953 and the beginning of the Thaw era. See the discussion about Stalin's death and the response in the cinema and animation industry in chapter 5.

the incongruous colors, line drawing, and lack of perspective, which was frequently used by Russian avant-garde artists (see Fig. 12).

Fig. 12. *Tale of the Boy-Kibalchish* (*Skazka o Malchishe-kibalchishe*, 1958), courtesy of Soiuzmultfilm.

Borrowing the avant-garde poster aesthetics of the 1920s, Snezhko-Blotskaia made the connection between her film, set during World War II, and Gaidar's tale, which was published after the Civil War. Both stress the importance of the ongoing battle against bourgeois mentality. In Snezhko-Blotskaia's film, the war is fought at the behest of the Head Bourgeois, described above and also reminiscent of Vertov's NEPman from *Soviet Toys*, who sits on the throne of capitalism, surrounded by the bags of money he reaps during the war, and at his beck and call are three Generals, representing Germany, Italy, and Japan. The film rather boldly states that capitalist greed was behind the war, but also warns that greed and the bourgeois disregard for life can be found at home, in the form of the fat little boy, whose shape and demeanor mirror the Head Bourgeois. The fat boy is set up as the antithesis of Boy-Kibalchish and his friends. While Boy-Kibalchish and the other children in town pretend to defend their motherland, the fat child is stealing fruit from other children, bending fruit-laden tree branches so he can have more fruit than the other children, and throwing sticks at helpless birds just for sport.[55] Boy-Kibalchish, demonstrating proper behaviour for good Soviet children, shares his apple with the child who lost his apple

55 This apple scene in the film is reminiscent of a part of another famous Gaidar story for children, *Timur and his Squad* (*Timur i ego komanda*, 1940).

to the fat boy. Boy-Kibalchish and a little girl also help the bird that was injured, and he tries to mend the broken branch. The obedient children also sing a rousing song that sticks in your head, as they go off to battle.[56] More importantly, Boy-Kibalchish and his friends are prepared and ready to fight, when they are called upon to do so, even if it means the loss of their life, which is the ultimate sacrifice that Boy-Kibalchish makes to ensure the protection of the Soviet Union.

Snezhko-Blotskaia, in this way, harnesses a very socialist realist tale, and reimagines it in an artistic style forbidden at Soiuzmultfilm since the 1930s. While the film lacks any sort of mother figure, and features mostly male characters, there is a girl who helps to take care of the injured bird. Later, when the children are called upon to fight, she grabs her medical kit and marches alongside Boy-Kibalchish. The film was not groundbreaking in terms of forward-thinking female representation, but it stands as an example of bold stylistic innovation made by a woman not long after the death of Stalin in the mid 1950s. This film also reinforces the idea that when society at large emphasized more traditional roles for women, female directors often pursued other directions to express themselves, including stylistic developments. *Tale of the Boy-Kibalchish* illustrates that Soviet female subjectivity should not only be linked with female representation and feminine aesthetics, but instead must be evaluated in terms of all the contributions that women made to the animation industry and how those contributions opened doors for women animators in subsequent years.

56 The song is like Disney's "Who's Afraid of the Big Bad Wolf," from *The Three Little Pigs* (1933), which sticks in your head long after the film has ended.

Chapter 5

Reshaping Women's Roles on and off the Screen: Animation during Khrushchev and Brezhnev

Stalin's death in 1953 marks the beginning of the Thaw under Nikita Khrushchev, which signaled a slow and uneven liberalization of the arts including animation. This liberalization and subsequent relaxation of censorship did not appear as quickly in cinema production as it did in literature, due to the time required to create a film.[1] For this reason, innovations in animation became more common in the 1960s and 1970s, hence, this chapter covers both Khrushchev's Thaw and the period referred to as Leonid Brezhnev's Stagnation.

After Stalin's death, Khrushchev began a process of de-Stalinization, that is, rolling back some of the more repressive regulations and eliminating Stalin's cult of personality. What this meant for artists, writers, and filmmakers was not entirely clear and the result was often contradictory behavior by authorities, who vacillated between increased freedom and harsher controls.[2] Khrushchev, who was fairly conservative in matters of culture, did not fully liberate cinema

1 Alexander Prokhorov, "The Cinema of the Thaw, 1953–1967," in *The Russian Cinema Reader*, vol 2, ed. Rimgaila Salys (Boston: Academic Studies Press, 2013), 14.

2 Pontieri in *Soviet Animation*, 51–82, gives a detailed description of the various periods within the Thaw and their relation to the animation industry.

from dominant ideology, and thus neither filmmaking nor animation completely abandoned their traditional role of responding to official policies and social imperatives. Nevertheless, the result of Khrushchev's reforms was not only an unprecedented growth in film production, but also the development of a Soviet New Wave by filmmakers like Andrei Tarkovskii, Larisa Shepitko, Andrei Konchalovskii, and Kira Muratova. According to Prokhorov, their films "revived the avant-garde spirit of the 1920s and revolutionized the visual and narrative aspects of film art"; he also emphasizes that these art films "undermined the myth of a harmonious Soviet community . . . and [sic] gave vision and voice to the discourses of individuality, ethnicity, and femininity."[3] In other words, their films signaled a crack in the veneer of socialist realism and marked an openness to alternative ideologies. Like live-action directors, femininity and a particular type of Russian-Soviet feminism became more important to women in the animation industry during this time period.

After Khrushchev's dismissal in 1964 and Brezhnev's ascension to power, several of the reforms initiated by Khrushchev were revoked. During the early years of Brezhnev's era there were still signs of relaxation in the arts, but they waned as the country experienced a period of economic and social stagnation. As the economy failed to provide what people needed for a comfortable life, Soviet citizens became even more disillusioned with the promise of Communism. The disillusionment and cynicism made its way into the cinema and the animation industries which had not entirely lost all the liberal gains of the Khrushchev era. Animation transformed in these years both thematically and aesthetically, and female directors were key in the precipitation of these changes.

Soiuzmultfilm in 1960s and 1970s

Significant changes hit the animation industry in the 1960s and 1970s. Foremost among them was the loss of four great animators. Khodataeva retired from animation after the release of *The Golden Little Feather* (*Zolotoe pioryshko*, 1960), a Disney-styled fairy-tale which she co-directed with Leonid Aristov. Three other female animators released their last films in 1974, the Brumbergs with *From Each Pine Forest—One Little Pine Tree* (*S boru po sosenke*) and Snezhko-Blotskaia with her film *Prometheus* (*Prometei*). Their

3 Alexander Prokhorov, "The Unknown New Wave: Soviet Cinema of the 1960s," in *Springtime for Soviet Cinema: Re/Viewing the 1960s* (Pittsburgh: University of Pittsburgh, 2001), 7–10, 27.

films in the 1960s and 1970s contributed greatly to the formation of Soviet female subjectivity, but also influenced how new women directors depicted both female representation and feminine aesthetics in their films. The loss of their voices, their aesthetic stylings, and their contributions to the development of Soviet animation is not to be underestimated.

During these two decades there also erupted a fierce debate about the direction in which the Soviet animation industry should move. The Art Council discussed whether to pursue new directions or continue with fairy-tales for children, a much safer but less engaging option; whereas a new path meant the ability to reach adults and to address serious social issues.[4] Ultimately, they chose to pursue both options: animated films for children began to feature the contemporary world, while trying to emphasize a Communist future; and films for adults focused more on satire and attempted to expose adults to the humor of everyday reality.[5] While making films centered on contemporary social ills was still risky to one's career, it was no longer life-threatening as it had been under Stalin.

Pontieri suggests that animation during this time period, whether for adults or children, brought its audiences into contact with the sometimes harsh reality of the present and the often bleak possibilities for the future.[6] In live-action filmmaking there was more exploration of characters' psychology and more attention to women's dual burden—the combination of their professional and domestic roles—which provided psychological conflict in many films.[7] As a result, animation also turned inwards and became more introspective. More attention was placed on the "individual" inner world of characters, in opposition to a collective world that was so popular with socialist realism. As Beumers succinctly states: "in the 1960s–1970s

4 The Art Council was responsible for discussing scripts, storyboards, and completed films as a step of censorship. The Arts Council also worked with the Party Committee, the local body of the Communist party. For more specifics about the debate about fairy-tales at this time see RGALI, Stsenarnyi otdel, "Perepiska s avtorami o predlagaemykh zaiavkakh i literaturnykh stsenariiakh" (1958), 21, Moscow, Russian Federation.

5 The introduction of many contemporary subjects into animated films and the use of satire is discussed at length. See Pontieri, *Soviet Animation*, 55–57.

6 Ibid.

7 Attwood discusses women filmmakers like Larisa Shepitko and Kira Muratova who were celebrated directors in the 1970s. While these women are often described as transcending gender in their films, Atwood argues that their films are a classic study of the female situation. See Attwood and Turovskaia, *Red Women*, 82–84. See also Kaganovsky, "Ways of Seeing."

the collective has collapsed."[8] This move away from collective identity allowed filmmakers more range in the types of characters and situations they could create. Pontieri also argues that animation at this time had a tendency towards the poetic, which started prevailing over social criticism, and that towards the end of the 1960s animation developed a lyrical genre, an expression of the artist's vision.[9]

The focus on the individual, social criticism, and introspection made the 1960s and 1970s a perfect time to expound upon issues related to the woman question. Women's agency as a trope in animation was not only prevalent in the Soviet Union: this trend has been noted in the United States and Europe by Wells in *Understanding Animation.*[10] Soviet animation made by women certainly begins to depict women in less traditional ways and to explore the notion of a feminist sensibility. However, Soviet female subjectivity still differs from the more prevalent Western view and requires a subtle unpacking of the female formation of self and Soviet versions of femininity, as will be evidenced by our discussions of films made by female directors.

New thematic directions aimed at adults, exploring interior psychology and even femininity were not the only major changes at Soiuzmultfilm. The other significant change was the conscious abandonment of Disney style for more individualized aesthetics. The shift away from Disney aesthetics was made easier by cost- and time-saving techniques that became popular in the 1950s, such as cycling and limited animation.[11] Limited animation, combined with sparse backdrops, sharp angular lines, and a creative use of sound, became the antithesis of Disney's realistic style and full animation. The term limited animation is by no means negative; rather, it was an aesthetic choice characterized by limited movement, simple backgrounds, and emphasis on the narrative plot or dialogue. Pontieri asserts that the more relaxed atmosphere of the Thaw allowed Soviet artists more exposure to

8 Beumers, "Comforting Creatures," 154.

9 Pontieri makes this argument about the poetic in animation about the end of the 1960s. We suggest expanding the time frame for the poetic period when discussing women animators. See Pontieri, *Soviet Animation,* 169–170.

10 For a more complete and detailed description of the feminine aesthetic in animation see Wells, *Understanding Animation,* 198–201. See also our discussion in chapter 1.

11 Cycling is the reuse of an animated sequence, usually an action shot, for example there is cycling in the *The Tale of Tsar Saltan* when the Tsar and his men go off to war. Limited animation refers to the practice of reusing all or parts of the frame and only drawing key areas, like mouths and eyes. Disney, however, was known for using full animation, where each frame is completely redrawn.

modern designs forbidden under Stalin, which inspired Soviet animators in the 1960s to embrace this innovative trend.[12] For instance, when comparing the background scenery in Brumbergs' *Little Red Riding Hood* from 1937 to Snezhko-Blotskaia's 1958 *Tale of the Boy-Kibalchish* twenty-one years later, the shift away from the detailed, fuller animation to an aesthetically limited style becomes apparent and sets the stage for further explorations. While *Tale of the Boy-Kibalchish* is a socialist realist propaganda film, it is ground-breaking as a stylistic transition to the aesthetic upheaval that takes place in the 1960s and 1970s.

The Brumberg Sisters in the 1960s and 1970s

The innovations of women, such as the Brumberg sisters, led the way to this pioneering style of limited animation in the Soviet Union. The Brumbergs made a clear break from the Disney realist style with their film *Great Troubles* (*Bolshie nepriiatnosti*, 1961), which, despite having an animation style reminiscent of children's drawings, like the character Little Man in *Fedia Zaitsev,* and utilizing an innocent child narrator, was in fact, their first "fairy-tale" film made for an adult audience. This aesthetic shift from Disney-inspired art to a more experimental style influenced by children's drawings parallels an aspect of animation theory that Wells outlines, namely, that the further removed from recognizable reality a film becomes, the less likely it is to be judged seriously.[13] This allowed the Brumbergs to deliver biting criticism of the Soviet system, the Soviet family, and Soviet femininity, as well as a critique of traditional roles for women. This film offers a satirical look at contemporary life, but on a theme that was acceptable at the time—the pitfalls of both parents and children who have strayed from Communist ideals. Pontieri offers an astute reading of the film, noting the Brumbergs' innovative use of style, satire, and narrative self-reflexivity. She also notes that the animators managed to comment on contemporary society under the guise of innocence, connected to the naive drawings and child's understanding of jargon and language in the film.[14]

What is lacking in Pontieri's analysis is an exploration of how these aspects also contribute to a discussion of Soviet womanhood, especially when taken into consideration with the sequel *New Great Troubles* (*Novye*

12 For a detailed discussion of the Brumberg sisters' *Great Troubles* and Fiodor Khirtruk's *Story of a Crime,* see *Soviet Animation*, 78–119.

13 Paul Wells, *Animation and America* (New Brunswick, NJ: Rutgers University Press, 2002), 108.

14 Ibid., 85–99.

bolshie nepriiatnosti, 1973). The second film is not so much a sequel as a satirical reenvisioning of the Soviet social ills twelve years later. Both films animate childlike drawings and are told from the perspective of a child narrator. In the first film, the child narrator repeats seemingly nonsensical phrases (common idioms) she hears other people saying about her family. In the second film, our little narrator insists she is an experienced kindergarten graduate, one who now understands everything, but, of course, the satire is rooted in the contradiction between her understanding and the visuals created by the Brumberg sisters.

The two films feature the same family, and while the films were made more than a decade apart, the family has only aged a year or two. At first glance, the three female characters (Mama, Kapa, and the little sister, who is the narrator) seem to function within and to perpetuate the Soviet patriarchal oppression of women, but a closer look reveals a subtle critique of Soviet womanhood. Age seems to be a determining factor in the characters' commitment to Soviet ideals, with younger generations having the least affinity for Soviet ideology, as is most evident in the relationship of the mother and Kapa, the oldest daughter. Kapa, like her brother Kolia, is influenced by Western culture, clothing, and music. Eschewing Communist ideals, Kapa, instead, represents the alienation of the younger generation. The mother, like the father, functions within a corrupted version of the Soviet system. She works, we can assume, in a low-paying job, as she, like the rest of the family, is a burden on the father's back. Yet, she wishes for nothing more than marriage to a wealthy man for her oldest daughter. The alienation between the generations is accentuated in how they are drawn. The mother is solid and substantial, much like the descriptions of the Brumbergs; but despite her size, she gets lost in the frame. Her white dress with pale green strips literally blends into the white background.

Representative of a system that has lost its way; the mother, believes the answer to the woman question is marriage. While in the first film, the mother would like Kapa to marry a solid man, in the second film almost any man will do. There is even a scene in the second film in which women are searching under trees for available men as if they were mushrooms, demonstrating how societal problems have continued to escalate over time. Kapa, on the other hand, is light and airy. As Pontieri points out, Kapa is not grounded: she floats, dances, or bounces her way through the animation.[15] When she is initially drawn in *Great Troubles*, to the sounds of syncopated jazz, Kapa is all sharp angles, more reminiscent of modernist architecture than a young teenage girl.

15 Ibid., 97.

In *New Great Troubles*, she is more substantial, softer, she smokes, and now has taken on the air of a hippie with long hair, bell bottoms, and a psychedelic blouse. Despite her attempts at rebellion, Kapa falls victim to the trappings of patriarchy and potentially ends the film herself a mother and married to an alcoholic mid-level bureaucrat, who in the end leaves her.[16]

Fig. 13. *Great Troubles* (*Bolshie nepriiatnosti*, 1961), courtesy of Soiuzmultfilm.

The Brumbergs' satirical approach to contemporary society in these films imparts the female characters with feminist undertones. Satire, a new tendency in animation in these years, is abundant in both films, both narratively in the story the little sister tells and visually in the juxtaposition between images drawn and the literal and figurative meanings of the phrases. Under the guise of offering a cautionary tale on how Soviet women should not act, the Brumberg sisters question the more traditional female roles in Stalinist animated films. Kapa and her mother are not good Soviet role models. The humor comes from the multiple layers of dysfunction interacting with each other linguistically and visually, but in the end, the film is also a tragedy about the dysfunction of Soviet womanhood.

16 While the film does not show Kapa pregnant, the scence is ambiguous. The sister narrator says that Kapa's husband left her how she was when her mother gave birth to her, that is, with nothing, but the accompanying imagery is Kapa in a cabbage path and then a shot of a baby in a cabbage patch. Given the number of Soviet women left to raise children on their own, it would not be suprising if Kapa was abandoned and pregnant.

Fig. 14. *Great Troubles* (*Bolshie nepriiatnosti*, 1961),
courtesy of Soiuzmultfilm.

The narrator of both films, the little girl, is the only potentially posi-
tive female role model. Though she misunderstands with a child's percep-
tion both the adults' verbal expressions and her family's situation, she does
not share their missteps. In the first film, her youth, innocence, and naive
wisdom offer a sense of hope for the future of Communism and Soviet
women. However, the main contrast between the first and second film is
that, despite the time lapse, Soviet society has not improved. In fact, the
increased emphasis on alcoholism and its impact on the family in the sec-
ond film demonstrates that the Soviet system has become even more corrupt
and morally bankrupt.[17] This lack of progress also diminishes the narrator's
ability to portray confidence about the future of Communism. Hence, in
both films, as the narrator attempts to reconcile her family's behavior with
her neighbors' collective negative reactions, she is alone and separated from
her family. In fact, she rarely shares the screen with any of her family mem-
bers, except the cat (see Fig. 13 and 14).[18] The Brumbergs do not clarify the
little girl's position; yet her voice and agency are unmistakable. Through her

17 Vladimir G. Treml, "Soviet and Russian Statistics on Alcohol Consumption and Abuse,"
in *Premature Death in the New Independent States*, ed. J. L. Bobadilla, C. A. Costello, and F.
Mitchell for National Research Council (US) Committee on Population (Washington D.
C.: National Academies Press, 1997), https://www.ncbi.nlm.nih.gov/books/NBK233387/.

18 There is one brief scene in the first film where the narrator appears unwillingly with her
family as she is dragged across the screen. While the narrator is also a burden on her
family, due to her age, it is not the same type of burden as the other members.

recounting of events, she critiques all that is wrong with Soviet society in the 1960s and 1970s.

With these films, the Brumbergs were among the first directors to abandon the Disney realistic style and push Soviet animation in new creative directions, including the criticism of Soviet society and the denunciation of traditional female roles. The Brumbergs' *Great Troubles* and *New Great Troubles* serve as evidence of how the position of women became even more complex under Khrushchev and Brezhnev. The films can be read as contributions to Soviet female subjectivity as the Brumbergs rework and reimagine generations of women and how they fit into the evolving Soviet society.

Woman Question in the 1960s and 1970s

As demonstrated in the Brumbergs' films, the Khrushchev era revived the woman question. Soviet women and family dynamics became important themes in women's animation as women directors attempted to express their selfhood on the screen. The press continued to publish articles about how socialism had given women equality with men, but also mentioned for the first time women's double burden—their full-time work both inside and outside the house—or sometimes the triple burden: motherhood, housework, and career.[19] According to Buckley, women experienced tension "between ideological claims about the successful liberation of women under Soviet Socialism and the more realistic observations about women's lives."[20] While their everyday lived experience came into conflict with official accounts about their equality, women made some progress with appointments to the Politbiuro, the apex of political power, as well as with a number of important legal decisions concerning women and the family. For instance, abortion was once again legal. There were also promises about increases and improvements in state-funded childcare, and men were called on to help their wives at home. Yet, working women felt that not enough was being done to ease their burdens and there was no real discussion about redefining existing gender roles.[21]

19 For a detailed discussion of women during the Khrushchev era see Buckley, *Women and Ideology* and Melanie Ilič, Susan E. Reid, and Lynne Attwood, eds., *Women in the Khrushchev Era* (Basingstoke: Palgrave Macmillan, 2004).

20 Buckley, *Women and Ideology*, 140.

21 Attwood, *Red Women*, 73.

Great Troubles from 1961 satirically attacks this problem of traditional roles, in which women, like Kapa, and, by extension, her mother, are prized for beauty and the film becomes part of the early dialogue about the revival of the woman question. Unfortunately, by the time *New Great Troubles* is released in 1972 the woman question is no closer to being answered. As the film demonstrates, it becomes even more complicated by the rising rates of alcoholism in the Soviet Union in the 1960s and 1970s.[22] In *New Great Troubles* the satire becomes more cynical as Kapa is doomed to repeat her mother's mistakes; her only option in life is marriage to an alcoholic and motherhood.

Reimagining the roles in the family was a common theme in live-action cinema during these years. John Hayes suggests in "Reconstruction of Reproduction? Mothers in the Great Soviet Family in Cinema after Stalin" that the live-action film industry contributed greatly to the debate about the "great Soviet family" as a way to help find a new direction for the state after Stalin's death.[23] Stalin cultivated his role of the great patriarch who led his children toward the creation of the great Soviet family, but with his death also came the failure of this family. Cinema, whether live-action or animated, during the Thaw and Stagnation helped to reimagine the social order and to challenge not only Stalin's vision of family but also the traditional roles that this family advocated. Female directors added to this revisualization of the social order and reimagining of the family and female selfhood during this period.

Snezhko-Blotskaia in the 1960s

In the late 1960s, Snezhko-Blotskaia developed into a covert champion of feminist filmmaking. After the success of *The Tale of Boy-Kibalchish*, she directed a handful of films based on ethnic fairy-tales, including a Latvian tale, *The Amber Castle* (*Iantarnyi zamok*, 1959), an East Asian tale, *Dragon* (*Drakon*, 1961), a Kazakh tale, *A Wonderful Garden* (*Chudesnyi sad*, 1962), and Rudyard Kipling's tales, *Rikki-Tikki-Tavi* (*Rikki-Tikki-Tavi*, 1965) and *The Cat that Walked by Himself* (*Kot, kotoryi gulial sam po sebe*, 1968). Snezhko-Blotskaia reimagines the family structure in *The Cat that Walked by Himself* creating one of the strongest examples of female empowerment

22 Treml, "Soviet and Russian Statistics on Alcohol."
23 John Hayes, "Reconstruction of Reproduction? Mothers in the Great Soviet Family in Cinema after Stalin," In Ilič, Reid, and Attwood, *Women in the Khrushchev Era*, 114–130.

by embedding in Kipling's tale domestic problems of Soviet women's every-day lives.

Kipling's *The Cat that Walked by Himself* attempts to explain why cats are so aloof, but actually describes how woman tamed and civilized man and thus created modern society. The original tale celebrates the power of women to domesticate not only men, but wild animals as well, with the exception of the cat. Each animal (including man) gains something in mak-ing a bargain with the woman: companionship, bones, protection, and so forth. The cat, however, makes no bargain, preferring his freedom. Daniel Karlin in his *Introduction to Oxford's Rudyard Kipling: A Critical Edition* suggests that "the cat may be allegorized as many things (the artist's imag-ination, the Freudian *id*, male sexuality) but the story remains a fable, not an allegory; like all Kipling's best stories, it is meaningful because no single meaning can be extracted from it."[24] Snezhko-Blotskaia offered an inter-pretation of Kipling's tale that was very powerful for Russian women in the 1960s. The selection of a safe traditional tale, with the possibility of multiple meanings, allowed the film to appear innocuous, while at the same time challenging traditional male-female relationships and giving women in the 1960s a revised version of Soviet feminity.

Snezhko-Blotskaia plays with the male-female opposition in signifi-cant ways in the film. For example, the choice of the masculine nouns for dog (*pes*), horse (*kon*), and even cat (*kot*), instead of the slightly more com-mon female nouns (*sobaka, loshad, koshka*) reveals how the woman inter-acts and negotiates with males to arrange the best outcome for her and her family. The cow is the only other female (*korova*) to enter the house-hold. The woman refers to the cow as a breadwinner (*dobytchitsa*), also a feminine-gendered noun in Russian. The cow and the milk she gives in exchange for shelter are symbols of a female's fertility and the ability both to create offspring and to feed them. Just like the cow, the woman sees her-self as the breadwinner for the family; she performs traditional "women's work": cooking, cleaning, milking, sewing, taking care of the man, the baby, and the animals. She also builds a fire, casts spells, and dominates the males by acting as the chief negotiator, the leader and organizer of the household, thus challenging the image of docile, helpless women.

24 For more analysis of Kipling's tale see Rudyard Kipling and Daniel Karlin, *Rudyard Kipling* (Oxford: Oxford University Press, 1999), xxi.

Fig. 15. *The Cat that Walked by Himself* (*Kot, kotoryi gulial sam po sebe*, 1968), courtesy of Soiuzmultfilm.

As a cautionary tale, while the woman in this film is powerful, she also demonstrates and must be wary of her weakness—vanity. Through Kapa the Brumbergs also focused on this theme in *Great Troubles*. In Snezhko-Blotskaia's film the female character's appearance transforms throughout the film. Initially, she is drawn with a small exposed waist and shapely legs appearing out from under a very short skirt. She also begins the film with exposed breasts, but soon exchanges her plain short skirt for one made from leopard skin, which her man has presented to her. She starts to wear a halter-top once she has domesticated the dog and the horse hence her desire to enhance her own beauty progresses in the film without regard to the male gaze differentiating this film from other female transformation stories. Nevertheless, the male cat is able to trick the woman into agreeing to let him stay in the cave, because he praises her by telling her that she is beautiful and the woman is flattered. After the domestication of the cow and the appearance of her own child, she combs her hair and wears jewelry. She becomes more feminine as she takes on more traditional female tasks and with this transformation she grows increasingly more aware of her feminine power. By the end of the film, she has added a little vest over her strapless top to indicate not modesty, but, rather, enhancement of her appeal which the cat responds to with flattery (see Fig. 15).

Feminine allure and its connection to power emerges as a component of Soviet feminism in the 1960s and 1970s. Second-wave feminism in Soviet Russia did not function the same as it did in the West. Saddled with the triple burden—motherhood, housework, and career—Soviet women wanted to display their differences from men. Both in live-action cinema and in animated film, Soviet women had a desire not for a Western-style equality, but rather for an acknowledgement of their differences.[25] Snezhko-Blotskaia's *The Cat that Walked by Himself* marks the path of differentiation, towards an individuation and reinscribing of gender to refeminize Russian women. The film celebrates the differences between the genders, with the woman's appearence becoming softer, more feminine as she wields more power.

Yet, the woman's transformation towards individuation and its subsequent "othering" comes from the objectification of the female body. This objectification appears to be on her own terms. While the male cat is the one who flatters her, she transforms her appearance for her own satisfaction, not for the cat, nor for her male partner. Her feminine transformation in this tale creates a female selfhood that is grounded in beauty, a stark difference from Western second-wave feminism.

Snezhko-Blotskaia strays from the traditional Kipling tale, inserting relationship advice for Russian women and revealing one of social ills facing women in Soviet Russia: domestic violence. At the end of the film, the man tells the cat, "If you don't earn your keep [catch mice] or if I am in a bad mood, I will kick you out with my boot." To demonstrate, he throws his boot at the cat, which the woman retrieves for him. The cat suggests that women should think before bringing men their boots; today it was the cat who got the boot, tomorrow it might be her. Snezhko-Blotskaia's ability to weave the issues facing women in the Soviet Union into this traditional tale attests to the changing face of Soviet female subjectivity and the animation industry in these years. As a woman working in a male-dominated field, creative freedom and autonomy were important to Snezhko-Blotskaia, as is evident in the feminist core of this film. Films such as *The Cat that Walked by Himself* demonstrate that Soviet women were aware of their position in the workforce, in relationships, and in society, as well as the inequality between men and women.

25 Michele Leigh, "A Laughing Matter: El'dar Riazanov and the Subversion of Soviet Gender in Russian Comedy," in *Women in Soviet Film: The Thaw and Post-Thaw Periods*, ed. Marina Rojavin and Tim Harte (Abingdon: Routledge, 2018), 112–133.

Inessa Kovalevskaia, Representative of a New Generation of Filmmakers

Regardless of the increased freedom and autonomy for Soviet filmmakers, many female directors were still overlooked in the 1960s and 1970s. One of the most popular films from the 1960s, *Musicians of Bremen* (*Bremenskie muzykanty*, 1969) was directed by a woman, Inessa Kovalevskaia. There are few films in the history of Russian and Soviet animation that have had such broad appeal as Kovalevskaia's *Musicians of Bremen*.[26] The soundtrack from this animated film, composed by Genadii Gladkov and with lyrics by Iurii Entin and Vasilii Livanov, is so popular and far reaching that this film has no analogue in the history of Russian culture.[27] Many fans of the film assume incorrectly that either Gladkov, Entin or Livanov directed the film instead of Kovalevskaia. After this film, Kovalevskaia began to specialize in the musical format and defended this direction for animated films during her career. She worked at bringing young audiences a variety of musical pieces written by both contemporary composers, such as Gladkov, Vladimir Shainskii, Anatolii Bykanov, Mark Minkov, Iurii Antonov, as well as by classical composers, such as Mikhail Glinka, Modest Mussorgsky, Pyotr Tchaikovsky, Sergei Prokofiev, Dmitrii Shostakovich, and Edvard Grieg.

Not surprisingly, due to the popularity of *Musicians of Bremen*, there have been biographies, interviews, and articles featuring Gladkov, Entin, and Livanov; but there has been almost no mention of or scholarly work on Kovalevskaia.[28] In fact, many accounts of the making of this film do not even mention the female director. However, in 2009 Kovalevskaia wrote her memoirs, in which she recalled the entire history of the production of the film—from the appearance of the original idea to the process of submitting the finished film to the Art Council. Acknowleging her own

26 We have given talks on this film several times, and audience members who grew up watching and loving the film are always shocked to hear this film was directed by a woman.

27 For a discussion of the music in *Musicians of Bremen* see Andrei Semenov, *Gennadii Gladkov: Kniga o veselom kompozitore* (Moscow: Muzyka, 2009), 62–65.

28 The screenwriters and musicians are discussed in various interviews and articles. Dubogrei does mention Kovalevskaia in his article, however, he does not discuss her role as a female director. See Vitalii Dubogrei, "Kak sozdavalsia mul'tfil'm 'Bremenskie muzykanty,'" *Pozitiv iz Goroda Solntsa*, accessed January 31, 2018, http://dubikvit.livejournal.com/16195.htm. For an interview with the scriptwriter, Iurii Entin, see Iurii Entin and Elena Iakovleva. "A mne letat' okhota!" Kak sozdavalis' luchshie khity Iuriia Entina," accessed January 31, 2018, http://www.aif.ru/culture/person/_a_mne_letat_ohota_kak_sozdavalis_luchshie_hity_yuriya_entina.

marginalization, she remarks that the director of animated films is often overlooked despite her importance. "Each of the participants in the film's creation sees the future film in their own way . . . the task of the director is to put together a mosaic of creative perceptions so that they look whole, and not separate. In this case, I had to take into account that every creative person is very vulnerable and accepts criticism with difficulty."[29] So, while the composer, the writer, and the animators, among others, contributed to the final product, it was Kovalevskaia's direction that produced the final and much-loved version of *Musicians of Bremen*.

Kovalevskaia benefited, in particular, from the more liberal atmosphere of the post-Stalinist period, which allowed her to change the direction of Soviet animation with *Musicians of Bremen*. Her career in animation is rather unusual despite the fact that the animation industry became a haven for artists who could not work in other areas. In 1950, just as Kovalevskaia successfully passed her entrance exam into Moscow State University, her father, a war veteran and an assistant professor in the History department at the Academy of Military and Political Science, was arrested and died.[30] Kovalevskaia and her mother were forced to move to the village of Cheremushki, and she was denied an education based on her father's status. Despite the decree that barred the children of "enemies of the people" from receiving an education and with the help of her father's friend, she was able to enroll in a pedagogical geographical institute outside of Moscow and then was allowed to simultaneously enroll in various theater and art courses.[31] Two years later, her father was rehabilitated, giving Kovalevskaia a chance at a more prestigious education. She entered into the third year in the theater department at GITIS, The Russian Institute of Theater Arts. One of her first jobs after graduation, from 1959 to 1961, was as a censor for the Ministry of Culture, censoring Soviet animated films.[32] Only after her experience as a censor did

29 Inessa Kovalevskaia, "Vospominaniia Inessy Alekseevny Kovalevskoi o sozdanii legendarnogo fil'ma 'Bremenskie muzykanty,'" *Kinograf* 20 (2009): 336.

30 See next note.

31 There is some confusion about her father's death. The website General.dk, hosted by Steen Ammentorp, Librarian DB., M.L.I.Sc., suggests that he committed suicide in 1950. Kovalevskaia states in an interview in *Moskovskaia pravda* that her father died after being arrested as an "enemy of the people." See Aleksandra Murasheva, "Mul'timaniia Inessy Kovalevskoi," *Moskovskaia pravda*, August 13, 2012, https://dlib.eastview.com/browse/doc/27529944.

32 Ibid., 336.

Kovalevskaia enter the directing courses at Mosfilm. In 1964, she graduated from the Higher Courses of Directors and Screenwriters and began working at Soiuzmultfilm as an assistant director.

Kovalevskaia's understanding of censorship comes from first-hand experience, and her insights are evident in the way she approached working on *Musicians of Bremen*. This film, a contemporary adaptation of a Grimms' tale, *Die Bremer Stadtmusikanten*, features Western music and Western fashion. It also serves as an example of the ways in which women thwarted censorship, as Kovalevskaia was astute at bridging the gap between state politics and actual studio practices.

Kovalevskaia's film is innovative in three ways: the approach to music, the depiction of women, and the thematic adaptations to the original Grimms' story. According to Kovalevskaia, the decision to animate a musical film was made when she and Gladkov had just finished working on her first film at Soiuzmultfilm, *Four from the Same Courtyard* (*Chetvero iz odnogo dvora*, 1967). From their love of music, they decided to play with the conventions of musical cinema and animation.[33] The choice to use the tale *Musicians of Bremen* was really more a process of elimination: to save time, they opted for an existing fairy-tale that had not been previously animated at Soiuzmultfilm, and one that had a connection to music. As this was the first animated musical for children in the Soviet Union, Kovalevskaia's film was groundbreaking and set the standard for future animated musicals. In this way, she innovated the Soviet animation industry and broke with tradition.

Kovalevskaia was committed to the musical format, so she was serious about the music and sound quality.[34] Since the music carried the plot, instead of dialogue, it was important to have a quality recording. She suggests in her memoirs that there were six different musical styles in the film. *Melodiia*, the official Soviet record label, agreed to allow the film crew to record at their studio at night, as Soiuzmultfilm did not have the technical capabilities at that time.[35] Kovalevskaia knew they were breaking from the past: "Youth never wants to go along the beaten path. It was necessary to

33 Ibid., 324.

34 For a discussion of music in the *Musicians of Bremen* see Semenov, *Gennadii Gladkov*, 73–91.

35 See "Bremenskiie muzykanty. Nepridumannaia istoriia," accessed February 2, 2018, http://2danimator.ru/showthread.php?p=62865.

do something that had never been done before."[36] While Kovalevskaia was referring to the musical format, her statement can also be applied to her fresh character design, which was just as novel as the music.

Grimms' *Die Bremer Stadtmusikanten* gave Kovalevskaia, Gladkov, and Entin the basis for the script, but the final film included additional characters and plot lines. The musical retains the four animals and the robbers from the original tale, but the plot of the Troubadour, the King, and the Princess was created by the animators. According to Kovalevskaia, the changes to the original story were made to conform to the generic form of the musical, but also to make the film more interesting and dynamic by producing human characters with whom older audience members could identify.[37] The Troubadour, a musical director-hero, was crafted first, and then the princess-king-castle motif was established to complete the fairy-tale formula. The Troubadour and the Princess fall in love, and the Troubadour tricks the King into permitting the marriage. At first glance, this film does not promote a feminist plot, and Kovalevskaia's innovation appears to be simply the incorporation of a new generic format, the musical. Yet, Kovalevskaia's representation of youth and young women was groundbreaking, especially with the increasing concern about the future of young people in the Soviet Union.

In the 1950s and 1960s there was concern that Soviet youth were not as active in the construction of socialism as past generations. In 1962, Khrushchev rejected the idea that the Soviet Union had a youth problem, which, in fact, emphasized the widening cultural disparity between the generations.[38] The more liberal political climate of the Thaw and the youth's response to it was obvious in big cities like Moscow and Leningrad, where youthful discontent was pervasive. Young people in large cities were turning to Western fashion, Western music, and Western attitudes for inspiration. This problem of the Soviet youth is clearly depicted in the Brumbergs' *Great Troubles* series as a widespread social ill: Kapa and Kolia have fallen away from the true socialist path, and instead worship entertainment and acquisitions, loathing hard work. Kovalevskaia, in her mid-thirties when she made *Musicians of Bremen*, draws from the youth rebellion to help develop her characters. Her vision for the characters in

36 Kovalevskaia, "Vospominaniia," 335.

37 Ibid., 357.

38 Tanya Frisby, "Soviet Youth Culture," in *Soviet Youth Culture*, ed. Jim Riordan (London: MacMillan, 1989), 1–15.

this film, especially the Princess, illustrates her desire to portray women as modern and defiant. The Princess is non-traditional in her dress and in her actions; through Kovalevskaia's reworking of the tale, the Princess becomes a feminist statement against patriarchy and the mores of the Soviet state.

The characters in the film are examples of unofficial youth subcultures that sprung up in the Soviet Union. One of the most visible youth cultures were the *stiliagi*, the style-hunters—the equivalent of Soviet hipsters, who first gained popularity in the 1950s. The style-hunters listened to jazz and wore pomaded hair, colorful suits, and big colorful ties. Their style evolved over the years often imitating Western styles.[39] Pontieri argues that Kolia, in *Great Troubles*, wearing narrow trousers with a wide striped shirt and dancing to jazz, is an example of these style-hunters.[40] The youth subculture in *Musicians of Bremen*, however, is more clearly related to the period of Brezhnev's Stagnation. The disillusionment among young people after 1964 has to be understood in the context of the deteriorating political climate under Brezhnev. More youth turned to unofficial youth groups as their needs continued to be ignored. In turning away from official Soviet culture, the gap between official and unofficial youth culture grew, and Western influenced youth culture filled this space. Music, fashion, and alternative lifestyles defined many components of youth subculture.[41] Kovalevskaia picks up on similar themes as the Brumbergs, but absent from the *Musicians of Bremen* is the obvious satire to undercut the representations. Kovalevskaia's film can be read as a pro-subculture manifesto that glorifies the choices of the youth.

39 Mark Edele, "Strange Young Men in Stalin's Moscow: The Birth and Life of the Stiliagi, 1945–1953," *Jahrbücher für Geschichte Osteuropas* 50, no. 1 (2002): 33–61. See also William Jay Risch, "Soviet 'Flower Children'. Hippies and the Youth Counter-Culture in 1970s' L'viv," *Journal of Contemporary History* 40, no. 3 (2005): 565–584. And also see Jim Riordan, "Soviet Youth: Pioneers of Change," *Soviet Studies* 40, no. 4 (1988): 556–572.

40 Pontieri, *Soviet Animation*, 88.

41 For an analysis of the genesis of informal youth groups, see Frisby, "Soviet Youth Culture," 1–15.

Fig. 16. *Musicians of Bremen* (*Bremenskie muzykanty*, 1969), courtesy of Soiuzmultfilm.

Kovalevskaia recalls in her memoir that she had difficulty with the character development for the film, especially the Troubadour and the Princess.[42] According to Kovalevskaia, artist Maks Zherebchevskii came up with the first sketches for the main characters, which resembled clowns more than royalty or hip young people. Kovalevskaia was very upset when she saw the designs, as she had imagined something completely different and atypical. She felt the characters were inconsistent with the music and the genre of the film. The dilemma was how to convince the artist to change his mind, without making him angry or wanting to quit. Kovelevskaia then took a risk—one that might only have been taken by a former censor. She decided to present the script, storyboards, and music to the Art Council, hoping they would insist on changes.[43] Kovalevskaia was successful at manipulating the censorship apparatus and the Art Council agreed that the character images did not fit the music or the genre and they insisted on changes.

42 For more details about the image design and a description in her own words see Kovalevskaia, "Vospominaniia," 325–326.

43 "Bremenskiie muzykanty. Nepridumannaia istoriia."

Zherebchevskii was placated and a new search for character designs was initiated. Inspiration for the Troubadour was found by looking at pictures of musicians in foreign magazines.[44] The actual image design for the Princess, with her au courant hair style, was offered by the assistant of the art-director, Svetlana Skrebneva. Kovalevskaia admits, "To design characters in these get-ups, even in cartoons, was unheard of bravery from the creators of the film."[45] The director found the dress for the Princess, a scandalous mini-dress, when leafing through the fashionable foreign journals in the closed library of the Goskino.[46] The 1960s was a decade that broke fashion traditions and mirrored the social movements of the time, hence, the Troubadour and the Princess are the quintessential 1960s characters both in attitude and in style. And these rebellious characters hid in plain view on the screen because they were part of an innocent children's cartoon. Kovalevskaia knew that the choices she made as director for the overall vision of this film were representative of youth subcultures active in the Soviet Union and throughout the world.

These characters are a mix between the British mods from the early 1960s and the hippie culture from the later 1960s (see Fig. 16). In the early-to-mid 1960s, London modernists known as mods influenced male fashion in Britain as demonstrated by British rock bands like the Beatles and the Who. The Beatles were initially recognizable for their mop-top look—a messy, longer cut that shifted away from the slicked back, classic looks of the 1950s. The style became a symbol of rebellion, and was quickly adopted by Beatles lovers around the world. The Troubadour sports this mop-top style in the film. His v-neck sweater also adds to his rebellious attitude. Sweaters in the 1960s bridged the gap between casual and formal wear for men. While the turtleneck was more common and popular with the youth of the 1960s, the v-neck that the Troubadour wears has always been enjoyed

44 There has been speculation about who was the inspiration for the Troubadour. For a recent discussion started by Oleg Kuvaev, the creator of the animated series Masiania, on his blog see Kuvaev, "Bremenskie muzykanty," accessed February 2, 2018, http://www.mult.ru/trubadur.

45 Kovalevskaia, "Vospominaniia," 337.

46 The closed section of the Goskino library was a special collection available only under particular circumstances and not open to the general library patron. Kovalevskaia gave a slightly different story in an interview in *Moskovskaia pravda* from 2012. She stated that she found the Troubadour in a French magazine, that they collectively decided on the princess's clothes, and that her assistant thought up the hair-do. See Murasheva, "Mul'timaniia Inessy Kovalevskoi."

by the younger generation.[47] However, these film characters also have elements of other 1960s counterculture youth movements as well.

The hippies were a late 1960s counterculture, and originally a youth movement that started in the United States and Great Britain.[48] While the Troubadour has certain characteristics of the mods, he also wears long orange bell bottoms with large geometric rectangular pockets and a wide belt; all markers of hippie fashion. The lighter shade of orange at the bottom of his pants is reminiscent of the frayed look common to this fashion trend but very difficult to animate. The Princess is adorned in an angel dress with a high hemline. By the late 1960s hemlines that had reached well above mid-thigh were called micro-minis. Boots, as footwear for women, reached the height of popularity in the 1960s.[49] The Princess's red knee-high boots with yellow embellishments recreate the Go-Go boot. The Go-Go boot and the micro-mini were symbols of both modern and free-spirited women, which shunned conservative notions of female sexuality. These character images challenged Soviet ideals about youth by representing a connection to rebellious foreign youth cultures.

The *Musicians of Bremen* is also a good example of how Soviet female subjectivity differs from Western models. During second-wave feminism in the United States and Great Britain many women "rejected traditional standards of feminine beauty as oppressive and objectifying of women."[50] Western feminists used self-fashioning techniques, often eschewing "feminine" fashion, hairstyles, and beauty culture that "defined women by how

47 For key texts in the development of subcultural theory in the West see Dick Hebdige, *Subculture: The Meaning of Style* (London: Methuen and Co., 1979). See also Paul Jobling, *Advertising Menswear: Masculinity and Fashion in the British Media since 1945* (London: Bloomsbury, 2014).

48 For a discussion of the evolution of Hippie cultures see Valerie Steel, "Anti-Fashion: The 1970s," *Fashion Theory: The Journal of Dress, Body & Culture* 1, no. 3 (1997): 279–295. See also eadem, *Fifty Years of Fashion: New Look to Now* (New Haven: Yale University Press, 2000); as well as Jennifer Grayer Moore, *Street Style in America: An Exploration* (Santa Barbara: ABC-CLO, 2017); and Djurdja Bartlett, *Fashion East: The Spectre that Haunted Socialism* (Cambridge, MA: MIT Press, 2010), 213–272.

49 Norman Norell, Louise Nevelson, Irene Sharaff, Alwin Nikolais, Andre Courreges, and Priscilla Tucker, "Is Fashion an Art?," *The Metropolitan Museum of Art Bulletin* 26, no. 3 (1967): 129–140. And see Gerda Buxbaum, ed., *Icons of Fashion: The 20th Century* (Munich: Prestel Publishing, 2005), 82.

50 For a more in-depth discussion of these ideas see Betty Luther Hillman, "'The Clothes I Wear Help Me to Own My Own Power':The Policitcs of Gender Presentation in the Era of Women's Liberation," *Frontiers: A Journal of Women Studies* 34, no. 2 (2013): 155.

they looked" and perpetuated strict gender binaries.[51] In Soviet Russia, much like in Western society, the politics of gender presentation—one's choice of dress, hairstyles, and self-fashioning—became a weapon for women to declare their feminine selfhood in a space separate from the world created by patriarchy and Soviet mores. Just like in the West, women's self-presentation became the site of cultural battles over the meanings of Soviet feminism and womanhood. But, while most second-wave feminists in the United States sought to eradicate gender binaries, in the Soviet Union feminists fought for the right to be feminine, to have the freedom to wear mini skirts, make-up, and Go-Go boots. The formation of both feminism and Soviet female subjectivity followed vastly different paths than in the West. The fashion and hairstyles in *Musicians of Bremen* are just part of the counterculture exhibited in this film.

The individuals who embraced these fashions, whether they were mods or hippies, also went against the established political and social grain of the time in their attitudes towards accepted norms. The Troubadour and his band are wanderers, with no stable job or stable address. From the opening song in the film the band claims that their calling in life is dearer to them than any palace: "There is nothing better in the world / Than to wander around the wide world with friends." This lack of work ethic and dedication only to the joys of laughter and freedom are far from proper Communist ideology. The Troubadour is able to win the Princess's hand from her oblivious father, the King, by pretending to be a robber and then pretending to be a hero who saves the day. The King happily gives his daughter away in marriage to the Troubadour after his false heroic act. The King's outdated notions of love and marriage and his gullibility are in stark contrast to the Troubadour and it would seem, his own daughter.

The wedding dance and the youths' departure at the end of the film reminds viewers that these young people are committed to a different type of ideal, eschewing work and family for love and adventure. After the formal wedding and dancing, the Troubadour instructs the orchestra to strike up a more rock-inspired tune and the Princess breaks out into a dance inspired by the Twist, Hali Gali, and the Frug—popular dances from the 1960s.[52] These dances, exemplifying the freedom of body movement, broke with past tradition and became another form of social critique of

51 Ibid 156–157.
52 Kariann Goldschmitt, "Doing the Bossa Nova: The Curious Life of a Social Dance in 1960s' North America," *Luso-Brazilian Review* 48, no. 1 (2011): 61–78.

past trasitions. The Princess subsequently jumps out of the window with the Troubadour, tossing her crown, to take up the wandering life of the musicians. The Princess's decision to absandom her old life and her commitment to a non-traditional female role is a stark contrast to Stalinist animated films. Her role emphasizes a changing female subjectivity that is more in tune to one's sexuality and power as a woman. While the film is set in nineteenth-century Germany, the message of this animated film is clear to Soviet audiences; it is a pro-subculture statement that promotes the choices of youth, especially young women.

Musicians of Bremen was part of a new direction in animated films that straddled the line between adult and youth audiences. According to both Pontieri and MacFadyen, in the last years of the 1960s and throughout the 1970s, the animation industry tried to reconcile two different paths: one aimed at children and one aimed at adults. The new generation of films had no definite target audience and really addressed both adults and children, which helps to explain the cult-like following of *Musicians of Bremen*. MacFadyen states that animators did not see these two paths as separate and instead they believed that their films for children had philosophical importance for adults. He also suggests instead that animation became a portrait of human thought and became more than the sum of its language.[53] Pontieri also proposes that while these films entertained children they also attracted adults because of the real-life situations in which the characters are placed. Other films, she suggests, straddled the two worlds by focusing on the director's or the screenwriter's personal artistic expression.[54] This more lyrical approach first began in live-action films in the late 1960s but continued into the 1970s with directors such as Tarkovskii. The lyrical tradition appealed to both children and adults with some of the most well-known films in Soviet animation, including Fiodor Khitruk's *Winnie-the-Pooh* (*Vinni-Pukh*, 1969), Viacheslav Kotionochkin's *Just You Wait* (*Nu, pogodi!*, 1969–1993); Iurii Norstein's *The Heron and the Crane* (*Tsaplia i zhuravl*, 1974), *Hedgehog in the Fog* (*Ezhik v tumane*, 1975); and Roman Kachanov's Cheburashka series, *Crocodile Gena* (*Krokodil Gena*, 1969) and *Cheburashka* (*Cheburashka*, 1971).

Beumers suggests that these films channeled the imagination of a modern-day child, which was poetically richer than themes that animators drew

53 MacFadyen, *Yellow Crocodiles,* 87–88.
54 Pontieri, *Soviet Animation,* 169–181.

from in earlier decades.[55] The characters of the Hedgehog and Cheburashka not only emulate the the imagination of children, they also gain perspective from self-discovery, thus widening their appeal to adults. *Musicians of Bremen* is in line with these other iconic animations, although it does not feature a child-like protagonist, the musicians certainly emphasize youth and youth culture. The film also offers its own philosophical and lyrical outlook on life which helped in turning this film into a cult classic. The musicians are isolated, but by choice; and they are not lonely, as they have each other. The characters, including the Princess, want to be free and they want to follow their hearts. These themes are distant from the moral messages of the recent Stalinist past, and this celebration of willful isolation also adds to the *Musicians of Bremen*'s rebelliousness. The depiction of the Princess is a break from the more traditional representation of women's roles on the screen and argues for a radical feminist ideal, a new Soviet female subjectivity, envisioned by a female director.

While women were more daring in these years, they also suffered for their boldness. For example, after the unusual success of *Musicians of Bremen* Kovalevskaia was forced to leave Soiuzmultfilm, realizing that she would not be given any more films to direct. She explained that "envy and scheming were more prominent in animation than in other fields. Complaints were written against me and I was harassed. My main competition, also a director, made sure the *Musicians of Bremen* was not allowed to play at any international film festivals. And since I had no work I was forced to move to television. This was the payback for success. At Soiuzmultfilm there were always cliques, and I worked by myself and did not fit into any of the cliques. I paid the price."[56] Kovalevskaia does not say that her troubles were a result of her gender, but the bitterness towards her main competition is clearly felt in her words. Kovalevskaia was not out of work for long. She began working at *Ekran*, creating a puppet film *Only for You* (*Tolko vam*, 1970), before returning to Soiuzmultfilm. The push-back that Kovalevskaia felt after *Musicians of Bremen* also changed the way she selected films to direct. In the 1970s there was a return to the idea of the

55 Beumers, "Comforting Creatures," 164–169.

56 Anna Beligzhanina, "S kogo risovali liubimykh geroev sovetskikh mul'tikov," *Komsomol'skaia pravda*, June 8, 2011, accessed October 5, 2018, https://www.kp.ru/daily/25700.3/901496/ By the 1970s animated films were more often made for television in order to reach a larger audience, but prestige was still tied to international film festivals and the big screen releases.

socially minded artist who was helping to build Communism, and animated films turned away from more controversial topics, looking again to the past. Women directors also gravitated toward safer topics due to the tightening of ideological control. Kovalevskaia continued to work on musicals for children into the 1970s, featuring famous classical composers. For instance, she directed *Songs of the Inflamed Years* (*Pesni ognennykh let*, 1971), based on music from the civil war and hence also a celebration of the past.

Kovalevskaia's *How the Little Lion and the Turtle Sang a Song* (*Kak lvenok i cherepakha peli pesniu*, 1974), while thematically a safer film than *Musicians of Bremen*, avoiding rebellious youth culture, is daring in its simplicity. This film's narrative, like the *Musicians of Bremen*, is carried mostly by Gladkov's lyrics. *How the Little Lion and the Turtle Sang a Song* became an instant hit among young children and their parents. Remarkably, this film also appealed to adults without children. Gladkov's catchy music is certainly part of the draw, but the philosophical outlook of the film may have also attracted the attention of adult viewers. The Lion plays alone until he hears the Turtle singing with joy in the sun with her eyes closed. When the Turtle notices the Lion, she indicates that they should sing together and hence the two become friends. The world around them is equally as happy as the song they sing: the sun shines, other animals run around and dance to the music. The background in this limited animation is plain with a sandy colored backdrop and outlines of various pebbles and wispy plants. Slight modifications to the background appear when other animals are introduced, during a water skiing scene, and as night falls at the end of the film. The plot is unassuming, and yet, there are multiple introspective meanings.

The screenplay for the film was based on poetic tales by the children's writer Sergei Kozlov, who frequently worked as a screenwriter in animation. He is probably best known for his work on Norstein's *Hedgehog in the Fog*, which was released a year after Kovalevskaia's film. Beumers suggest that the main theme of the *Hedgehog in the Fog* is that while repetition may be boring, it also brings stability and a new perspective on life.[57] Kovalevskaia's film has a similar message for children and adults: repetition may, in fact, be understood as inner peace and happiness. When Kovalevskaia was asked what her film is about, she responded, "If you ask such a question, then it's

57 Beumers, "Comforting Creatures," 168.

just not your type of cartoon."[58] *How the Little Lion and the Turtle Sang a Song* is a contemplative film on the human value of happiness and finding joy in one's life, thus challenging the status quo.

Fig. 17. *How the Little Lion and the Turtle Sang a Song* (*Kak lvenok i cherepakha peli pesniu*, 1974), courtesy of Soiuzmultfilm.

How the Little Lion and the Turtle Sang a Song avoids controversy with its plot and character design, unlike the *Musicians of Bremen*, yet the character design is reminiscent of Kovalevskaia's earlier work. The Turtle is a representative of the older generation, who possesses a wisdom and a philosophical outlook on life that comes from living for almost a hundred years. While the other animals swim, or swing, or run, the Turtle, according to her song, just lies in the sun looking at it. The Turtle is drawn in olive green, a popular color in the 1970s, and her song has a jazzy tune indicating that even the older generation can enjoy the uncertainty of improvization. She even scats in the middle of the film. While not a fashion plate from the 1970s like the characters from *Musicians of Bremen*, the Turtle sports a groovy pair of butterfly sunglasses with tinted lenses, an obvious connection to the hippie-inspired characters in *Musicians of Bremen* (see Fig. 17). The Lion cub is youth personified. Fresh and inexperienced, he is not yet

58 Anna Beligzhanina, "S kogo risovali."

considered king of the beasts. He perceives everything enthusiastically and literally, as most small children do. Kovalevskaia claims that the image of the Turtle was quickly adopted but she passed over a lot of lions before she chose "the most cheerful, smile, amusing, with a red, 'solar' mane" and the Art Council approved the work without any difficulty.[59] These characters are subtle representative of the 1970s youth subculture, and as such they were in accordance with the tightening of ideological control during this decade.

The song, the source of the film's introspection, is what originally attracts the young male Lion to this more experienced female Turtle. Unlike the usual situation where the youth holds the future, in this film the ancient female Turtle holds the attention of the youth. The Turtle's philosophy is not hard work or joining the collective, but happiness in sitting and looking at the sun. The main point of contention between the Lion and the Turtle in the song and world outlook came about accidentally. Oleg Anofriev, the voice of the Lion, was writing the song down and mistakenly wrote "I'm sitting in the sun" and suddenly realizing his mistake, called "Oh-oh, I'm lying!" Kovalevskaia decided that it was a wonderful mistake, and this change from the uniform refrain became a main feature in the film.[60] The sitting/lying (*sizhu/lezhu*) is more than a sweet wonderful mistake, it also adds to the philosophical differences, although slight, between the two friends.

These two also abandon solitude for friendship: as night descends, the friends decide to meet again. However, it is the Lion, the younger generation, who falls into metaphysical questioning as he leaves the Turtle: What can you do with your eyes closed? Can you see the sun? Can you sleep with your eyes open and sing a song at the same time? He does not know the answers, but looking up at the infinite expanse of the stars, he feels fine. The Turtle has forced the Lion to look inward and, at the same time, has expanded his world view outward. A wise female has taught this young male a lesson about life.

How the Little Lion and the Turtle Sang a Song is representative of how animated films in the 1960s and 1970s slowly moved away from the building of Communism required in earlier decades and into more complex emotional directions. The characters and the aesthetic design in *How the Little Lion and the Turtle Sang a Song* are not traditional and continue to

59 Ibid.
60 Ibid.

push the Soviet animation industry in new aesthetic directions. While the argument may be too subtle to claim a true female aesthetic, Kovalevskaia adds to a version of Soviet female subjectivity with her own tenacity to continue in the animation industry and her unconventional female hero in the form of the Turtle. Kovalevskaia's persistence and her propensity towards the unconventional set the stage for subsequent female animators to impart subjectivity amidst a changing industry.

Chapter 6

When One Door Opens Another Shuts: Perestroika and Proto-Feminist Films

The reforms of the 1980s ushered in a new group of female animators. Not surprisingly, as directors these women created more proto-feminist animated films and took on more leashership roles within the industry.[1] The idea to restructure the Soviet economic and political system was first introduced in 1979 by Brezhnev during the era of Stagnation, but it was not enacted upon or promoted as a policy until Mikhail Gorbachev came into office. Gorbachev was relatively young, only fifty-four, when he took office as the General Secretary of the Communist Party of the Soviet Union in 1985. He was also part of a different generation than his predecessors as he entered politics after Stalin's oppressive regime. Within his first year in office, Gorbachev introduced two new policies, *perestroika* (restructuring) and *glasnost* (openness). Although *perestroika* was initially a way to decentralize the planned economy and build economic responsibility, this rebuilding had to enter all levels of society and people had to believe in the system again. Therefore, the idea of openness—*glasnost*—was promoted to encourage people to legitimize the changes. The political and cultural changes under *perestroika* allowed for open resistance to Soviet

1 By proto-feminist we are referring, not to intentionality on the part of the filmmakers to create feminist films, but rather to aesthetics or thematics that can be read in light of changing attitudes towards both the woman question and feminism.

cultural norms, which altered the film and animation industries as well as the position of women in Soviet society. Female directors during this time distanced their work from officially prescribed socialist realist themes, portrayed women in a wider variety of roles than in the past decades, and made strides towards embracing animation as part of women's cinema. In continuing to explore new aesthetic styles and different subjectivities, women made it possible for animation to become a space where a women's cinema was not just a possibility, but a reality.

The new policies introduced in the 1980s changed the animation industry and the opportunities available to women filmmakers. The Union of Cinematographers in support of Gorbachev ousted old party-line leaders and bureaucrats, and elected Elim Klimov as the head of the union at its Fifth Congress in May 1986.[2] Over the next several years the Union of Cinematographers changed the relationship between the filmmakers and the state, revamped its charter, and dropped the adherence to socialist realism, supporting a cinema that was independent of state control. Yet reforms were slow to appear on screens. One of the first results of *glasnost* and *perestroika* was the rediscovery and release of films that had previously been banned.[3] Klimov set up a new model for filmmaking based on a few simple principles: freedom of expression, the absence of socialist realism, managerial decentralization, and self-financing. Despite all the positive changes he was instituting, Klimov stepped down after two years. So, while the Union of Cinematographers was committed to change, these modifications came with upheaval and uncertainty.

Woman Question during *Perestroika* and *Glasnost*

The woman question was again revisited though discussions were often indecisive and contradictory. On the one hand, Gorbachev acknowledged that women had failed to climb to the upper echelons of professional and political life, acknowledging the inequality that existed in the Soviet Union.[4] The official Soviet explanation of this gender inequality proclaimed

2 Vera Tolz, "'Cultural Bosses' as Patrons and Clients: The Functioning of the Soviet Creative Unions in the Postwar Period," *Contemporary European History* 11, no. 1 (2002): 87–105, http://www.jstor.org/stable/20081818.

3 Some two hundred previously lost films were found at Gosfilmofond and screened at the Giornate del Cinema Muto in Italy in 1989.

4 Attwood, *Red Women*, 104.

that because women carried the primary responsibility for childcare and domestic chores, they had less time for careers and political roles; yet there was no effort made to remedy the situation. Although some concluded that traditional attitudes toward women resulted in discrimination, others felt that women were still less politically conscious than men.[5] In response to these rather degrading official ideas, there was some initial progress at giving women more opportunities in the workplace. For example, women in the film industry joined together internationally with other female filmmakers to create their own association called KIWI (Kino Women International) in 1987, which was tasked with promoting women filmmakers, until it was abandoned in 1991 because of funding issues and conflicts between the different republics and former Soviet bloc countries.[6]

Despite these small steps made for women in cinema and other industries, Gorbachev suggested that women's emphasis on work in the past had led to the neglect of the family, and that he wished to make it possible for women to return to "their purely womanly mission," giving birth to and raising good Soviet families.[7] The pro-family campaign that had begun in the 1940s was reimagined in the 1980s, as women were once again encouraged to be full-time mothers and homemakers. In fact, Russian female sociologists often talked positively about women's ability to now stay home, especially as the switch to the market economy under *perestroika* promised mass unemployment.[8] In other words, it was better for the nation if women returned to the role of housewife and mother, thus preserving the careers of men. Encouraging women to stay home became a coping mechanism for dealing with the consequences of the changing market. Some women rejoiced at the opportunity to perform just one job, instead of the triple workload of child rearing, housework, and professional work. For others, however, the suggestion that women return to the home increased the attractiveness of a Western-style feminism.[9] Interest in feminism was

5 Genia Browning, "Soviet Politics: Where are the Women?," in *Soviet Sisterhood*, ed. B. Holland (London: Fourth Estate, 1985), 210.
6 Attwood, *Red Women*, 106.
7 Ibid., 104.
8 Maxine Molyneux, "The 'Woman Question' in the Age of Perestroika," *Agenda: Empowering Women for Gender Equity* 10 (1991): 89–108.
9 See Holmgren for an explanation on why Western feminism cannot be imposed on Russian women: Beth Holmgren, "Bug Inspectors and Beauty Queens: The Problems of Translating Feminism into Russian," in *Postcommunism and the Body Politic*, ed. Ellen E. Berry (New York: New York University Press, 1995), 15–31.

fostered because the ban on autonomous organizations was lifted, allowing women to organize special interest groups. Several independent women's organizations such as KIWI rallied to defend women's careers and encouraged women to become more active in politics.[10]

Soiuzmultfilm in the 1980s

Progress towards gender equality in the animation industry was perhaps even slower than it was in live-action cinema, due to the economic crisis in late Soviet Russia. The studio, in the 1980s, was the largest animation studio in Europe and had won over one hundred prizes at international festivals. The studio broadened its boundaries, thematically and geographically, in ways that had not previously been allowed. For example, there were attempts at co-productions with other Eastern bloc and Western companies. But, while the success and openness of the studio meant that more female animation directors were able to create films that represented an evolving Soviet female subjectivity, the continued commitment to children's animation hindered this direction. More than eighty percent of animation produced during this time was made for children, and as MacFadyen suggests, animation for children was still seen as the height of adult creativity. He argues that in the 1980s Soviet animated films became even more childlike than they had been in the 1960s and 1970s.[11] In other words, those films that were made for children became even more closely connected to fantasy and make-believe, rather than looking to contemporary reality for source material.

Soiuzmultfilm also experienced a number of restructuring initiatives aimed at the governance, organization, and financing for the studio.[12] Historically, there had been two production associations within Soiuzmultfilm, focusing on cel animation and puppet animation, respectively. But the 1980s and the early 1990s saw different organizational production associations being formed, disbanded, and reformed. A new organizational plan attempted to split the cel and puppet production associations into subsections: cel animation, puppet animation, experimental animation, and Iurii Norstein's own personal unit. As Goskino began to

10 This is discussed at length in Attwood, *Red Women*, 99–106.
11 Sergei Asenin, "Fantaziia i istina," in *Mudrost' vymysla*, ed. Sergei Asenin (Moscow: Iskusstvo, 1983), 23 and MacFadyen, *Yellow Crocodiles*, 91–94.
12 Borodin, "Kinostudiia."

reduce the funding for animated films, there was increased competition among directors, not only for financial backing, but also for production space and services in the various workshops within Soiuzmultfilm. In 1988 Soiuzmultfilm instituted a new governing body called the Board, which consisted of the studio director, the head editor, the art directors of the different production associations, and several political positions. The Art Council was also given more powers than they previously had and took on the role of collective producer for all films at Soiuzmultfilm.[13] The numerous changes affected the studio's ability to make films, organize new courses, and to bring in new animators.

Despite the restructuring of governing boards, and the reduction in funding at Soiuzmultfilm, which created obstacles for female employment within the industry, the late 1980s saw more women in leadership roles within the studio and the industry. One of the highest ranking women was Nataliia Golovanova who served as the chairman of the Board from 1990 to 1996. Additionally, Ideia Garanina was elected chairman of the Creative Department at Soiuzmultfilm in the early 1990s. *Glasnost* and *perestroika* also allowed animators the possibility of thinking more theoretically about animation as an art form and incorporating these ideas into their animated films. Women also spoke more openly and candidly about their roles as mothers, artists and animators.

Nataliia Golovanova

One female animator who successfully navigated the turbulence of the late Soviet era and managed to influence the future of the animation industry was Nataliia Golovanova, animation director and chairman of the Board at Soiuzmultfilm in the early 1990s. Golovanova graduated from the director's department at VGIK in 1968 and began working at Soiuzmultfilm in 1969 as an assistant director. In terms of her technical contributions to animation, Golovanova designed a special technique called "stained glass," which involved a unique method of preparing, lighting, and filming the

13 The Art Council at this time discussed thematic plans and creative output, selected films for participation in festivals and workers for delegations, made decisions on financing films, awarded prizes, announced creative competitions, invited candidates for positions (directors and artists), managed conflict resolution between film crews and editorial boards. See Borodin, "Kinostudiia."

cels in order to replace static backgrounds with moving cels.[14] Like many other directors in the 1960s and 1970s, she began working at the studio creating Disney-style animation for children, based on both Western and Russian fairy-tales. She won prizes for her film *Fox and Bear* (*Lisa i medved*, 1975) at the Fourteenth International Film Festival for Children and Youth in Spain in 1976. Her other early films for children include *Zhikharka* (*Zhikharka*, 1977), *Poiga and the Fox* (*Poiga i lisa*, 1978), *Little Girl and the Bear* (*Devochka i medved*, 1980).

MacFadyen briefly analyzes the work of Golovanova but does not discuss her work as women's cinema, as he is not interested in a gendered approach. He suggests that Golovanova's film *A Boy is a Boy* (*Malchik kak malchik*, 1986) is an example of the "materialization of fantasy" in which materialism has been broken down and reduced on screen and then reimagined as an alternative to the Soviet existence.[15] His observation is valuable for understanding Golovanova's contribution to animation, as she does, indeed, offer a visual alternative to Soviet life, although her alternative is rooted, at least partially, in the family and motherhood. Golovanova also illustrates a new version of selfhood which focuses on exposing the double or triple burden (career, housework, and children), of which women in these years were acutely aware.

Unlike in her previous films, Golovanova chose to work with screenwriter Mariia Deinego on the script for *A Boy is a Boy*, thus solidifying the female voice that is the subtext for this film exploring Golovanova's own experience raising two sons. The role of motherhood, which is a consistent theme for female Soviet directors, is more politically nuanced during this time period than in previous decades. The film does not represent a Western feminist view, but it is proto-feminist, couched in the context of motherhood at the end of the Soviet Union. This type of motherhood is aptly described by Tatiana Tolstaia, writer, essayist, and publicist. According to Tolstaia, while Soviet women already had the basic rights that Western women fought for in the 1970s, they often purposely chose low-wage jobs, feeling that ambition was synonymous with corruption and that climbing the ladder to better pay and prestige, as Soviet men did,

14 "Golovanova, Nataliia Evgen'evna," accessed December 16, 2018, http://animator.ru/db/?p=show_person&pid=1957&sp=1.

15 MacFadyen, *Yellow Crocodiles*, 91.

left one morally bankrupt.[16] This might also explain why so few women became directors during previous decades. At a time when so much was in flux, politically and economically, women "tried to protect their own little space from the influence of the state. They locked themselves in with family and children."[17] Tolstaia argues that Soviet women remained true to themselves in the Soviet Union precisely because of their domestic lives. *A Boy is a Boy* can be read as a celebration of motherhood, a mother's protection of her child and by extension of childhood and imagination. In light of Tolstaia's vision of Soviet women, then the mother in this film shelters her son from the Soviet state, she is fearful of and encourages a more creative pursuit for her child, in an attempt to protect him as she protects herself from moral decline.

Fig. 18. *A Boy is a Boy* (*Malchik kak malchik*, 1986), courtesy of Soiuzmultfilm.

While many of Golovanova's earlier films like *Zhikharka* are representative of the Disney aesthetic style, *A Boy is a Boy* is a dramatic departure, which relies more heavily on abstraction to stress the importance of imagination. The film tells the story of Aliosha, a five- or six-year-old boy who lives a very imaginative life, and begins with line figures drawn in black on a white background,

16 Tatyana Tolstaya and Irena Maryniak, "The Human Spirit is Androgynous," *Index on Censorship* 19, no. 9 (2007): 29–30.

17 Ibid., 29.

representing the adult world as a stark, colorless space (see Fig. 18). The open-
ing scenes of the film contrast this adult world, without imagination, yet filled
with city streets, escalators, subway cars, and people—lots of people (the chaos
of which is shown via a tripartite split screen), with Aliosha's world of the park
with its wide-open spaces, wildlife, and imagination.

Aliosha connects with nature and, more importantly, with animals to
such an extent that he is transformed into a rabbit, a bird, a dog, and vari-
ous other animals during the film. Aliosha's transformations into different
animals are not just the workings of an overactive imagination; they are so
complete that people around him see him as the animal. Rachel Kearney
suggests that because animation is so firmly grounded in the imagina-
tion, the worlds that are created through the imagination allow viewers to
metaphorically "go" beyond everyday lived experience and to accept that
which otherwise would not make sense.[18] In this film the imaginative world
becomes a haven from the pressures of everyday life, from adulthood, and,
more importantly, from the Soviet state for the boy and anyone else willing
to join him—including the viewer. While his mother, a career woman, is at
times uneasy with his transformations, she also nurtures her son's imagi-
native behavior. After work, she takes him from the confines of their small
Soviet apartment and the urban world to the park. Here she takes off her
heels and relaxes under a tree while her son's imagination soars. She does
worry about his behavior and scolds him when he goes too far and becomes
the animal he is pretending to be. She even sends him to stand in the corner
and has his father take him to the doctor, all in an effort to make sure there
is nothing wrong with him. The mother's worries reflect her own inner con-
flict. Her desire to let her child be a child is at times at odds with her beliefs
and hopes that he is well prepared for school and that she is raising a son
who will be a contributing male member of Soviet society.

Aliosha turns out to be very well adjusted for school and fits right in.
His teacher is able to make the connection between an active imagination
and the genius of Russian poets, writers, and artists. As the teacher reads
Pushkin's poem *Ruslan and Liudmila* (*Ruslan i Liudmila*, 1820) to the young
students, the imaginations of Aliosha and his fellow classmates bring this
fantastic poem to life. Color appears for the first time in the film and the stu-
dents begin to fly around the room. The teacher briefly leaves the room and

18 Rachel Kearney, "The Joyous Reception: Animated Worlds and the Romantic
 Imagination," in *Animated 'Worlds,'* ed. Suzanne Buchan, David Surman, and Paul
 Ward (Bloomington: Indiana University Press, 2006), 1–2.

when she returns, Aliosha, who has turned into Pushkin's cat-poet, captures the teacher by piercing her with his quill (see Fig. 19). The teacher transforms into a bird-angel and joins the festivities in her classroom. The classroom provides Aliosha with an unexpected environment in which his imagination can survive and thrive. While the teacher's response appears at first negative, having run from the room, she is the first adult who has not lost her sense of imagination and along with Aliosha is able to transform into anything. She joins him and the other children in Pushkin's imaginary world.

Fig. 19. *A Boy is a Boy* (*Malchik kak malchik*, 1986), courtesy of Soiuzmultfilm.

Golovanova reminds her audience that imagination leads to creative pursuits such as art and literature. Aliosha's mother is correct in her assessment that her boy and his imagination are prepared for school. The collective imagination of Aliosha, his classmates, and the teacher, exemplified by the brilliance of the color, makes the world complete, literally coloring in the empty spaces seen in the earlier line drawings. Imagination, it would seem, in *A Boy is a Boy*, not only has a place in the adult world; it also has a positive influence in connecting to Russian national heritage. It is a necessity not only in a child's world, but in the adult's world as well. Imagination is an escape from reality, it also has the potential for creativity and the promise of a more colorful future. Golovanova's film suggests a way that

Soviet mothers can protect their children from the system (a suggestion that years earlier would have been unthinkable); she offers a coping mechanism for both mother and child, imagination. In this animated film, motherhood and the protection that a mother offers a child are important not only for the child's success but also for the mother's survival in a Communist world.

Golovanova's career and her works demonstrate that working mothers can be nurturers and have a professional life at the same time. She calls attention to the importance of the domestic sphere for cultivating the imagination and the fantasy world of future generations, as well as, by extension, the future of Russian culture. Soviet female subjectivity manifests in Golovanova's emphasis on imagination, motherhood, and the family and marks a shift in the themes found in late Soviet animation.

Nina Shorina

Nina Shorina's animated films are some of the most provocative in terms of women's cinema and Soviet female subjectivity. Shorina also began her career in the 1970s after a short span as a child actress. According to Jayne Piling in *Women and Animation*, Shorina abandoned acting because she literally did not like the feeling of being manhandled by directors.[19] Shorina started in animation creating advertisements and "ordered films" for television at Soiuztelefilm and Multtelefilm, before she became a director at Soiuzmultfilm in 1972.[20] She directed many films for children early in her career, including some well-loved literary adaptations, *Know-Nothing 2: A Meeting with a Magician* (*Neznaika 2: Vstrecha s volshebnikom*, 1976), *Moomintroll and the Comet: A Way Home* (*Mumi-troll i kometa: put domoi*, 1978) and *The Poodle* (*Pudel*, 1985). Throughout her career, Shorina worked in a variety of animation formats, including stop-motion 3D animation, pixilation, and cel animation, often combining multiple techniques within her films. Shorina has never been afraid to make films that she believed in, which occasionally caused her to run up against the Art Council. She is also an anomaly among the women we discuss in this book because she has occasionally written about animation and her career, thus offering a unique perspective on the changing field of late Soviet animation.

19 Pilling, *Women and Animation*, 103.
20 "Shorina, Nina Ivanovna," accessed December 5, 2018, http://animator.ru/db/?p=show_person&pid=1968&sp=1.

Shorina chose a career in animation because she believes that animation is unique: it is the only type of cinema where the artistic image, individual thinking, and personal style reign.[21] While she returned to live-action filmmaking in the late 1990s, she suggests that the animator has a different relationship with art than the live-action director: "Inside the cold multimedia space emptiness grows more and more; animation, which is done mainly by the artist's hands, is still trying to revive the steadily deadening world."[22] For Shorina, the presence of the artist and the manipulation of the materials by her hand add meaning and life to animation in a way that is not possible in a digitally mediated world.

Interestingly, modernist theories of live puppet theater appear in Shorina's own approach to her puppet films. Like the symbolist Russian puppeteer, Iulia Slonimskaia-Sazonova, Shorina believes that the puppet is the inner expression of the artist made tangible.[23] Slonimskaia-Sazonova, a writer, theater critic, historian, actress, and puppeteer, began writing about puppet theater in the 1910s, before she emigrated to Paris in the 1920s. Her writings were influential not only in the puppet theater, but also in modernist theater of Vsevolod Meyerhold. Slonimskaia-Sazonova's theories about puppets so closely aligned with Meyerhold's that he made her essay required reading for his State Workshop students in the 1920s.[24] Her belief that puppets represent "the victory of the forces of life over lifeless matter" makes an important distinction between live-action and puppet theater that Shorina also echoes in her own understanding of puppets on the screen.[25]

Shorina has a particular relationship with the objects that she works with, by means of her hands. She believes as an animator she adds not just movement, but life to the inanimate objects and thus she is able to create meaning where there was none. Shorina, like material performance theorists, focuses on the movement—the animation—of the object, the point that infuses independent life, agency, into an object in performance.[26] Shorina's

21 Kirill Razlogov, "Nina Shorina," in Margolina and Lozinskaia, *Nashi mul'tfil'my: litsa, kadry, eskizy, geroi, vospominaniia, interv'iu, stat'i, esse*, 252–255.

22 Ibid., 252.

23 Dassia N. Posner, "Life-Death and Disobedient Obedience: Russian Modernist Redefinitions of the Puppet," in *The Routledge Companion to Puppetry and Material Performance*, ed. Dassia N. Posner, Claudia Orenstein, and John Bell (London: Routledge, 2014), 130–137.

24 V. Zabrodin, *Eizenshtein o Meierkhol'de* (Moscow: Novoe izdatel'stvo, 2005), 120.

25 Iuliia Slonimskaia, "Marionetka," *Apollon*, March 3, 1916, 29.

26 Dassia N. Posner, "Material Performance," in Posner, Orenstein, and Bell, *The Routledge Companion to Puppetry and Material Performance*, 5–7.

self-expression, her philosophical views on the animator's use of objects, and her films, as a whole, differ significantly from the accepted Soviet ideology under which she began her career in the 1970s. In this way, she has advanced a formation of self-expression that subtly altered Soviet female subjectivity toward a more traditional Western version—a proto-feminist subjectivity.

There is an inclination among animation scholars, especially those who research women, to dismiss films made for children, not viewing these films as serious art. As mentioned in the introduction of this book, Piling acknowledges that women have had a more authoritative and creative role in films for children, but in general she dismisses this type of animation, considering it neither an art form, nor a form of personal expression, and, therefore, not part of women's cinema.[27] Piling maintains that Shorina was forced to make animation for children in the 1970s and early 1980s, and that she was only allowed to work on films for adults as a result of *perestroika* and *glasnost*. While it is true that animators were certainly allowed more freedom and breadth of topics during the collapse, as we have seen already, Soviet animators were very adept at addressing more than one target audience in their films. For example, in all her films Shorina utilizes differences in scale, materials, and movement that challenge the viewer's perception and appeal to both children and adults.

In her films for children, Shorina creates a veil of innocence that allows her to pursue narratives about female identity, the role of art, motherhood, objects of domestication, and the feminine in the formation of the self. For Shorina's stop-motion film *About Buka* (*Pro Buku*, 1984), utilizes bright colored backgrounds and puppets with stark white heads, decorated with geometric circles of different sizes to create characters reminiscent of Dymkovo toys. These toys are a type of Russian folkart handicraft constructed out of painted clay to resemble people and animals. Not surprisingly, this handicraft is traditionally created by the hands of women.[28] The film features a little girl called Buka, who refuses to eat her cereal, to find her lost shoe, or to get dressed and only wants to ride the tram around the city

27 Pilling, *Women and Animation*, 5.

28 The name comes from the town where the toys are made. Andrew Walker, "World War II and Modern Russia at the Philadelphia Museum of Art: The Christian Brinton Collection, 1941–1945," *Archives of American Art Journal* 41, no. 1/4 (2001): 34–42. See also N. N. Menchikova, *Viatskie narodye promysly i remesla: istoriia i sovermennost'* (Kirov: O-kratkoe, 2010).

and play with her friends outside.[29] By the end of the film she has managed to become not Buka, but Ania—an obedient little girl—who agrees to eat, dress, and act appropriately. She transforms into the perfect Soviet child, shaped under socialist realism, it seems, and serves as a model for other children.

Fig. 20. *About Buka* (*Pro Buku*, 1984), courtesy of Soiuzmultfilm.

Regardless of the ideological bent of this animation, it is also a tale that calls into question the formation of female identity through repurposed domestic objects. Shorina makes a clear connection between female identity and domesticated spaces. Shorina's objects have a past, and they reveal themselves in the film hidden under bright colors. While the town is drawn flatly in muted colors on cardboard, three dimensional objects are created with paper cups and discarded cartons, painted in bright colors. Objects associated with women's work—sewing, cooking, and self-care—are scattered throughout the scenes. Shorina's animation has a way of bringing life into inanimate objects, but it also distances the past associations of these objects to create something new. For example, we see an old spool appear

29 According to the *Large Academic Dictionary of the Russian Language*, Buka is a fantastical creature, which scares children. See *Bol'shoi akademicheskii slovar' russkogo iazyka*, ed. L. I. Balakhonova (Moscow: Nauka, 2004), vol. 2, 240.

and spring to life as a cat, and a matchbox transforms into a dog. Their liveness is accentuated by the flat background from which they came; shedding their inanimate past, the figures become something more. The items that jump out at the viewers are predominantly those related to the domestic space and women's work: repurposed spools of thread, coat hangers, hairpins, an old candy box, a coffee advertisement, a carton of milk, bars of soap, buttons, and thread (see Fig. 20). Not only is Buka being molded ideologically into the perfect Soviet child, she is also being shaped, literally, into a future adult woman by the objects that will surround her.

In *About Buka* the child is not powerless, and through her search for identity and difference, she alters the world around her. After refusing to eat and to get dressed, Buka finally dresses in a haphazard manner, with crazy uncombed hair, so that she can go out to play with the other children. Her demands turn a little boy into a ball, add a fancy tail to the dog, and she even manages to turn the world upside down, as the children now walk on their heads towards Buka. Buka's defiance of the rules in tandem with her imagination frees her friends from the confines that bind them, such as reality or gravity.

At the end of the film, a bottle of shampoo and multiple bars of soap march in to give Buka a bath; through this act she becomes Ania, a properly dressed, neatly coiffed, well-behaved little girl. Buka is forced to conform to society, but Shorina's objects—markers of women's work—litter the animation and redefine women's labor, from cooking and cleaning to the creative outlet and artistic endeavor, as part of the animated film. Repurposing these domesticated objects into art is an act of changing the intent of the objects. Even though Buka becomes Ania—a little girl who cares about her appearance—her change may also signal a return to the feminine and an opposition to the cultural modes of the Soviet Union that aimed to erase the differences between men and women. As Buka, it is difficult to tell whether she is male or female based on her appearance alone. The female subjectivity proposed by the film is grounded in the transformation of feminine objects, as well as the transformation of Buka. Together, they become weapons of a Soviet type of proto-feminism that through a process of defamiliarization reinscribes them with femininity.

Shorina continues her search for female identity in later films in more provocative ways. Her 1989 film *Alter Ego* (*Vtoraia ia*, 1989) is her most self-reflexive and most personal work, which serves as a self-portrait, and directly addresses women's issues and the formation of self. Shorina herself appears in this film, made for an adult audience, which is a combination

of puppet stop-motion, pixilation, collage, live action, and static images. Roger Noake, a Welsh animator, scholar, and instructor, has suggested that in this film, "it is the frame and the framing which carry meaning, rather than the narrative" and that her technique "breaks down boundaries between the animate and inanimate."[30] While Noake does not assign a gendered meaning to her framing, Shorina's technique not only adds to her relevance as an innovative filmmaker, but also creates a social commentary on femininity and being female in the Soviet Union during its final years.

This film, that begins with the artist's face obscured by chiaroscuro lighting and steam, is an example of how a female artist sees herself in a male-dominated artistic world. She accomplishes this connection by cycling Rembrandt's paintings, including a large number of self-portraits of the male artist, with shots of herself. A hand, Shorina's, turns the pages of an art book, past a portrait of Rembrandt's *The Night Watch*.[31] Shorina alternates and overlaps images of Rembrandt himself, the male figures he painted and the woman in the crowd in *The Night Watch* with various images of herself either in profile or glancing out a window, the art book in her hands. These images are superimposed over an image of a Russian church which vascillates in and out of visibility along with the steam. This series of cuts articulates that this is a film about a woman's place in a man's artistic world, at the same time that is situates Shorina, the artist within Russia and the domestic sphere. The next series of cross-cuts shows that a woman is often alone in this artistic world of men. The objects that Shorina chooses to animate are representative of Soviet women's double burden of housework and childcare, making it difficult and lonely for her as an artist. Toilet paper, meat grinder, pots, bowls, a toilet, and food in various stages of decomposition all illustrate the distraction and chaos which represent the cycle of never-ending housework consuming and destroying women's creative spirits. The food spreads across the art book, obliterating the images. The toilet paper, worn over the neck of a male papier-mâché figure, unrolls to cover and to disfigure Shorina's face, masking what identity remains. She is both made and unmade by the papier-mâché man. He makes her into a replica of himself, a paper person, he also unmakes not

30 Roger Noake, "Nina Shorina: the State of Narration," in Pilling, *Women and Animation*, 107.

31 Noake identifies Rembrandt's painting and the repetitive focus on the only woman in the painting, but he does not comment on the role of women in the film and Shorina as a female animator and artist. Ibid., 105.

only her identity, but also her feminity. Together, the toilet paper mask and the oversized bathrobe serve to obcure all notions of female subjectivity with the exception of motherhood. Domestic objects work to obscure her identity and to block her access to art, creativity, and identity.

Fig. 21. *Alter Ego* (*Vtoraia ia*, 1989), courtesy of Soiuzmultfilm.

Motherhood also appears to encroach on the ability of women to be creative: she holds a plastic baby doll swaddled in toilet paper and grasps the handle of a baby carriage. Motherhood, in this film, no longer is sacred as it was during the era of Stalin's great Soviet family. Shorina purposely selects objects like scales, empty boxes, and queues of people, that are indicative of the dying Soviet state and an oppressive domesticated sphere, connecting these objects to motherhood. In the film she queues in line with life-sized puppets, rocking a baby carriage, demonstrating the burden of the Soviet system not just on artists but on everyone (see Fig. 21). Shorina also uses repetition and superimpositions overloading the viewer and creating visual detritus that mirrors the trash strewn streets and queuing people being churned out of the meat grinder. Looming throughout in the background are images of Jesus Christ's sacrifice, his crucifixion and death, equating the way Soviet women sacrificed themselves for their children,

family, and for their country, obliterating their own identity. The collapse of the Soviet system brings a tangible change in the evolution of Soviet female subjectivity. Women depicted in the film demonstrate the destructive effects of the Soviet system on women's ability to create and preserve their former identity.

Noake suggests in his article that Shorina has developed a more complex thematic of identity and that simple notions of narrative resolution and narrative progression are inappropriate for her more mature films.[32] While his idea is undeniable in her later films, like *Alter Ego*, it is important that we also identify these complex themes of identity and difference in her films for children, such as *About Buka*. Taken together, the two films are in dialogue. In both films Shorina questions notions of femininity and female identity through the use of objects from the domestic sphere. Shorina's films create proto-feminist statements that reimagine female subjectivity in the Soviet State. Shorina's choice of objects and materials relate to a women's double or triple burden in the late Soviet Union, and this burden is implicated in the creation of meaning, identity, and creativity in her stop-motion films—whether for adults or children. Shorina purposely selects objects that are representative of female labor and domestic space, and thus recreates a transformational, philosophical, and a particularly feminist subjectivity in the search for a new identity for the animator and for the audience.

Ideia Garanina

Another filmmaker whose work not so subtly addresses the woman question is Ideia Garanina. Her feature-length film, *The Cat Who Walked by Herself* (*Koshka, kotoraia guliala sama po sebe*, 1988), is another reworking of the Rudyard Kipling tale *The Cat Who Walked by Himself*. The film reinterprets traditional women's roles, and does so in a way that greatly differs from Snezhko-Blotskaia's 1968 adaptation of the same story.[33]

Garanina came to animation rather late in her career and took a very different route from our earlier directors. Born in 1937 in the Irkutsk region, she began to study acting at the B. V. Shchukin theater school in Moscow in the 1950s. Garanina performed for many years in the Moscow Youth Theater. In

32 Ibid., 108.
33 See chapter 4 for a discussion of the Kipling tale and of Snezhko-Blotskaia's film in the 1960s.

1960 she moved on to television, briefly studying at the Moscow Television Center. From 1961 to 1964 she worked her way up to assistant director at the State Committee on Television and Radio Broadcasting. Garanina returned to school again in 1964 to study directing at VGIK, concentrating on animation. After graduating she worked for a short time at Multtelefilm and co-directed her first film at Ekran with Marianna Novogrudskaia, *Anansi, The Little Spider, and the Magic Wand* (*Pauchok Anansi i volshebnaia palochka*, 1973). Garanina then worked at Mosfilm, before settling in at Soiuzmultfilm, where she directed several films from 1976 until 1992, including *Poor Liza* (*Bednaia Liza*, 1972), and *Buffoonery* (*Balagan*, 1981).[34]

Garanina's background in acting and directing informed her approach to animation which she referred to as "live action."[35] The term references not only her use of puppets in animation, which imparts a sense of "liveness" not found in traditional cel animation, but also her use of elaborate sets and dynamic camera techniques. Her use of zoom, pan, rack focus, and dolly shots are more often associated with "live-action" filming than with animation of the time period. Garanina also takes a "live-action" approach to her use of dramatic lighting, such as "replacing the movement of the doll itself with various lighting and other effects that convey the subjective feelings of the character."[36] For instance, when the Man and Woman meet in *The Cat Who Walked by Herself*, we see a close-up shot of the woman's face, accentuated with soft focus and low-key lighting, a trick straight out of classical Hollywood cinema, establishing both her desirability and her ability to desire. The mouths of Garanina's dolls do not move when they speak, yet the viewer is left with the impression of speaking, because of the camera angles used, the lighting, and the subtle ways the dolls move. This live-action approach to stop-motion and cel animation was unique to Garanina and rather ingenious, in that this combination adds depth and complexity to a rather simple story.

Garanina's interpretation of the Kipling tale reflects the openness of *glasnost* and *perestroika*, which allows her to offer an interesting deviation from the story itself and from animation norms. Her take on the story differs greatly from both Kipling's and Snezhko-Blotskaia's versions, encompassing two lyrical digressions: the tale of the Red and White Books; and

34 "Ideia Nikolaevna Garanina," accessed March 05, 2018, http://www.animator.ru/db/?p=show_person&pid=1999.

35 Aleksandra Vasil'kova, "Ideia Garanina," in Margolina and Lozinskaia, *Nashi mul'tfil'my: litsa, kadry, eskizy, geroi, vospominaniia, interviu, stat'i, èsse*, 224.

36 Ibid.

the inclusion of other Kiplingesque tales—how the world was made, how the dog came to hide his bones, and how the man learned to ride a horse.[37] The most obvious deviation is in the naming of the film itself. In Kipling's tale, the Cat is gendered by the pronoun himself, and Snezhko-Blotskaia maintains the masculine gender of the Cat through the use of the masculine noun *kot*. Garanina changes the gender of the eponymous Cat, who is also the narrator of the film, using the more common, feminine word *koshka* to name the Cat. Another major difference is that Garanina's tale does not include the story of how the cat and the woman came to a compromise, although at the end of the film the Cat promises the Child to finish the tale another day. The open-endedness of the film and the promise that it will be continued another day give agency to the female voice and to the Cat's story, à la Scheherazade and the tales of *One Thousand and One Nights*; if the story never ends, the female storyteller retains her position of power over the narrative.

Fig. 22. *The Cat Who Walked by Herself* (*Koshka, kotoraia guliala sama po sebe*, 1988), courtesy of Soiuzmultfilm.

37 The vignettes are not actual stories found in Kipling's *Just So Stories*, but are similar in their construction—fables that explain the nature of different beasts.

Garanina's film also differs through the very distinct worlds that it creates with the use of live-action filmmaking techniques and the combination of cel and stop-motion animation, with each animation technique serving a separate function. The stop-motion puppet animation is connected to liveness and reality through the use of real objects being manipulated in real space, and the cel animation is firmly grounded in the imagination, as in Golovanova's *A Boy is a Boy*. Garanina uses cel animation to add stories that are not included in either of the previous versions of the tale, but are critical for the film's understanding of the beginning of time and humankind's relationship to the natural world. When discussing the power of cel animation to create new worlds, Kearney notes, "Cel animation is sometimes considered to be a subversive medium. Due to its graphic freedom from the rational and indexical, it has sometimes been connoted as an anarchic comment upon modernist society and culture, a 'world upside down.'"[38] In Garanina's film, cel animation is associated with the unknown, the chaos and randomness of the formation of life on earth (see Fig. 22). Wells, of course, also speaks about the graphic fluidity offered by cel animation to create worlds that defy the logic of reality and in doing so have the potential to be subversive and critical in nature through their ability to present a world of infinite possibility, as well as infinite instability.[39] For Garanina, that is exactly what cel animation offers: transformation and possibility through irrationality and fluidity. Cel animation is not a fixed world like that of the puppets or live-action film.

The cel animation in this film signifies, quite literally, the world of imagination. We first encounter the shift from stop motion to cel animation when the Cat, who serves as a surrogate mother or teacher, scolds the Child for pulling her tail. The Cat begins with the words reminiscent of a child's fairy tale, "This happened, this took place, this came about, in those age-old, in those far-off prehistoric times" (that is, "once upon a time . . ."). As the Cat speaks, we see the shift from stop-motion to cel animation. The beginning of the world before man, for Garanina, is a natural world connected to a world of imagination (see Fig. 22). It is a world of unfamiliar shapes and colors that transform and mutate into recognizable forms and abstractions. The primordial ooze transforms eventually into a great mastodon, among other things. This fantastical

38 Kearney, "The Joyous Reception," 4.
39 Wells, *Understanding Animation*, 68–69.

beginning of the world is combined with the use of a multi-plane animation method, dynamic zooming and camera movements, in addition to dolly-esque shots, creating a style more reminiscent of experimental animation than standard Soviet children's animation. This sequence requires suspension not only of disbelief, but of logic, and, more importantly, it requires imagination in order to make sense of everything we are seeing.

The connection between cel animation and imagination is reinforced later in the film when the Child is involved in the telling of the story. After the Child learns of how Man first came to ride the Horse, he tells the Cat of the adventures he would have if he could ride. The viewer is treated to the Child's imagination as he rides or, perhaps, flies with a horse all over the world (even America), with complete freedom and utter abandon. The viewer is encouraged to imagine what it would be like to ride fluidly with great speeds across land and sea, and because this is shown through a first-person perspective, the viewer, too, travels to exotic places as we experience what the Child imagines.

More subversive and critical than the imaginative musings of the Child are the sections that deal with the White Book and the Red Book. The first book teaches an understanding of the natural world, while the second one details man's atrocities against that world. This sequence is striking not just because of Garanina's unique combination of cel and stop-motion animation, but because of its overt critique of mankind. The story of the White Book includes the names of all living things in nature and begins with stop-motion which cuts to cel animation. Garanina uses the frost of the Child's nursery window (stop-motion) to transition to the frosty blue landscape (cel animation) with gusts of swirling white snow blowing across the frame. Garanina's camera movements paired with the cel animation create a pure, yet whimsical setting in the White Book section, which is in stark contrast to the destruction displayed by the Red Book.

The White Book concludes as the Dog tracks various animals, accompanied by ethereal choral music. The music stops and the silence is broken by the sound of shattering ice, as a black hole the size of a man's footprint appears on the screen, followed by other footprints and shards of ice. This is the transition to the Red Book. The Dog walks around wondering who could possibly have made such a mess of things. The scene then cuts back to a shot from outside the Child's bedroom window, of the Cat looking out the frosty window, shaking her head. As she tells the Dog that it was mankind who caused the destruction, the camera zooms

in for a close-up. This shot acts as a punctuation mark, accentuating the gravity of the Cat's accusation, as well as marking the difference between the imaginary world of the Cat's story and the reality where mankind is capable of such selfish atrocities.

The crimes against nature are so heinous that again the film shifts back and forth between cel animation and stop-motion, as it tells the story of the mysterious Quagga. The intercutting allows Garanina to fluctuate between a position of presentness, safety, and innocence (the Child's room) and a chaotic past where mankind is the source of danger and destruction (the Red Book). The death of the Quagga, a feminine-gendered noun in Russian, is harrowing, yet Garanina's use of cel animation allows the child spectator some distance from the events taking place on the screen. The sweet zebra-like creature appears to come right up to the camera, breaking the fourth wall, when suddenly there is a red flash and the sound of a gun. Haltingly, she makes her way to the foreground, before she stops and sinks sound-lessly to the ground, out of frame, in a series of dissolves (literally fading away). The scene cuts to a shot of the Quagga's small lifeless body, sur-rounded by emptiness, as the voice of the Cat tells us of mankind's cruelty. The blood stain beneath her grows until nothing else is left on the screen. The scene shifts briefly back to stop-motion, shot from outside the Child's room, as Cat tells the Child that the Red Book, contains all the names of animals and plants lost to this world through man's disregard. This addition to the Kipling tale allows for a criticism of humankind's destructive ways. The scene calls for wisdom and encourages a humanity that is respectful of other creatures. Garanina's animation proves that imagination is, in fact, power, which brings to this children's animated film philosophical discus-sions of the senseless violence of humankind and conservation.

For Garanina, cel animation is tied to a world of fluidity, metamor-phosis, and imagination, and marks a shift away from the presentness and realism of the puppet animation in her films. This is not to say that the puppet portions of *The Cat Who Walked by Herself* are devoid of imagina-tion, quite the contrary. As viewers, we are still expected to suspend disbe-lief, as we listen to the Cat tell the story behind the Woman's domestication of the Man and the animals. The stop-motion provides the framework for the present telling of the story, which functions as the backbone of the film. The presentness is reinforced through the opulent, multilayered sets (see Fig. 23), the puppets themselves, and the live-action-styled lighting and filmmaking techniques that Garanina used to make the film.

Fig. 23. *The Cat Who Walked by Herself* (*Koshka, kotoraia guliala sama po sebe*, 1988), courtesy of Soiuzmultfilm.

According to Wells, "three-dimensional animation is directly concerned with the expression of materiality, and, as such, the creation of a certain *meta*-reality which has the same physical property as the real world."[40] Garanina's stop-motion animation creates a world where logic, reason, and physicality prevail; a world that replicates our own lived reality, yet allows for talking cats. The talking Cat, also acting as babysitter or surrogate mother, is not the only subversive aspect to the stop-motion scenes in the film; the pagan pseudo-religiosity practiced by the Woman and the Woman herself subvert previously established Soviet norms. Before each animal is domesticated, the Woman performs a ritual where she sings the praises of, and calls upon, fire, sun, and moon to help her strike a deal with the Dog, Horse, and Cow. While this spell casting is a part of the original Kipling tale, Garanina enhances these scenes in her film, creating a stark difference between her work and Snezhko-Blotskaia's. This glorification of religiosity, albeit pagan, challenged the tenets of socialist realism and was only possible because of the liberalization of *perestroika*

40 Wells, *Understanding Animation*, 90.

and *glasnost*. Finally, subtly woven throughout the narrative is the fact that the Woman herself upsets all norms and ideological positionings; she is the one responsible for modern civilization. While the Man is physically fit, it is the Woman who has the brains and cunning necessary to tame the wilderness and potentially save the world.

Garanina's contribution to animation includes aesthetic, technical, and philosophical advancements that challenged the ideological status quo and put forward a pro-woman and proto-feminist understanding of the world.

Chapter 7

The End of an Era: Women's Animation and the Fall of the Soviet Union

The 1990s were a time of transition economically, politically, and socially, as the Soviet Union collapsed and the new Russian Federation was established. Various reforms enacted by Gorbachev in the 1980s, combined with unrest in the republics and satellite states in 1989, came to a head in February 1990 when Gorbachev permitted multi-party elections leading to the decentralization of the Communist party's political control. In August of 1991, reactionary conservative forces staged a coup, which failed, resulting in Gorbachev dissolving the Central Committee and stepping down. In December of 1991 the Soviet Union was disbanded and the Commonwealth of Independent States (CIS) took its place. Boris Yeltsin, who had just been elected as the president of the Russian Federation, became the head of the largest successor state of the former Soviet Union.

Socially, the fall of the Soviet Union brought about a reinvention of Russianness based on past traditions. Yeltsin made a show of breaking from Communism by removing a statue of Lenin from his office in the Kremlin, but he did not completely break the Russian Federation's connection to its Soviet past. For instance, the State Anthem of the Russian Federation has the same melody as the State Anthem of the Soviet Union, but with new lyrics written by children's author Sergei Mikhalkov. However, Yeltsin also initiated links to pre-Soviet Russia as a way of reestablishing a connection

to the Tsarist past. Thus, the Russian Federation's coat of arms with the two-headed eagle and the mounted figure slaying the dragon predates Peter the Great as a symbol of Russia. Economically, Yeltsin's plan included "a healthy mixed economy with a strong private sector" which included a privatization of the largest divestiture of state resources in history.[1] The privatization of media industries resulted in a turbulent transformation and restructuring in both the film and animation industries. Women directors rose to the challenge by assuming leadership roles, starting their own animation studios and producing more pro-woman themed films. They continued to add layers to female Soviet subjectivity in the post-Soviet period, but they did not jettison their Soviet past completely.

Privatization of Media Industries

The fall of the Soviet Union devastated the national film industry, which was privatized in a long drawn-out process that resulted in an almost complete collapse of Russian cinema, including a breakdown in both the structure of the film industry and the film distribution system. Movie theaters and audiences disappeared despite the fact that filmmakers were now allowed to openly address social problems and everyday reality. The focus on reality that began during *glasnost* and *perestroika* was pushed to extremes with *chernukha*—visually and thematically dark films, which focused on a naturalism inspired by problems long ignored during the Soviet Union: violence, drugs, and sexual promiscuity.[2] The general inability of live-action filmmakers to connect with their audiences after the fall of the Soviet Union made the recovery of the film industry an even lengthier process.[3] One positive change was the election of screenwriter, Mariia Zvereva, as vice-president of the Union of Cinematographers in 1990 in an effort to shake up the old political order in the industry.

1 Timothy Colton, *Russia* (New York: Oxford University Press, 2016), 100–102.
2 Volha Isakava, "Reality of Excess Chernukha film in the Late 1980s," in *Ruptures and Continuities in Soviet/Russian Cinema: Styles, Characters and Genres before and after the Collapse of the USSR*, ed. Birgit Beumers and Eugenie Zvonkine (New York: Routledge, 2017), 147–165.
3 There were a handful of live-action filmmakers that garnered audiences, Aleksei Balabanov and Sergei Mikhalkov, both come to mind here. See Susan Larsen, "National Identity, Cultural Authority, and the Post-Soviet Blockbuster: Nikita Mikhalkov and Aleksei Balabanov," *Slavic Review* 62, no 3 (2003): 491–511.

The end of the Soviet Union also brought about the collapse of the main studio that produced animated films, Soiuzmultfilm. The state relinquished control over the production of animation in the 1990s, and new animation studios emerged. Contrary to the direction at Soiuzmultfilm that concentrated on films for children, most of the films produced in the 1990s were screened at international film festivals and not made with a child audience in mind. While some animators, like Oleg Kuvaev, certainly turned to the *chernukha* and adult themes of live-action cinema, the new animation did not alienate the audience in the same way as live-action films. The privatization of the animation industry also ended the decades-long pattern of censorship. Previous chapters have demonstrated that animated films pushed the boundaries of censorship, but in the 1990s Russian animators were liberated from government control in ways not seen in the past, and while this may have freed animators to experiment, changes in the industry curtailed such experimentation. For instance, the shift towards CGI, computer generated imagery, alienated older generations of animators. The collapse of the Soviet Union also brought serious financial concerns to the animation industry. As the industry could no longer completely rely on the government's financial support, there was a shift towards regarding audience appeal, commercialism, and financial returns as decisive considerations that governed which animated films would be made.

The decline of Soiuzmultfilm was the result of many different factors that arose from the fall of the Soviet Union. Natalia Lukinykh, a film and animation critic, in her article "Soiuzmultfilm: traditions and ambitions" argues that Soiuzmultfilm began to collapse in the 1980s, but the ruin intensified in the 1990s. She maintains that panic, poverty, and tragedy replaced the creative and joyful collectives of the past. She blames several factors for the demise of the studio. First, the studio, housed in an old church, had small and cramped working spaces, making creative work difficult. In addition, there was no money to invest in new CGI technologies as Soiuzmultfilm had done in the 1930s when transitioning to cel animation, and finally, workers wanted to be paid fairly for their work.[4] Soiuzmultfilm was in turmoil; Garanina, elected Chairman of the Creative Department, said in the 1990s, "There is nowhere further for everything to fall."[5] The studio had hit rock bottom. Soiuzmultfilm was a studio founded under the principles of Communism and when the Soviet Union collapsed, so did its premier animation studio.

4 For more details about Soiuzmultfilm during this period see Natal'ia Lukinykh, "Soiuzmul'tfil'm: traditsii i ambitsii," *Iskusstvo kino* 2 (1991): 56–67.

5 Ibid., 65.

Indeed, both a power struggle and copyright issues contributed to the failure of the studio. In 1993, when Soiuzmultfilm lost state funding, the studio was broken into two parts, with one branch holding the rights to distribute the old films in order to raise funds and the other branch retaining the ability to create new animated films. As a way to finance new productions at Soiuzmultfilm, the studio signed a deal with the American company, Films by Jove, owned by Oleg Vidov and his wife Joan Borsten. Films by Jove purchased the worldwide rights, outside the CIS, to Souizmutltfilm's 547 most popular films for a period of ten years, and in return Souizmultfilm was to receive thirty-seven percent of the profits.[6] Films by Jove restored and dubbed the films into English for release on television and DVD. Profits, however, never materialized because the money was diverted into new soundtracks, lawsuits, and copyright protection. Both American and Russian courts debated the legality of the deal with conflicting outcomes.[7] In 2007 Russian businessman, Alisher Usmanov bought back the collection and donated it to the Russian state children's TV channel Bibigon.[8] In June 2011 on the eve of the 75th anniversary of the founding of Souizmultfilm, Norstein, Leonid Shvartsman, Andrei Khrzhanovskii, and Edvard Nazarov published a letter in *Novaia Gazeta* to Vladimir Putin and Dmitri Medvedev explaining the dire situation at Souizmultfilm and asking state support so that the studio could rise again to an operational level.[9] In response Putin promised support to Souizmultfilm.[10] Today, Soiuzmultfilm once again is owned by the state, the Ministry for Culture of Russia, but the studio has never regained its premier status.

During Soiuzmultfilm's financial difficulties and temporarily closure, the animation industry moved in various commercial directions.

6 Ivan Filippov, Iuliia Fedorinova, and Ekaterina Dolgosheeva, "Cheburashka luchshe Faberzhe," *Vedomosti*, April 11, 2007, accessed September 9, 2019, https://www.vedomosti.ru/newspaper/article.shtml?2007%2F04%2F11%2F123914.

7 "Battle over Russian Cartoons," *BBC News*, June 16, 2003, accessed September 9, 2019, http://news.bbc.co.uk/2/hi/entertainment/2981688.stm.

8 Olga Razumovskaia, "Studio Renews Fight for Soviet Cartoons," *Moscow Times*, August 17, 2010, accessed September 9, 2019, https://www.themoscowtimes.com/2010/08/17/studio-renews-fight-for-soviet-cartoons-a715.

9 Yuri Norstein, Leonid Shvartsman, Andrei Khrzhanovskii and Edvard Nazarov, "Kogo pozdravliat' s 75-letiem, esli Souizmul'tfil'ma uzhe net?," *Novaia gazeta*, no. 6, June 8, 2011, https://novayagazeta.ru/articles/2011/06/07/45255-kogo-pozdravlyat-s-75-letiem-esli-soyuzmultfilma-uzhe-net.

10 Stanislav Sokolov, Interview with Ekaterina Vyskokovskaia. "Kak seichas zhivet studiia Souizmul'tfil'm? Nad chem rabotaiut ee mastera? Kakova sud'ba otechestvennoi mul'tiplikatsii?," *Radio Maiak*, June 27, 2013, https://radiomayak.ru/shows/episode/id/1122612/.

Some animators moved into advertising as a way to earn a living, others left the country to work in foreign studios, and a smaller group attempted to open their own studios in order to keep making animated films. For instance, in 1988 Aleksandr Tatarskii, Igor Kovaliov, Anatolii Prokhorov, and Igor Gelashvili decided to establish Pilot, the first private animation studio.[11] Pilot managed to receive limited funding from the government for some of its projects and became one of the leading animation studios in post-Soviet Russia, providing opportunities to both male and female animators.[12] Independent studios, like Pilot, paid their workers twice as much as Soiuzmultfilm for the same work and hence they attracted talented animators and produced quality films.

With the economy and the studios struggling, many animators needed to be flexible in order to keep working, and Shorina is a good example of the ways women adapted in these chaotic years. Shorina moved to France in 1993 to work, but returned to Moscow in 1994 to organize her own studio Nina Shorina-Film, which ensured that she could make films she was passionate about.[13] A variety of other animation studios were established in the early 1990s, but due to the difficulties with distribution and financing most animated films made by pop-up studios were only screened at festivals and not released either theatrically or on television, and thus had limited exposure within the CIS.

The New Woman Question and Women's Cinema in the 1990s

Gorbachev's policies reopened the discussion about women and equality in the Soviet Union, which influenced the way filmmakers began to view women's cinema. As discussed in the introduction, the term women's cinema first appeared in print in Russia with Turovskaia's 1981 article. As the Soviet Union collapsed in June of 1991 the journal *The Art of Film* put out a special issue with a number of articles dedicated specifically to the concept of women's cinema, deepening the debate about how this term relates to Soviet cinema's past and future. The issue illustrates both the progress made regarding the consideration of a woman's cinema, and the limitations surrounding women's equality and Western feminism in Russia at the time.

11 For more information on Pilot see the studio's website at http://www.pilot-film.com.

12 Kononenko, "The Politics of Innocence," 286–287.

13 "Shorina, Nina Ivanovna."

The journal includes Turovskaia's article "Woman and Cinema," in which she discusses her interpretation of Roland Barthes's notion of myth in relation to Russian cinema. She asserts that Western feminist criticism has needed the myth—the utopian ideal of equality offered by socialist societies—to counteract capitalism and bourgeois culture. But Western feminism fails to consider how the bourgeois myth-linked with material security—separates Western women from Soviet women, which complicates the application of Western feminism in a Soviet, and as we argue, post-Soviet context.[14] Turovskaia suggests that Westerm feminist criticism hinges on the concepts of the family, motherhood, and the femme fatale, and that Western feminism does not accommodate the Soviet woman, who is alienated from the consumption of capitalism. The Western myth of family and motherhood is linked to the idea of the private home and "presupposes a huge industry for the production of household goods, starting with dishwashers . . . and ending with supermarkets . . . and fast food," which Soviet women never had and which remained rare in the 1990s.[15] Additionally, the sexualized femme fatale is virtually unknown to Soviet culture with its absence of eroticizing industries: fashion, advertisements, cosmetics, perfumes, jewelry. Turoskaia notes that "all of this never existed for the Soviet women—not even to this day."[16] Turovskaia's discussion of women's cinema and the mythologization of Soviet women opens the discussion about women not only in the industry, but also in the post-Soviet society in general. As the Soviet system collapsed, women did not immediately shed their Soviet mentalies. While Soviet and Russian female subjectivity came closer to resembling the Western version more during the 1990s than at any time earlier, as Turkovskaia points out and we agree, there remains a chasm between Russian, or Soviet, and Western feminism.

Western and Russian versions of feminism and femininity still remained divergent as the Soviet system was replaced by a new capitalistic framework in the 1990s. Holmgren reinforces Turovskaia's stance that Western feminism cannot be imposed on Russian women because one cannot assume a common ideology based on the experiences of certain privileged groups of Western women. Western feminism has produced a bias

14 Turovskaia, "Zhenshchina i kino," 131–137.
15 Ibid., 134.
16 Ibid., 135. While she may have been absent from Soviet culture, the femme fatale was a staple of pre-Revolutionary art, literature, theater, and cinema, especially the urban melodramas of Evgenii Bauer.

that does not take into account the political traditions and historical perspective of Russian women.[17] During and after the Thaw filmmakers and animators started to tackle issues related to femininity, beauty, and even sexuality, yet female subjectivity still differed from the Western model.[18] In animation, directors like Snezhko-Blotskaia and Kovalevskaia initiated the reinvention of Soviet femininity which included both notions of beauty and hints of sexuality as parts of female Soviet subjectivity. Directors making films in the 1980s and 1990s, like Shorina, shifted away from purely feminine representations to explore the implications of sexuality and identity, as part of a new direction for female subjectivity in animation.

One of the reasons for the late arrival of sexuality in Russian animation was the Soviet state's neglect of the domestic sphere, which also limited the production of specialized goods and services for women, including fashion and beauty products. According to Russian social anthropologist Irina Popova, during the Soviet era, most women had no choice but to wear frumpy clothes, work full-time jobs, and maintain homes.[19] They had no time to explore sexuality. The result in the post-Soviet period was the adoption of the myth of man as the competitive, capable, and committed employee in this new capitalist system, which left woman in the secondary position as helpmate. Popova notes that the consequences for Russian women were very far from liberation in a Western sense, it was "considered liberation to be a sex symbol, get married early and stay home with the kids."[20] Popova believes that Russian society in the 1990s was similar to that of 1950s America, when homemakers and wholesome movie stars were idealized, but in Russia's case, because of the rebellion against the state-decreed sexual puritanism of the Soviet era, the ideal Russian woman was more sex kitten than girl next door. While not all women directors explored sexuality in animated films, this theme appeared in Russia during the first years of the post-Soviet period. Despite the inequalities inherent in Russia's new capitalist system, women managed to be more vocal and more visible than in the past. Few industries were as condusive to these changes as the animation industry where women directors became leaders and helped to redefine what female subjectivity and femininity meant to women in post-Soviet Russia.

17 Holmgren, "Bug Inspectors and Beauty Queens," 17–20.
18 For an example of how this functioned in live-action cinema see Leigh, "A Laughing Matter," 112–133.
19 Elizabeth Shogren, "Russia's Equality Erosion," *Los Angeles Times*, February 11, 1993, 1.
20 For Popova's discussion of new Russian feminism see ibid., 1–2.

Mariia Muat

Mariia Muat is one animator whose work helps to redefine female subjectivity from the 1990s onward. Her career in puppet animation is the result of persistence and dedication despite the obstacles she faced. Born in 1951 in Moscow, Muat entered the Theater Academy (GITIS) after two failed attempts, where she worked on her only student stage production under the directorship of Sergei Obraztsov, the famous Soviet puppeteer, before turning to animation.[21] Later, at Multtelefilm, she worked her way up the ladder, finally directing her first puppet film *Uncle Ahu in Town* (*Diadiushkia Au v gorode*, 1979). Her dedication to puppet animation solidified in the 1980s, but her decision came at an unusual time for the art form. In the 1960s and 1970s under male directors like Norstein and Kachanov stop-motion and puppet animation was considered high art, but its status waned during the budget shortages of the 1980s and 1990s. Regardless of its loss in status, Muat became interested in combining puppet animation with literary adaptations for children while working at Multtelefilm, and in 1983 she directed *Humpty Dumpty* (*Shaltai-Boltai*, 1983) based on Samuel Marshak's translation of the English nursery rhyme.

Leaving Multtelefilm, Muat joined the puppet division of Soiuzmultfilm in 1988, often working with her husband and playwright, Vladimir Golovanov. As the Soviet Union collapsed, puppet animation experienced two different crises: one financial and one spiritual.[22] Larisa Maliukova, a leading film critic, screenwriter, and publicist, suggests that when the Soviet Union fell, puppet animation was hit harder than other forms of animation, "The puppeteers were swept out with a broom from their home studio in an Arbat alley and literally scattered around the world."[23] Losing studio space and budgets forced puppet animators to think and work creatively and allowed them time to ponder the nature of puppet animation. Like Shorina, Muat assumes a philosophical approach to her puppet animation, which is pivotal to her development as an entrepreneur and as a director. Muat also saw the need for more creative approaches to film financing, an insight which would serve her well in the years to come, as a way to ensure the protection of her vision for puppet animation.

21 Muat's parents, who also had theatrical backgrounds and worked at GITIS, refused to pull strings to get her into the academy. Larisa Maliukova, "Igrushechnye istorii Marii Muat," *Iskusstvo kino* 6 (2003): 69.

22 Ibid., 69.

23 Ibid., 70.

Muat's first experience working on a foreign project came in the early 1990s when Soiuzmultfilm participated in the creation of a series of films adapted from the works of William Shakespeare, financed by BBC, S4C, and Christmas Films. She directed the puppet film based on *Twelfth Night* (*Dvenadtsataia noch*, 1993). These years at Soiuzmultfilm allowed Muat to understand the difference between Russian puppet animation and Western forms, which encouraged her to set about saving the soul of Russian puppet animation. Muat felt that the "English puppets have more facial expressions, more plasticity," yet she did not like working with them because she considered them too life-like and felt limited by the British puppets.[24] Muat's approach was influenced by her teacher, Obraztsov, but also by the modernist puppeteer Nina Simonovich-Efimova, who was his teacher.[25] Simonovich-Efimova was responsible for the appearance of puppet theaters throughout the Soviet Union. She "believed that the essential truth lies in the puppet itself, in its limitless expressive capacity" and that "these little actors do not have facial expression, but they do have effective gesture."[26] The gesture is what brings life to the otherwise inanimate, lifeless puppet. This movement and its connection to expressivity are what prevents the puppet from being an automaton, but it is the connection between the artist and the puppet that brings the greatest success. Muat brought Simonovich-Efimova's theories into contemporary puppet animation in the 1980s and 1990s, through her thoughtful practice and promotion of stop-motion filmmaking.

Muat soon left Soiuzmultfilm to pursue new opportunities with startup studios, solidifying her role as an entrepreneur within the animation industry. As the funding structures changed with the fall of the Soviet Union, the Russian government continued to finance animation, but at much smaller investment rates.[27] Muat, along with her colleagues, was able to receive some of this funding for various projects, and from 1994 to 2002 she helped to establish several animation studios in an attempt to fulfill her goal to bring literary classics to children through animated films. Part

24 Ibid., 69.

25 Henryk Jurkowski and Penny Francis, *A History of European Puppetry*, vol. 2: *The Twentieth Century* (Lewiston, NY: Edwin Mellen, 1998), 105; and Posner, "Life-Death and Disobedient Obedience," 137.

26 Nina Simonovich-Efimova, "O Petrushke," *Vestnik teatra* 34 (September 23–28, 1919): 6–8.

27 Borodin, "Kinostudiia."

of her desire to form new studios was the distance she often felt from the creative process given the constraints placed on the animator from the outside world.

For example, these external pressures are evident at the studio Animatograf, which Muat helped found in 1994 to create animated puppet films for television. Muat's experience at Animatograf demonstrates how she learned to adapt, to innovate, and to lead. At Animatograf, Muat directed Russia's first full-length puppet animation *Kings and Cabbages* (*Koroli i kapusta*, 1996) based on O. Henry's 1904 novel of the same name. Even with help from the Russian government Muat struggled to fund the film: "The state gives money just to sustain this kind of art, and in such an amount, so as not to die from hunger. You can't make money on this. It turns out to be some kind of nonsense. We make films out of love for art, but still we make them for the audience, or what's the point of doing this?"[28] Despite the poor funding, Muat was able to complete *Kings and Cabbages,* while there was financial and emotional strain on the animators during the production process it was balanced by Muat's passionate commitment to finishing the project. In the end *Kings and Cabbages* was supported financially by the Committee of the Russian Federation for Cinematography and Moscow's Children's Fund (despite the adult themes in the film).

Like Garanina in *The Cat Who Walked by Herself*, Muat utilizes a number of different animation techniques: cel animation, puppet stop-motion animation, and cut-out animation, in order to add layers of mystery and illusion to *Kings and Cabbages*. O. Henry's novel is a collection of interwoven short stories that occur in the fictional country of Anchuria. He uses a writing style reminiscent of satirical vaudevillian slapstick to depict US fruit companies, who were putting up puppet governments in Latin American to be able to trade without regulation.[29] In Muat's film, two main plot threads are interwoven with multiple digressions, making the film's plot similar to the disjointedness of O. Henry's novel. Muat's plot includes O. Henry's themes of revolving dictators and the power of people to bring about change. However, she focuses mostly on Anchuria as an exotic "land of mysteries, love, flowers and whisky," creating a space that is

28 See Muat's more detailed response to *Kings and Cabbages* see Elena Konovalova, "Mariia Muat: 'Chuvstvuiu sebia Karabasom-Barabasom,'" accessed November 7, 2017, http://newslab.ru/article/312607.

29 Malcolm D. McLean, "O. Henry in Honduras," *American Literary Realism, 1870–1910* 1, no. 3 (1968): 39–46.

very unRussian and allows her to more than hint at the sexual undertones in this film.[30] For instance, in the opening sequence, the president's airship spots Anchuria through binoculars. From above, the island looks like a naked woman floating in the water. In reaction to the voluptuous island of Anchuria the airship sprouts numerous erections, or rather devices for listening and looking at the island. So, from the very beginning of the film, Muat establishes the female body as an exotic, erotic object of male gaze. The sexual references and overt voyeurism thus making this film decidedly not a children's animation.

Fig. 24. *Kings and Cabbages* (*Koroli i kapusta*, 1996)

While O. Henry's novel is really a tale of the machinations of men and power, Muat uses a mix of animation techniques to illustrate the power of women's sexuality within the story. Muat's female puppets are impressive exaggerations of femininity; most have large lips, protruding hips, bulbous butts, and heaving bosoms. They are in essence larger than life amalgamations of feminine sexuality and overshadow the male puppets. Muat's female puppets and their suggestive movements exude not just femininity, but sexuality; hinting at a new type of post-Soviet feminism, in which women use their sexuality to wield their power over men. Even the savviest of male characters are influenced by women at some point in the

30 Konovalova, "Mariia Muat."

film, bringing the femme fatale character to the screen for the first time in Russian animated film (see Fig. 24).

Fig. 25. *Kings and Cabbages* (*Koroli i kapusta*, 1996)

Muat incorporates female sexuality into both plot lines in the film. For instance, her first plot line involves the president of Anchuria, who flees with the sexy cabaret singer, Isabel, and a suitcase of the state's money. Detailed colorful puppets, smooth stop-motion animation, and the creative use of lighting brings both, the passion and suspense of this plot, together. Like O. Henry's novel, the film includes vaudevillian slapstick style humor and digressions, of which the most provocative is a flashback to the evening when the president and Isabel fall in love. The flashback is created with sepia-toned cut-outs and a multiplane camera, giving the scene an old-fashioned, romantic feel, complete with intertitles crafted in the style of silent films (see Fig. 25). The use of the silent film aesthetic, harkens back to the silent comedies of Anton Fertner, like *Antosha Ruined by a Corset* (*Antoshu korset pogubil*, 1916, Eduard Puchalski), which utilized sex and promiscuity combined with slapstick comedy to create the humor.

The second plot twist depicts the president's son, who falls in love with Jessica, the barmaid. Her ample bottom filling the screen, Jessica attacks the president's son with a frying pan after he tickles her foot with a feather. The two fall in love instantly and he promises to marry her. In keeping with Nina Simonovich-Efimova's theory that it is through gesture that puppets are

endowed with "limitless expressive capacity," Muat's puppets have mouths and eyes that move, but emotion is conveyed through gesture.[31] Through movements and the use of shadows Muat brings her puppets to life in this scene. The Puppets fight and fall in love, and through these movements they are imbued with a sensuality and expressivity that draws the audience into the scene. The use of the frying pan as a domestic weapon is also reminiscent of other female animators like the Brumbergs, Khodataeva, and Shorina. Muat adds a post-Soviet nuance as the frying pan and violence lead to an overt display of sexuality linking the domestic sphere not only to power, but also to sex.

Audiences, however, did not embrace *Kings and Cabbages*. The film was only screened a few times on Russian television before it all but disappeared. While the Animatograf studio still exists today, the studio now focuses on digital animated films—a much more profitable and less time-consuming direction. This experience, however, set the stage for Muat to launch a successful production company, Pchela which is dedicated to puppet animation and to helping new animators enter in the field.

Anna Belonogova and CGI

Anna Belonogova began her animation career during these chaotic years and became one of the preeminent mentors to other women animators in post-Soviet Russia. While her name may not be as well-known as some other women directors working today, her impact on the field cannot be underestimated. Belonogova studied animation during one of the most trying times in Russian animation history. The changes in both the financial structure of the industry and the technological changes drastically affected the field of animation and the animator's role within it.

Belonogova was part of the first wave of animators who received computer instruction at VGIK. The first computers appeared in the animation department at VGIK in the mid-1980s, and the first computer graphics courses were taught in the beginning of 1989.[32] By the early 1990s, a new emphasis on animation and computer graphics was started, but the first group of computer animators did not become an integral part of the production and direction departments until 1995.[33] Students used well-known

31 Dassia N. Posner, "Life-Death and Disobedient Obedience," *The Routledge Companion to Puppetry and Material Performance*, New York: Routledge, 2014, p.139.

32 "Fakul'tet animatsii i mul'timediia—samyi molodoi vo VGIKe," accessed August 30, 2018, http://www.vgik.info/teaching/animation/.

33 Ibid.

commercial animation software, such as 3D-Studio Max, Animator Pro, and Photoshop; they were instructed in all areas of animation production—scanning the source material, dubbing, editing, and making titles.[34] Graduating students were no longer expected to be making children's animation when they finished, but considered careers in advertising, special effects, and video gaming. This new computer education also radically changed the students' focus away from one final or diploma film; instead, animation students were able to direct and create multiple films during their student years.

Belonogova faced several setbacks while she was an animation student. Despite new technological advancements in the 1990s, students struggled to make their films and screen them for audiences. All of Belonogova's early films are for children, yet her plans were much grander in terms of innovations in the animation industry. She had wanted to work on an adaptation of Gabriela Garcia Marquez's early works, but was discouraged and blocked by her instructors who warned her of copyright issues.[35] Despite this creative roadblock, she continued to persevere, set high goals for herself, and continued working. For instance, she worked to save money in order to reshoot one of her films with a specialized VGIK camera that would allow her film to be screened on television, garnering a broader audience and more exposure.[36] Belonogova's experience shows that while censorship did not exist in the same form after the fall of the Soviet Union, students still experienced barriers due to financial constraints and copyright issues.

Belonogova completed three student films, all of which won prestigious awards. In her work Belonogova utilizes the unexpected as the punchline to her films, which is an especially pertinent theme given the economic, political, and cultural upheaval that Russia was going through when she was in school. Her first student film, *I'll Eat Breakfast Myself* (*Zavtrak siesh sam*, 1995), is a two-minute black and white film about a mouse with a surprise twist ending. While the viewer believes the mouse is about to have breakfast from a huge vat of sour cream, in an unforeseen turn, there is the black cat hidden in the vat who makes a nice little breakfast of the mouse. One of the more liberating changes in the post-Soviet animation industry was that students could more easily showcase their films in international

34 Aleksei Orlov, "Tri prekrasnye damy," *Isskustvo Kino* 9 (2000): 117–119, accessed August 30, 2018, http://kinoart.ru/archive/2000/09/n9-article22.
35 For more details about Belonogova's student years see Orlov, "Tri prekrasnye damy."
36 The internet now helps with exposure beyond Russia. Belonogova's films can be seen on her Youtube channel.

festivals. For instance, Belonogova screened *I'll Eat Breakfast Myself* at both the Leipzig Festival in 1995 and the Tarusa Festival in 1996.

Belonogova's second student film, *How Volodia Quickly Flew down the Hill* (*Kak Volodia bystro s gorochki letel*, 1996) is based on a poem by Daniil Kharms written in 1936, which she uses to narrate the film.[37] A testament to her skills with digital animation, the credits note that the film was made using Animator Pro, Adobe Photoshop 3.5, Pro Tools and Fast V.M. In the film, as in Kharms's poem, Volodia descends the hill on his sled, running into and collecting a hunter and various animals along the way. The poem and the film both end with Volodia crashing into a bear, making it impossible to continue sledding down the hill. The poem concludes, in the typical Kharmsian absurdist style, with the following lines: "From that time, Volodia no longer sleds down the hill," leaving the reader unsure of what happens next, perhaps assuming that the bear eats Volodia.[38] In Belonogovian style, the film has a turn of events. The bear does not eat Volodia, though for a second it does look like he might eat the sled. Instead, the bear smiles, runs off with the sled slung around his waist, and takes the sled down the hill for a gleeful solo ride. Belonogova's characters are endearing and whimsical with large expressive eyes and are accentuated with bright colors against the white snow. This film with its joyful surprise ending won the prize for Best Artist at the VGIK festival in 1998.

Belonogova's third and final student film, *Not-a-kopek* (*Nikopeika*, 2000), came out in 2000. She began this film in 1996 with the storyboards and characters. The film was shot on a Betacam video under time pressure due to financial obstacles that earlier generations could not have imagined. Belonogova was paying for her education and she simply did not have the money to pay for the use of the camera she had intended for her film.[39] This film is based on the poem "Market Square" by A. A. Milne (*When We Were Very Young*, 1924) and, characteristically, Belonogova adds a plot twist to the original poem. In the poem, a little boy heads to a market to buy a little rabbit with his penny. He is tempted by many different sellers, but he is unable to find the bunny he so desires and leaves the market without one.

37 This poem first appeared in the Soviet children's magazine *Chizh* 12 (1936). It is based on a poem by the German poet Wilhelm Busch.

38 I. B. Kondakov, "Nichego tut ne poimesh'! Diskurs detstva v poezii D. Kharmsa," *Obshchestvennye nauki i sovremennost'* 2 (2004): 154–165.

39 Orlov, "Tri prekrasnye damy."

Fig. 26. *Not-a-kopek* (*Nikopeika,* 2000)

Belonogova's film is set in a distinctly Russian market featuring nesting dolls, traditional stalls selling food, and rides. With his penny to spend, the boy pushes through crowded stalls looking for a bunny. When he offers his penny to the vendor selling a bunny made of fruit, the vendor offers him just one banana. Finding more money, he shows it to another vendor, who offers him a tankard of beer, while another woman shows him a cooked rabbit. Shocked by the woman selling cooked rabbit, the little boy flees the market, following a bird who leads him to a carrot strewn path. He eventually abandons the money he has found to the bird and, unlike the poem, finds the perfect bunny friend in a nearby field (see Fig. 26). As in her other films, Belonogova's characters are amplified by large expressive eyes and bright colors against a colorless background, allowing the sole focus to be on the characters in the frame. In the final scene, the little boy and his bunny jump through the air and hop from treetop to treetop, as if they are almost flying, using fantasy and imagination to end the film.

Like the films of Golovanova, we are reminded of Kearney's suggestion that worlds created through the use of imagination allow viewers to metaphorically "go" beyond everyday lived experience and to accept that which otherwise would not make sense.[40] Belonogova's film finds a way for viewers to imagine the impossible, to forgo the familiar sights and sounds of the market, and through her camerawork and drawing to feel as if they, too,

40 Kearney, "The Joyous Reception," 1–2.

are jumping alongside the boy and rabbit along the treetops. Animation and the power of imagination allows the boy's dreams to take him and the viewer beyond the expected. This same rupture between the everyday and the nonsensical may have been what people felt as the Soviet Union fell and the system that had been in place for seventy years was no longer: a sense of freedom combined with the impossible and the unknown.

Belonogova has continued working, doing commercial work for television, and eventually moved from behind the camera to the front of the classroom where she has become a mentor to future animators. Belogovona is now an instructor at VGIK teaching her own animation students and shaping the future of Russian animation. Belonogova now keeps a Youtube channel where she periodically posts compilations of her students' work. A recent post reveals that out of twenty-one students featured in the clip, only three are males, illustrating that Belonogova is now inspiring new generations of female animators.[41]

Aware of the contributions of women to Soviet and Russian animation history, Belonogova authored one of the only works in Russian that highlights the labor of women in the industry. Belonogova is the first female animator to theoretically link the term "women's cinema" with animation. In her article, Belonogova makes a case for the need to examine women's animation: "if we look at the problematics, the figurative and stylistic language of women's films, it becomes clear that they are not inferior to men in the pursuit of beauty, or in the breadth of creative thought, or in the discovery of artistic devices. And on the part of sincerity, confidence and purity sometimes surpass them."[42] While she stops short of concluding that women's animation is inherently better than men's, Belonogova does advocate for the idea that women animators offer their own personal films, uniquely shaped by their lives as women in the Soviet and post-Soviet eras. In other words, she also identifies a female subjectivity in animated films made by women, a female subjectivity that we believe is still grappling with the affects of Soviet ideology and Russian misogyny

Belonogova also fights back against the negative associations with the term women's cinema (*zhenskoe kino*), suggesting that this term is often associated with cinema devoid of logic or design. She argues instead

41 Films made by Belonogova and her students are presented on her Youtube channel. See, for example, "Sbornyi rolik studentov-mul'tiplikatorov, take 5, pedagog Anna Belonogova," accessed August 30, 2018, https://www.youtube.com/channel/UCbHcKQ6MyF7MI4wl6GESuMQ.

42 Belonogova, "Gori, sverkhnovaia."

that women worked tirelessly and selflessly, despite difficult living conditions and family obligations, all of which adds value to their films. For Belonogova, that women were moved to make their mark in animation, "even with a kind of desperation," becomes evident on the screen.[43] Female animators may not have been as productive as men, and they may not have pushed for higher incomes and positions of power like the men around them, but, instead, they found fulfillment in their work. The films made by female animators were a way for women to express themselves poetically and intelligently, adding to the ethos and beauty of life.

This poetic intelligence is the thread that defines Belonogova's own films and the driving force for her as a teacher and mentor. The unexpected twists and turns that she includes in all of her films are examples of a poetic reflection on the demise of the Soviet state. Her more recent film also combines her playful surprise ending with a comment on gender in the twenty-first century. Belonogova's 2004 film *The Gift* (*Podarok*), supported by the Ministry of Culture and based on a poem by Genrikh Sapgir, actively skirts obvious gender roles. Sapgir's original poem is a contemplation about the best gift for grandmother's birthday, but visually, the film tells a different story. The father in the film wears not just the literal pants, but also the apron, as he makes breakfast for the family, and bakes a beautiful birthday cake. The mother dresses smartly and watches her husband's domestic activities. But even the parents in their gender non-conforming roles seem to misjudge the grandmother. While the parents give grandmother knitting needles and reading glasses as gifts, her grandson imagines her as the captain of a ship, a cavalry officer fighting a war, a train engineer. He imagines her in non-conforming gender roles and breaks ageist sterotypes as well as making a connection back to the original poem's notion that grandchildren are the most precious gifts.

Belonogova's defense of women's cinema and contributions to the animation industry make her and her films unequivocal examples of women's cinema and help to define female subjectivity in a post-Soviet context. Belonogova has influenced countless animators through her teaching and she has joined the many women before her who taught, but have received little recognition for their contributions, including such women as Elena Gavrilko, Svetlana Sichkar, Galina Barinova, Rosaliia Zelma, Elvira Maslova and Violetta Kolesnik. These women have influenced countless generations

43 Ibid.

of animators with their selfless work teaching the art of animation.[44] While their names are relatively unknown outside the classroom, they have cultivated the love of the art and animation in their students. Belonogova is among these influential women who insured that through teaching, "a new creative personality is cultivated—[which is] the future of art," and the future of Russian animation.[45] In the 1990s Belonogova and Muat both helped in their own way to lay the foundation for women in the animation industry in the post-Soviet period. Both women contributed to the idea of women's cinema within animation and strove to create an industry in which new animators would thrive.

44 Ibid.
45 Ibid.

Chapter 8

Women Navigating the Past and Looking to the Future

Russia entered the twenty-first century with a new president, Vladimir Putin, who brought to bear, both a desire to restore Russia's geopolitical status and an interest in economic liberalism creating a new future for the Russian Federation. The path to this new future has been complicated by many factors, including recession, territorial disputes, and political intrigue. The collapse of the Communist system allowed people to begin to voice their dissatisfaction on many issues, among them, gender inequality. Interestingly, the system that supposedly granted women equality with men had to collapse in order for the power dynamic to begin to shift. Many groups dedicated to gender issues have been formed, some as early as the mid-90s, like the Moscow Center for Gender Studies whose goal is to explore women's issues and gender inequality; or like the Women's Union of Russia, which aims to help women enter and succeed in the emerging market economy.[1] Groups like these have opened a dialogue about women's place in Russian life and industry, but feminism in Russia is still very different than Western feminism because of the political traditions and historical perspectives that have shaped it. Women animators have also contributed to the dialogue about the changing face of women's issues both inside and outside the animation industry.

1 The Women's Union of Russia was granted the status of a public-state organization in December 2018.

The animation industry, especially feature-length animated films and women's animation, has flourished in Russia since the economy became stronger in the 2000s and 2010s. In concluding, we will focus on areas of the animation industry which have made space for women's voices and women's animated film. Women in the 2000s and 2010s have approached the animation industry in various ways revealing their agency and intentionality in shaping female subjectivity. This final chapter is not meant to be an exhaustive investigation into women's animation in recent years, but rather an overview into the ways in which women directors have continued the themes and directions laid out by previous generations. Still grounded in children's animation, as in the past, this new generation of women animators have succeeded in the animation industry, mastering new technologies and aesthetic directions, tackling themes such as motherhood and the family, and championing women in their films. Mariia Muat, Iuliia Aronova, and Darina Shmidt are just a few directors who are developing and advancing Russian animation today. We identify three distinct ways women are shaping not only the industry, but also female subjectivity in animation: directing pioneering animated films, working with dedication at innovative studios, and mentoring newer animators. Their achievements in the animation industry boldly emerge amidst the challenges women face in Russia today.

The Animation Industry in the 2000s and 2010s

Over the past two decades, the increasing financial stability and the geographical expansion of the animation industry have given women more opportunities. The years following the fall of the Soviet Union were chaotic for the media industries, as filmmakers scrambled for limited state funds and competed for private funding. The animation industry today still mainly relies on government funding for production, so it has been vulnerable to economic fluctuations. Two economic recessions complicated the recovery of the animation industry. The first financial downturn, known as the Ruble Crisis, came to a head in 1998 under Yeltsin when the government abandoned its defense of a strong ruble exchange rate against the dollar, defaulted on domestic debt, and placed a ninety-day moratorium on

commercial external debt payments.[2] The Ruble Crisis directly affected the animation industry, as an all-time low of only seventeen films were made in 2000. As the economy rebounded under Putin, the Russian Government stepped in with state support for cinema, making it possible for a record number of sixty-eight animated films to be produced in 2004.[3]

The second economic recession in 2008–2009 was fueled by a drop in the price of crude oil, resulting in Russian markets plummeting more than a trillion dollars.[4] The consequence of the Great Recession was that the Russian government indefinitely postponed funding to animation studios, negatively impacting the industry and reinforcing the need for more self-financing. By 2010, the state animation budget was still half of what it had been in previous years, causing many of the animation studios to either close or be on the verge of closing. Pilot, for example, was the first independent animation studio to shut its doors due to financial hardship.[5] However, the industry has since begun a slow recovery. In 2011 state funding for animation reached 500 million rubles, increasing the volume of production to about 3000 minutes, and by 2017 production of animated film had surpassed 4200 minutes per year. The number of animation studios has also increased from thirty in 2011 to fifty in 2017.[6]

In response to variability of state funding, the industry has begun to take steps to become more self-reliant. One way has been to diversify geographically bringing more distinct voices by creating more studios and

2 During the decline in world commodity prices, countries heavily dependent on the export of raw materials were among those most severely hit. Petroleum, natural gas, metals, and timber accounted for more than eighty percent of Russian exports, leaving the country vulnerable to swings in world prices. As a result of the crisis, a default on state securities was declared, the national currency fell heavily. See Padma Desai, "Why Did the Ruble Collapse in August 1998?," *The American Economic Review* 90, no. 2 (2000): 48–52; and Nevafilm, *The Film Industry in the Russian Federation*, ed. André Lange (Strasbourgh: European Audiovisual Observatory, 2010).

3 Larisa Maliukova, "The State of the Art: Russian Animation Today," *Kinokultura* 23 (2009) accessed November 2, 2018, http://www.kinokultura.com/2009/23-maliukova.shtml.

4 Guy Faulconbridge, "Russian Stocks Shed over $1 Trillion in Crisis," *Reuters.com*, November 3, 2010, accessed June 28, 2019, https://www.reuters.com/article/us-markets-russia-trillion/russian-stocks-shed-over-1-trillion-in-crisis-idUSTRE4AC5M020081113.

5 For data on the animation industry see Sergei Merinov, "Pobedonosnoe umershchvlenie …," Livejournal.com, July 3, 2010, accessed December 12, 2018, https://sergey-merinov.livejournal.com/131015.html.

6 For these and other recent statistics see "Vstrecha s rossiiskimi mul'tiplikatorami," accessed September 15, 2018, http://kremlin.ru/events/president/news/54644.

hence more films from various parts of the Russian Federation.[7] Since the 2000s, animation is no longer dominated by Moscow, Soiuzmultfilm, and Multtelefilm. New Russian animation studios popped up in Saint Petersburg, Saratov, Ekaterinburg, Kazan, and Iaroslavl. One of the most influential studios, Melnitsa, located in St. Petersburg, was officially established in 1999, with financial backing from Sergei Selianov's STV Film Company. Melnitsa made space for women animators, most notably Darina Shmidt. Melnitsa is probably best known for its *Three Bogatyrs* series which has grossed over $135 million. With ten films in the series, the *Bogatyrs* franchise is the most successful in the history of Russian animation to date.

In the late 2000s the animation industry also attempted to position itself globally, with the help of the internet, in an effort to return to the level of success it enjoyed during the Soviet era. So while in previous years, the focus had been on getting Russian animated films into international festivals, in the 2000s the goal was to locate the animation on much smaller screens, like tablets, computers, and televisions all over the world. *Masha and the Bear* (*Masha i Medved'*, 2009–present), created by Oleg Kozuvkov and produced by Animaccord Animation Studio in Moscow, is one of the biggest multiplatform sensations to date, airing on television in over 100 countries and streaming worldwide on Netflix, iTunes, Google Play, and YouTube. In 2016 the *Masha and the Bear* episode "Recipe for Disaster" was the only non-music video to crack YouTube's 10 most watched video list, with over 2.9 billion views, and today the English version alone has 12.6 million subscribers, over 5 billion views, and earns 1.4 to 22.9 million dollars a year (this number does not take into account merchandising and live events).[8] However, the animation industry has only been able to attempt this more international approach with the active help and support from the government

7 For example, the studio Film Fay located in Kazan is sponsored in part by the local Kazan government, as well as other businesses, to create animated films to sell products. See "Film Fay Animatsionnaia studiia," accessed Feburary 28, 2020, http://filmfay.com/.

8 These statistics are distilled from the following sites: Elizaveta Vereykina, "Russian Animation Rises From Ashes of 1990s," *The Moscow Times*, May 25, 2015, https://www.themoscowtimes.com/2015/05/25/russian-animation-rises-from-ashes-of-1990s-a46842; Jordan Teicher, "Why a Russian cartoon bear is more popular than Taylor Swift on YouTube," *IBM*, March 19, 2018, https://www.ibm.com/blogs/industries/youtube-loves-russian-cartoon-bear-biggest-global-pop-stars/; "Masha and the Bear," *Socialblade*, accessed February 26, 2020, https://socialblade.com/youtube/user/mashabearen.

and the Cinema Fund.[9] Women like Muat have taken advantage of the current government funding structure, taking successfully funded pitches and forming small studios to produce the films. Many smaller studios have opened, and unfortunately, sometimes closed, during the last eighteen years, including Animos, Pchela, and Isolant, which were all started with the help of women animators.[10]

Today, the industry is still focusing on ways to finance films and relying less on governmental support. For example, by again looking to a Disney model, some companies are developing and marketing goods connected to their films to bring in additional revenue streams, a la *Masha and the Bear*. Studios are also targeting foreign export revenue, which was basically nonexistent before 2011, but exceeded 2.4 billion rubles in 2016.[11] This rise in foreign revenue is matched by domestic box office returns which have doubled in the same time frame. Finally, there is a move to create a large industrial technopark dedicated to animation. In 2017, Soiuzmultfilm moved to a new, larger building with the idea of attracting young fledgling studios to join them. While this may seem like a step backwards, toward the height of Soiuzmultfilm's domination, it actually would ease the burden individual companies face, because they could work more collaboratively and share the costs. The question still remains, what roles women will have in these new ventures and whether their small-scale businesses will be able to thrive in this collaborative but competitive atmosphere.

The Woman Question in the 2000s and 2010s

The current climate surrounding women's rights in the Russian Federation continues to be problematic, despite the 1993 Russian constitution which reaffirmed gender equality under the law. As before, this equality is nominal and women are still fighting for their rights, such as the right to choose any career path. The 1922 Soviet Labor Code banned women from dangerous careers in an effort to protect traditional women's roles such as

9 Will Tizard, "Russian Animation Proves to Be an International Draw," accessed December 10, 2018, https://variety.com/2018/film/global/russia-animation-international-1202800414.
10 Animos has been translated in various ways including Animose and Animouse.
11 See "Vstrecha s rossiiskimi mul'tiplikatorami."

childbearing and childcare.[12] These restrictions on women have continued in Putin's Russia. During his first year as president, Putin passed a government resolution that continued the ban on women in fields considered to be dangerous or too strenuous, prohibiting them from working in 456 professions including miner, carpenter, firefighter, train driver, blacksmith, and ship mechanic.[13]

In addition to professional prohibitions, women have continued to have their rights limited in other spheres. Most recently, in 2017, a law was passed to decriminalize certain types of domestic violence, making them only administrative offenses; this in a country where one woman dies of domestic violence approximately every forty minutes.[14] Governmental policies which increase gender inequality have spurred more Russian women to embrace feminism than in past decades. Some Russian feminists have looked to the West for guidance. For example, in 2018 Russian feminists created a list of rights they are actively pursuing, including changes to the domestic violence law, better paid maternity and paternity leave, abortion rights, divorce laws, and laws to eliminate the wage gap. Iuliia Alezeieva, an activist and volunteer at Sisters, a sexual assault NGO, suggests that "To a first world citizen these priorities won't look extreme but in Russia, they're almost radical."[15] While the goals may appear similar to those desired by Western feminists, one should remember that Russian feminism is significantly different due to the historical and social contexts in which is was formed.

In Putin's Russia, women are actively pursuing equality in a variety of areas including politics, art, business and through the community offered by internet support groups. Russian women are changing the understanding of womanhood and transforming the social and political fabric of Russia today. In the political sphere Russian women are working to obtain

12 Rosalie B. Levinson, "The Meaning of Sexual Equality: A Comparison of the Soviet and American Definitions," *New York Law School Journal of International & Comparative Law* 10 (1989): 151–182.

13 Tom Balmforth, "Barred from Hundreds of Occupations In Russia, A Few Women Fight Back," *RadioFreeEurope/RadioLiberty*, April 21, 2016, accessed December 18, 2018, www.rferl.org/a/russia-womens-occupations-limited-soviet-law/27680005.html.

14 Shaun Walker, "Putin approves legal change that decriminalises some domestic violence," *The Guardian*, February 7, 2017, accessed December 18, 2018, www.theguardian.com/world/2017/feb/07/putin-approves-change-to-law-decriminalising-domestic-violence.

15 Loretta Marie Perera, "Russia's Feminists Work to Smash the Taboo," *Moscow Times*, accessed February 21, 2018, https://themoscowtimes.com/articles/smashing-the-taboo-60587.

more representation. Despite comprising the majority of the population, women are still woefully underrepresented in politics. Female politicians hold only 61 out of 450 State Duma seats as of 2018. Alena Popova, a women's rights activist and former journalist who has twice run for Parliament, believes that unity is necessary to achieve these goals: "We have to strategize, to use all the doors we have to promote equality."[16] The internet has played an important role in bringing women together. Some of the internet groups are not political, but instead focus on everyday issues like family life, professional life, body-positive fashion, and supporting young mothers. Motherhood, careers, and supporting other women are the very themes that women animators often advance both in their films and in their interviews. So, in this way women animators reflect the thoughts and aspirations of women in contemporary Russia.

The arts have also been an important part of empowering women in Russia. Holmgren suggests that the most active Russian women in terms of social and political influence have been female journalists, media pundits, artists, and writers.[17] One of the most well-known and outspoken artist groups, Pussy Riot, a feminist punk rock collective, first performed in 2012 as a reaction to the Russian government's "overt display of heterosexist machismo," for which two of the members received two-year prison sentences.[18] Another example of women using art as a form of protest was an exhibition at London's White Space Gallery, *Women at Work: Subverting the Feminine in Post-Soviet Russia*. The exhibit features the work of contemporary artists Tatiana Antoshina, Vita Buivid, Olga Tobreluts, Gluklia, and Lera Nibiru, whose work speaks of their experience as women and "ultimately seeks to emphasise the role of the artists as active agents in the Russian art context, with the power to transform it."[19] The exhibited works address the power of women's subjectivity and its usefulness as a framework for the creation of art and political commentary.

16 "Feminism in Russia: On the Streets and Behind the Scenes," *Moscow Times*, February 21, 2018, https://themoscowtimes.com/photogalleries/feminism-in-russia-60586.

17 Beth Holmgren, "Toward an Understanding of Gendered Agency in Contemporary Russia," *Signs* 38, no. 3 (2013): 535–542.

18 Ibid., 537.

19 Katie Davis, "Women at Work: New Exhibition Aims to Subvert the Feminine in Post-Soviet Russia." *The Calvert Journal*, July 10, 2018, accessed December 7, 2018, https://www.calvertjournal.com/news/show/10476/women-at-work-new-exhibition-subverting-the-feminine-in-post-soviet-russia.

Russian women are also making their mark on the business world. Andrea Mazzarino, a human rights activist, suggests that Russian women entrepreneurs are dissatisfied with the male-dominated establishment and hence are looking for new forms of agency in business.[20] Business as a profession in post-Soviet society is considered by Russian journalists, politicians, and average citizens to be a male activity and is often connected with corruption and lack of morality. However, businesswomen are creating new social spaces for women and changing the understanding of womanhood and gender in their business ventures. Mazzarino argues that businesswomen "undermine cultural attitudes that motherhood and marriage are the only acceptable aspirations for women."[21] While the numbers of women-owned businesses are still staggeringly low in Russia, less than 30%, more women are now interested in opening their own businesses as a way to improve their lives and the lives of those around them, such as Muslim Latypova, Olga Slutsker, and Tatyana Bakalchuk, owners of the Bakhetle grocery chain, the Russian Fitness Group, and the internet store Wildberries, respectively.[22] Russian women animators have also managed to bring business, leadership, and art together in a way to support women and their choices. Despite the traditionally gendered power networks, which impede a women's movement into leadership positions, these women have become well-known animation directors, producers, studio owners, and educators, giving them a unique position in terms of redefining female selfhood on the screen.

The Evolution of Mariia Muat

Muat is an example of how women have changed the animation industry over the last few decades, combining business and animation. Muat has been a leading entrepreneur in terms of rethinking the animation industry and has made space for other women animators to develop their talent. Today her animation studio, Pchela, is dedicated to making children's films

20 Andrea Mazzarino, "Entrepreneurial Women and the Business of Self-Development in Global Russia," *Signs* 38, no. 3 (Spring 2013): 623–645, accessed December 07, 2017, http://www.jstor.org/stable/10.1086/668550.

21 Ibid.

22 Ibid. See aslo Tom Parfitt, "Former teacher Tatyana Bakalchuk is Russia's richest woman," *The Times*, February 21 2020, accessed February 29, 2020, https://www.thetimes.co.uk/article/former-teacher-tatyana-bakalchuk-is-russias-richest-woman-02cbh8nxq.

and releasing debut works of new animators.[23] Her perseverance has made her a strong advocate in the animation industry, helped her to advance both Russian classics for children and puppet animation, as well as to influence a new generation of animators.

From 1994 to 2002, Muat founded several animation studios in an attempt to save and revive puppet animation.[24] On the cusp of the twenty-first century, Muat was involved in starting Animos, which was funded in part by Christmas Films, S4C, and BBC, among others, to work on a television series called *Animated Tales of the World* (2000–2004). The partnership allowed Animos to buy equipment and to offer a variety of different animation styles, but on a small scale. In 2000 Muat directed *The Crown and the Scepter* (*Korona i skipetr*, 2000), as part of the series that aired on HBO in 2002. After 2002 Muat focused on classic Russian literature for children including *Lucy Girl and Grandpa Krylov* (*Devochka Liusia i dedushka Krylov*, 2003) and *About a Little Mouse* (*Pro myshonka*, 2004). In 2007, she won a NIKA award for *Snow Maiden* (*Snegurochka*, 2006), a film that beautifully illustrates Muat's vision of the puppet's soul.

The *Snow Maiden* is based on Aleksandr Ostrovskii's play (1873), which Nikolai Rimskii-Korsakov (1882) used to write his famous opera. This animated film celebrates the pagan ritual of Maslenitsa, saying farewell to winter and welcoming spring, with the sacrifice of its main character. In Muat's film, the Snow Maiden, the daughter of Father Frost and Spring Beauty, evolves from a character who is unable to experience the human emotion of love to a femme fatale, who attracts young men of the local village, including Mizgir, a not-so-faithful merchant. At the end of the film, as the Snow Maiden confesses her love to Mizgir, a bright ray of sunlight appears over the hill and she bursts into a white flame echoing her love. She ascends into the sky, representing both the end of winter and the power of love. In response to losing his love, Mizgir throws himself off a cliff, and while the village is horrified, they rejoice that cold winter is finally over.

23 "Studii 'Pchela' ispolnilos' 10 let," *Animalife*, July 28, 2016, accessed July 22, 2018, http://animalife.ru/2016/07/28/studii-pchela-ispolnilos-10-let/.
24 See the discussion of Muat's work in chapter 7.

Fig. 27. *Snow Maiden* (*Snegurochka*, 2006)

Muat's theoretical understanding of the role of the puppet and her ability to make the puppets come alive complement the mystery of pagan ritual depicted in *Snow Maiden*. The puppets in the *Snow Maiden* are full of life, which is accentuated by Muat's use of bright colors against the greys and whites of the wintery background and the browns of the village. The movement of the dolls and their clothing resembles human movement, but does not attempt to mimic it, instead Muat's puppets move in a more fluid over exaggeration of the gesture, distinguishing them from other well-known puppet films. According to Maliukova, puppet animation lost its prestige in Russia, because the puppets lost their souls, owing to how they were constructed and animated.[25] Maliukova maintains that Muat is an exception, and that her work is high art due to her unique approach to movement.[26] Muat's coupling of the fluidity of the body with the limited facial movement (only the eyes and mouth move) adds a magical and uncanny component to the film (see Fig. 27). Invoking her teacher Obraztsov, Muat claims that "the puppet can do everything, but it should not portray a person, it must be an image . . . Why humanize the dolls, if there are live actors? With dolls, you need to do things that people

25 For a discussion of the recent evolution of puppet animation, see Maliukova, "The State of the Art," 69.

26 Konovalova, "Mariia Muat."

can not."[27] Muat's intention is not to imitate real life with her puppets: the puppet has a life of its own. The fluid movement of the body enlivens the statuesque head of the puppet in a way that is incompatible with the movements of live actors. Her puppets embody an otherworldliness, which is captured in the incongruence of the head and body movements. Like Iarilo, the sun god referenced in *Snow Maiden*, Muat has the power to bring forth life through her love of the medium.

It is this love for the medium that has driven Muat's search for the perfect animation studio, one that encourages new animators, a space where women can express their subjectivity. Muat suggests that women like her have been ignored in the animation industry, even in the smaller studios. For instance, despite her role in its formation, she left Animos because she felt her projects and puppet animation were being overlooked.[28] In 2006 she founded Pchela studio together with her husband Vladimir Golovanov, in order to bring passion projects to the government for funding. She reports that Pchela does not receive a lot of government funding, but it is enough for them to continue making films while they search for other sponsors.[29] Muat's description of Pchela offers insight into how small studios operate with limited government funding and the struggles of female entrepreneurs.

The need to bring in new talent was inherently a problem at many animation studios, and at Animos most of the animators had been working in the industry for a long time, with no infrastructure for giving young animators a break. Muat's concern was that if there was nowhere for the young professionals to go, then these new animators would just leave the industry.[30] Additionally, she laments that "[a]lthough there is a young generation of directors and designers coming out of universities not many of them are interested in puppet animation and there are not many puppet animators being trained."[31] For these reasons Muat has also become a dedicated mentor for younger and inexperienced animators just entering the industry. In addition to mentoring, Muat is involved in several professional activities to help encourage young animators to

27 Ibid.
28 Ibid.
29 Ibid.
30 Ibid.
31 Irina Goundortseva, "Animose and Russian Animation," accessed July 21, 2018, http://www.liaf.org.uk/2011/04/animose-and-russian-animation-%E2%80%93-irina-goundortsev.

stay in the field. She is a member of the Russian Academy of Cinema Arts and Sciences, which presents the NIKA awards. The result is that Muat is filling a void helping to establish new animators. She has become, inadvertently, a mother-like figure who guides both new studios and new animators in the field. But she also has become the mother of puppet animation—striving to separate the puppet from live-action cinema and the human actor.

Iuliia Aronova

Iuliia Aronova is one of the new animators who has successfully broken into the industry, in part, with help from Muat by working at Animos and Pchela. Aronova graduated from VGIK in 2002 where she was trained in a variety of animation formats: puppet, cut-out, and CGI, all of which she has used in her animated films. As Muat has done numerous times, Aronova was involved in forming a short-lived studio, Isolant, where she worked until 2001 during her student years. Her student film *Eskimo* (*Eskimo*, 2004) won awards at both the International Children's Film Festival in Iran and the Suzdal Animation Festival and was later released by Animos.[32] This nine-minute wordless puppet film tells the story of a circus master and his trained penguin, who becomes homesick while gazing at the wrapper of an Eskimo ice cream. Much like Muat, Aronova is able to convey emotion through the incongruent movement of her puppets' bodies and immoble statue like heads in which only the eyes move. *Eskimo* also hinges on the unexpected, like Belonogova's films: when the penguin disappears from the circus tent, the circus master looks down on the ground finding an ice cream wrapper. He is shocked to discover that the wrapper now has his old friend the penguin on it.

In 2004, Aronova began working on her first professional film at Animos, *Beetle, Boat, Apricot* (*Zhuk, korabl, abrikos*, 2004), a stop-motion cut-out film. Aronova's next films *Mother and Music* (*Mat i muzyka*, 2006) and *Kamilla* (2008), were also made at Animos. Aronova moved on to Pchela and directed *My Mother is an Airplane* (*Moia mama—samolet*, 2012), making all mothers superheroes, especially one's own. This endearing six-minute computer animation was financed by the Russian

32 "Aronova, Iuliia," accessed December 16, 2018, http://www.animator.ru/db/?ver=eng&p=show_film&fid=6597.

Federation's Ministry of Culture Federal Agency on Cinematography. The film, narrated in a child's voice, celebrates the beauty of a world with all different mothers. Aronova captures on screen the exuberant love of a child for his or her own mother, a type of love that places one's mother higher than all others.

Fig. 28. *My Mother is an Airplane* (*Moia mama—samolet*, 2012), courtesy of Pchela and Iuliia Aronova.

Fig. 29. *My Mother is an Airplane* (*Moia mama—samolet*, 2012), courtesy of Pchela and Iuliia Aronova.

The mothers in the film are musicians, veterinarians, construction workers, dentists, princesses, scientists, circus performers, shopkeepers, athletes, ballerinas, truck drivers, and an airplane. On a grey and rainy day, the mothers, faces hidden by their umbrellas (with the exception of the truck-driver

and airplane mothers), are drawn walking through the city with their children. The mothers are identified by and some identifying markers of their profession, be it a cello, a ladder, or ballet shoes. The child narrator's mother is the airplane; she is radically differently than other mothers. She is the plane, not the pilot. All other mothers look out from under their umbrellas to see her fly by. This mother flies her child into the air—her wing holding the child's hand (see Fig. 28). The mother airplane delivers letters not only to people, but anthropomorphic world landmarks, and even puddles. She brings smiles to everyone and everything she passes. She challenges menacing military planes and returns the mothers safely home after single-handedly breaking up a deadly storm that threatened them. With the exception of the narrator's father, a boat, who is not seen until the very end of the animation, there is a decisive lack of male influence in the lives of the children (see Fig. 29).

Aronova's animation, with its childlike drawings of heavy black outlines and unexpected scribbles of color, is like many of the films we have discussed, relying heavily on the child's imagination. Aronova encapsulates the child's fantasy and love with the imagined superpowers of all mothers in the world, at least in the eyes of their children. She also suggests, contrary to Russian law, that women, especially mothers, can be any profession, even those that are arduous and/or dangerous (carpenters, truck drivers, and even airplanes). With this film Aronova has added to the body of films about family and motherhood, creating a continuum within Soviet and Russian culture, and within Russian women's cinema.

Aronova's film also shapes female subjectivity in a way that accepts tradition while embracing individuality. This is an inherent difference from female subjectivity in the West where individual subjectivity is often at odds with tradition, as Laura Olsen and Svetlana Adonieva suggest in *The Worlds of Russian Village Women*.[33] In the West, men who make changes to traditions are expressing their individuality, while women are thought to be harming traditions. In Soviet and Post-Soviet Russia, female subjectivity is more complicated; women's selfhood is a combination of adopting, adapting, and sometimes rejecting tradition. Women's subjectivity can be both traditional and individual, which is succinctly demonstrated in *My Mother is an Airplane*. Aronova's film creates an image of female selfhood based on a non-conformist career and the traditional role of the mother. This film encourages women to be both traditional and individual; to be their child's superhero.

33 Laura Olsen and Svetlana Adonyeva, *The Worlds of Russian Village Women* (Madison: University of Wisconsin Press, 2012).

Melnitsa, Darina Shmidt, and Russian Animation

One of the most prominent post-Soviet studios Melnitsa, located in St. Petersburg, has also provided a platform for female animators to cut their teeth in the animation industry. In 2018 Melnitsa had a full-time staff of over 150 employees, which allowed the studio to do all of its animation production in-house. Melnitsa produces both 2D and 3D animated shorts, feature films, shows for television, and advertisements.[34] They also have their own sound division, Midi Cinema, as well as 1C Games that handles video game production linked to their animated films. Melnitsa has had considerable success with several films and television series; one of the most popular being the television series *Luntik* (*Luntik i ego druzia*, 2006–present), which was created in part by Darina Shmidt who worked on the series from 2006 to 2011.

Shmidt began working at Melnitsa in 2003 while a student of classical drawing and multimedia direction at St. Petersburg State University. Shmidt believes strongly that students in animation must have opportunities to work in the industry in order to get practical experience. In this way, she is part of a new generation of animators acknowledging the need for practical experience beyond the classroom. She says the university gave her the foundation for self-realization and development, but the industry values quality and production speed, skills which come from working in the business.[35] At Melnitsa, she worked under Konstantin Bronzit and was an animator on his short film *Cat and Fox* (*Kot i lisa*, 2004). She insists that Bronzit guided her and supported her ideas, but that her choice of profession came from her analytical thinking and her love of cartoons as a child.[36]

At Melnitsa, Shmidt directed the first seven episodes of *Luntik*, the story of a fuzzy purple alien with four ears, who hatches from an egg and falls to earth from the moon. According to Shmidt, the original idea for the *Luntik* series originated with Aleksandr Boiarskii; she also gives credit to the screenwriter, Sara Anson.[37] Shmidt suggests that inspiration for the animated series came

34 For more information about Melnitsa, see "O studii Mel'nitsa," Mel'nitsa.com, accessed December 12, 2018, http://melnitsa.com/about/.

35 See "Darina Shmidt: Universitet dal pochvu dlia samorealizatsii i razvitiia," accessed July 20, 2018, http://www.gup.ru/studlife/alumni-interview/multimedia/darina-shmidt/.

36 Iana Saidasheva, "Rezhisser 'Luntika' Darina Shmidt: Sovremennym mul'tfil'mam ne khvataet dramatizma," *Sergievskie kuranty*, accessed August 29, 2018, http://s-kuranty.ru/2016/10/28/098765434567890/.

37 Ibid.

from her own love of unusual and fantastical animated creatures, but also from children's perceptions of the world around them. Shmidt designed the original sketch for Luntik herself while on the metro, and then created images and personalities for all of his friends.[38] Shmidt continued to be involved with the series until 2011. *Luntik* is targeted to a preschool age group and has had over seven billion views on Youtube.[39] The premise of these five- or six-minute self-contained films is that Luntik learns about his new home through interactions with anthropomorphized insects and amphibians. In 2015 the collective creators of the series, including Shmidt, received the Russian National Award for Culture.[40] Shmidt strongly believes that films for children should not be superficial, but should engage children with serious emotional experiences, have personal dramatic undertones, and should not shelter children from the real world.[41] Characters must grow, change, and evolve. *Luntik* fulfils these requirements, and the interaction of Luntik's child-like persona and the more experienced adult-like characters also contributes to themes celebrating family and childhood, like the female animators who preceeded her.

In 2007 Shmidt wrote, animated, and directed *Little Vasilisa* (*Malenkaia Vasilisa*, 2007) which interweaves various Russian fairy-tales about Vasilisa into an engaging story. *Little Vasilisa* won ten national and international awards, including the prestigious Best Debut and Best Film for Children at the Thirteenth Russian Animation Festival in Suzdal in 2008. This computer animation features characters that appear to have been pieced together in a patchwork quilt style. Shmidt tells the story of a young orphaned girl, Vasilisa, who is adopted by cruel merchants. Her new parents force Vasilisa to quilt scraps of fabric, and they abandon her in an underground cave in the forest to work. While in the forest she runs into infamous folklore villains, Uncle Misha, a bear, and Baba Yaga, a witch, who both want to eat Vasilisa.

Russian folklore tales about Vasilisa the Beautiful are usually puberty tales in which the girl, who is not ready to be married, learns how to become a perfect wife.[42] In these tales, Vasilisa must be obedient and complete tasks that will prepare her to become an exemplary woman and to take care of a family. In Shmidt's version, Vasilisa befriends several animals: a mouse, a cat, and even

38 Ibid.

39 "About Luntik," accessed December 12, 2018, https://www.youtube.com/user/luntik/about.

40 Ibid.

41 Saidasheva, "Rezhisser 'Luntika' Darina Shmidt."

42 Sibelan Forrester and Jack Zipes, *Baba Yaga: The Wild Witch of the East in Russian Fairy-Tales* (Jackson, MS: University of Mississippi Press, 2013), xxxix–xliii.

Uncle Misha, who help her to run away from Baba Yaga and her evil parents. Shmidt's Vasilisa becomes an independent modern girl, breaking away from tradition and siding with individuality. More importantly, she never finishes sewing the quilt, defying society's desire for her to become a perfect Russian woman. *Little Vasilisa*, like *My Mother is an Airplane*, shapes women's subjectivity with a combination of adopting, adapting, and rejecting of tradition.

Fig. 30. *Little Vasilisa* (*Malenkaia Vasilisa*, 2007), courtesy of Melnitsa.

Shmidt notes the animation collective at Melnitsa also played a role in the creation of *Little Vasilisa*. While it was her idea to make a film about a girl who suffers at the hands of adults and is helped by animals, Bronzit guided Shmidt towards the idea of basing the film on a Russian fairy-tale.[43] Interestingly, Shmidt identifies most with Baba Yaga, not Vasilisa, and used herself as a model for the character development. Baba Yaga, like Vasilisa, is represented by a patchwork of fabric, yet what stands out is her mechanical robot arms and her long-flowing animal-infested hair. Shmidt claims that while she had help animating the other characters, she trusted only herself to animate Baba Yaga.[44] Just like Baba Yaga, Shmidt admits that she has stood in front of a mirror in a rage with a comb stuck in her hair. She also used many of her own facial expressions in creating the character. Shmidt's identification with Baba Yaga parallels the way in which Shmidt sees her role in

43 For Shmidt's identification with Baba Yaga see Sergei Kapkov, "Baba-iaga—moi liubimyi personazh," *Gazeta* 48 (March 17, 2018), accessed July 20, 2018, http://www.animator.ru/articles/article.phtml?id=286.

44 Ibid.

the industry today. Successful women animators need to be less interested in beauty, to work like robots, and to have fantastic imaginations. Shmidt uses the villain, not the heroine, to model her own version of female selfhood.

It is Shmidt's work as a director of feature-length animated films that illustrates both the challenges and successes of women in the contemporary animation industry. In 2016, she directed the successful third part in the Ivan the Simpleton series, *Ivan Tsarevich and the Grey Wolf 3* (*Ivan Tsarevich i seryi volk 3*, 2016). The film had a budget of four million dollars, brought in over ten million dollars in its first seventeen days, and also won a prestigious Ikar Russian National Animation prize in 2016.[45] *Ivan Tsarevich and the Grey Wolf 3* is a modern retelling of a Russian fairy-tale. Its main character, Ivan the Simpleton, is a simple guy, hard-working and good-natured. But Ivan's wife Princess Vasilisa is both conventional and atypical. In this third film of the series, the Tsar leaves Ivan in charge of the kingdom when he goes on vacation. Ivan's wife, Vasilisa, implores him to take her on a long-awaited honeymoon. Agreeing to the honeymoon, Ivan hastily appoints an ordinary scarecrow to look after things, but the scarecrow comes to life and destroys the kingdom.

Fig. 31. *Ivan Tsarevich and the Grey Wolf 3* (*Ivan Tsarevich i seryi volk 3*, 2016), courtesy of Melnitsa.

45 Sergei Lavrov, "Mul'tfil'm studii 'Mel'nitsa' preodolel otmetku $10 mln.," Kinodata.pro, January 20, 2016, accessed December 13, 2018, http://kinodata.pro/vse-o-kino/obzor-kassovyh-sborov-v-rossii/9979-multfilm-studii-melnica-preodolel-otmetku-10-mln.html. See also "Ikar. Natsional'naia animatsionnaia 2016," accessed December 13, 2018, http://animaprize.ru/laureati-2/.

This version of Vasilisa could be considered a stereotypical woman who spends much of her time shopping; with her guidebook in hand, she attempts to make Ivan cultured, but really only demonstrates her own lack of understanding. In the end of the film though, she becomes the hero, breaking a staff in two and killing the villain, thus saving Ivan's life (see Fig. 31). Shmidt's comments on her female protagonist speak to the complicated nature of Russian feminism; she defends not the princess's heroic deed, but her weaknesses. Shmidt claims that "the bane of our time is girl-superheroes, who are cooler than guys. I want to fight against this notion. Because I am sure that a woman should be weaker. They shouldn't faint, but princesses should look for a knight to help them, and not cut the dragon's head off herself."[46] In a way, her film struggles with this notion as Vasilisa fights alongside the other characters; she cannot successfully defeat the villain by herself. While she breaks the staff containing the villain's soul, she did not guess the secret without help. Shmidt's representation of Vasilisa reminds viewers that the lives of Russian women are complicated; Russian female selfhood can combine elements of both tradition and individuality. Shmidt, as a woman and as a director, embraces these contradictions, always insisting on the collective nature of her animation.

Looking Back and Moving Forward: The Future of Women's Animation

The history of women's animation in the Soviet Union and Russia is rife with this tension between tradition and individuality. In terms of labor, women working in the animation industry in Russian have made great strides since the 1917 revolution and have worked diligently in order to move up from those nameless women, inking and in-betweening, featured in the pages of Ivanov-Vano's 1950 book on animation. In the early years, proletarian principles of equality, open discussions regarding the woman question, and small working collectives encouraged women like Zinaida and Valentina Brumberg, and Olga Khodataeva to enter the animation industry and provided a framework for their success. While the period between the 1930s and 1950s was constrained by Stalinist policies and strict censorship, women working in animation, like Aleksandra Snezhko-Blotskaia, continued to provide female perspectives in their films and to push the animation industry into

46 Ibid.

new artistic spheres. Khodataeva, the Brumbergs, and Snezhko-Blotskaia, among others, were instrumental in bringing about stylistic and aesthetic changes during their tenure at Soiuzmultfilm. These women challenged the animation industry during the Stalinist period and led the way for new generations of women to permeate Soviet and Russian culture with impactful changes.

By contrast, directors in the 1960s and 1970s, such as Inessa Kovalevskaia, the Brumbergs, and Snezhko-Blotskaia, became more politically charged in their films, empowered during these years to be more daring in their work than they had in past decades. Despite the continuation of more traditional formats like literary adaptations and fairy-tales, their films also became more poetic, personal, introspective, and openly addressed issues that concerned women, illustrating a selfhood that pushed against traditional roles for women. The 1980s and 1990s saw the collapse of the Soviet Union, the privatization of the animation industry, and the downfall of Soiuzmultfilm. With these drastic changes came an influx of films by animators such as Nataliia Golovanova, Nina Shorina, Ideia Garanina, Mariia Muat, and Anna Belonogova, all of whom stepped up to shape animation aesthetics and the industry itself through their works, interviews, theoretical writings, and business acumen, as well as through the education of future animators.

Finally, in the 2000s and 2010s there have been more women in positions of power, making creative and business-related decisions than ever before. In the animation industry, women reflect the complexity of female subjectivity informed by Soviet ideology, both in their own lives and in their films. Twenty-first century directors like Mariia Muat, Iuliia Aronova, and Darina Shmidt all approach animation in ways that adopt, adapt, and reject both tradition and individuality to fit their situations. The culmination of almost one hundred years of women navigating the tensions within the animation industry creates a form of female subjectivity unique to the Soviet and Russian experience.

We feel that it is important not just to acknowledge that women were and are working in the industry, it is necessary to discuss their work in terms of its contribution to film and animation history, art, and culture. Each of the women discussed in this book is deserving of scholarly inquiry in her own right. Yet, taken as a whole, they represent something more significant: they point to a women's cinema within Soviet and Russian animation. To return to the quote from Butler that began this volume,

a "'women's cinema' is a complex critical, theoretical and institutional construction . . . a hybrid concept, arising from a number of overlapping practices and discourses."[47] The notion of a women's cinema within Soviet and Russian animation is made even more complex by its association with propaganda, but more importantly, by its designation as children's entertainment. When Valentina Brumberg stated in 1931 that "the value of animation, that is to say, drawn film, unfortunately is not valued enough in our country,"[48] she encapsulated one of the concrete reasons why women were welcomed into the animation industry: it was not considered a valued profession. The undervaluing of animated films resulted in women having a platform not just for artistic expression, but also to voice opinions on important issues, from women's roles as mothers and nurturers, to women's participation in politics, and for projecting the changing notion of female subjectivity.

In analyzing the films and writings made by these twelve women we begin to see how their work, when understood within the industrial, political, and cultural climate in which it was made, offered alternatives to dominant cinema and culture. According to film scholar Annette Kuhn, "Such alternatives are not necessarily confined to types of cinema whose overt content is informed by a consciously feminist intent on the part of the filmmaker."[49] So while the films and filmmakers we have discussed may not have been overtly feminist in their orientation or intent, they have presented Russian-styled feminist challenges to dominant Soviet and Russian ideology. Through their animated films, these twelve women have shaped a notion of female subjectivity that has changed over time, yet is still informed by its origins in the false assumptions of Soviet gender equality.

Nowhere is the reality of Russia's complicated relationship with gender equality made clearer than in Shmidt's interview with Elena Bobrova where Shmidt talks about women's place in animation. Shmidt recalls, "Konstantin Bronzit correctly states that direction is not a woman's profession. At any rate, if we are talking about full-length animation. Because it's stressful! It is emotionally harder for a woman to restrain herself."[50] Shmidt's comment speaks to

47 Butler, *Women's Cinema*, 2.

48 Brumberg, "Zvukovaia mul'tiplika," 63.

49 Annette Kuhn, *Women's Pictures: Feminism and Cinema* (London: Routledge & K. Paul, 1982), 129.

50 Elena Bobrova, "Pochemu my liubim Ivana-Duraka?," accessed September 10, 2018, https://freetime.ru/lyubim-ivana-duraka/.

one of the biggest challenges that many women in the industry face – the struggle over the work-life balance between family and career. Her comment also encapsulates the contradictory nature of Soviet informed female subjectivity.

Shmidt is a very successful director and has proven that animation certainly is a woman's profession, she has been able to give "fanatical devotion" to her films and much of her free time to the industry.[51] Shmidt's career illustrates one of the major feminist platforms for equality in Russia today, the assumption that women must choose between a career and family, and that the very act of choosing calls into question one's womanhood.[52] On the other hand, Shmidt, like the Brumbergs and others, illustrate that it is acceptable for women to have highly successful careers; that family and motherhood are not the only components of female identity. In this way Shmidt both breaks with tradition while at the same time reaffirming it, and in doing so adopts new aspects of what we refer to as Soviet female subjectivity. While female subjectivity is an evolving concept in Russia that is still informed by the Soviet past which assumes an incomplete gender equality.

As Holmgren states "Women in Russia may choose to occupy facilitating positions or work behind the scenes for a variety of reasons: to make what they consider to be more pragmatic contributions, to retain a sense of the goodness of their labor, and to avoid the public stigmatization of female "abnormality."[53] In other words, this idea of abnormality is often associated with ambition to succeed in professions that had traditionally been the purview of men, or as Shmidt fears a perception that as a director she might be unable to restrain her emotions. It is the quiet pragmatic contributions which have allowed women animators in Russia to contribute to a women's cinema. Holmgren and all the animators we have discussed remind us that Russian feminism is significantly different from Western feminism and is determined by the unique political traditions and historical perspectives that have shaped it. Russian women animators over the decades have shown a zealous dedication to representing themes such as motherhood, childhood and family, and even, occasionally, the rights of women. These women have pioneered new animation technologies, established new aesthetic styles, and in this way, they changed the animation

51 Ibid.
52 Perera, "Russia's Feminists Work to Smash the Taboo."
53 Holmgren, "Toward an Understanding," 539.

industry and contributed to the expansion of a women's cinema within its boundaries.

We believe that merely pointing out the fact that there have been and are successful women working in the animation industry is not enough. To do just that would be to perpetuate the fallacy of gender equality and gender parity within the Soviet and Russian animation industry. It would also further obscure the contributions these women have made and, perhaps, reinforce justifications for continuing to leave them out of animation and cinema histories. Examining these animators and their films through the lens of women's cinema helps to secure their place in history, highlighting the unique ways in which they have distinguished themselves, the additions they have made to the craft, and the contributions they have made to notions of female subjectivity. Mayne points out that one of the simplest definitions of "women's cinema" is cinema made by women.[54] In this sense and in the ways we have highlighted, then, yes, there is a women's cinema within Soviet and Russian animation and it includes not just the women or films discussed in this book, but also, by extension, the work of those unnamed women who have inked, drawn, painted, moved, coded, edited, and otherwise helped to create the films. While our book in no way pretends to be an exhaustive account of female directors in the Soviet and Russian animation industry, we do hope that it begins a dialogue about women animators, preserving their legacy through the concept of women's cinema.

54 Mayne, "The Woman at the Keyhole."

Filmography

About a Little Mouse (*Pro myshonka*, 2004, Mariia Muat)

The Adventures of the Little Chinese (*Prikliucheniia kitaichat*, 1928, Mariia Benderskaia)

Aelita: Queen of Mars (*Aelita*, 1924, Iakov Protazanov)

Alter Ego (*Vtoraia Ia*, 1989, Nina Shorina)

The Amber Castle (*Iantarnyi zamok*, 1959, Aleksandra Snezhko-Blotskaia)

Anansi, The Little Spider, and the Magic Wand (*Pauchok Anansi i volshebnaia palochka*, 1973, Ideia Garanina and Marianna Novogrudskaia)

Ancient Lyric (*Antichnaia lirika*, 1989, Mariia Muat)

Antosha Ruined by a Corset (*Antoshu korset pogubil*, 1916, Eduard Puchalski)

The Beautiful Lucanidae (*Prekrasnaia Liukanida, 1910,* Wladyslaw Starewicz)

Bambi (1942, David Hand)

Beetle, Boat, Apricot (*Zhuk, korabl', abrikos*, 2004, Iuliia Aronova)

Betty Boop (1932–1939)

A Boy is a Boy (*Mal'chik kak mal'chik*, 1986, Natal'ia Golovanova)

Buffoonery (*Balagan*, 1981, Ideia Garanina)

The Cameraman's Revenge (*Mest' kinomatograficheskovo operatora*, 1912, Wladyslaw Starewicz)

Cat and Fox (*Kot i lisa*, 2004, Konstantin Bronzit)

The Cat Who Walked by Herself (*Koshka, kotoraia guliala sama po sebe*, 1988, Ideia Garanina)

The Cat Who Walked by Himself (*Kot, kotoryi gulial sam po sebe*, 1968, Aleksandra Snezhko-Blotskaia)

Cheburashka (*Cheburashka*, 1971, Roman Kachanov)

China in Flames (*Kitai v ogne*, 1925, GTK: Zenon Komissarenko, N. Maksimov, Iurii Merkulov, Nikolai Khodataev)

Classic Fairy Tales from Around the World (1986)

Crocodile Gena (*Krokodil Gena*, 1969, Roman Kachanov)

The Crown and the Scepter (*Korona i skipetr*, 2000, Mariia Muat)

Dragon (*Drakon*, 1961, Aleksandra Snezhko-Blotskaia)

The Dragonfly and the Ant (*Strekoza i muravei*, 1936, Valentina Brumberg, Zinaida Brumberg)

Eskimo (*Eskimo,* 2004, Juliia Aronova)

Father Frost and the Grey Wolf (*Ded Moroz i seryi volk,* 1937, Ol'ga Khodataeva)

Fedia Zaitsev (*Fedia Zaitsev,* 1948, Valentina Brumberg, Zinaida Brumberg)

A Fire Burns in the Yaranga (*V iarange gorit ogon',* 1956, Ol'ga Khodataeva)

Fritz the Cat (1965, Ralph Bakshi)

For Buka (*Pro Buku,* 1984, Nina Shorina)

Four from the Same Courtyard (*Chetvero iz odnogo dvora,* 1967, Inessa Kovalevskaia)

Fox and Bear (*Lisa i medved',* 1975, Natal'ia Golovanova)

Fox, Hare, and Rooster (*Lisa, zaiats i petukh,* 1942, Ol'ga Khodataeva, Leonid Amal'rik)

From Each Pine Forest—One Little Pine Tree (*S Boru po sosenke,* 1974, Valentina Brumberg, Zinaida Brumberg)

Frozen (2013, Jennifer Lee, Chris Buck)

The Golden Little Feather (*Zolotoe pioryshko,* 1960, Ol'ga Khodataeva and Leonid Aristov)

Great Troubles (*Bol'shie nepriiatnosti,* 1961, Valentina Brumberg, Zinaida Brumberg)

Hare-Tailor (*Zaiats-portnoi,* 1937, Valentina Brumberg, Zinaida Brumberg)

Happy Life (*Veselaia zhizn',* 1932, Ol'ga Khodataeva)

Happy Moscow (*Veselaia Moskva,* 1934, Ol'ga Khodataeva)

Hedgehog in the Fog (*Ezhik v tumane,* 1975, Iurii Norstein)

The Heron and the Crane (*Tsaplia i zhuravl',* 1974, Iurii Norstein)

How Avdotia Became Literate (*Kak Avdot'ia stala gramotnoi,* 1925, Zenon Komissarenko, Iurii Merkulov, Nikolai Khodataev)

How the Little Lion and the Turtle Sang a Song (*Kak l'venok i cherepakha peli pesniu,* 1974, Inessa Kovalevskaia)

How Volodaia Quickly Flew from the Hill (*Kak Volodia bystro s gorochki letel,* 1996, Anna Belonogova)

Humpty Dumpty (*Shaltai-Boltai,* 1983, Mariia Muat)

I Drew a Little Man (*Chelovechka narisoval ia,* 1960, Valentina Brumberg, Zinaida Brumberg, Valentin Lalaiants)

I'll eat breakfast myself (*Zavtrak s'esh' sam,* 1995, Anna Belonogova)

In Self-Defence (*W obronie własnej,* 1982, Beata Tyszkiewic)

Interplanetary Revolution (*Mezhplanetnaia revoliutsiia,* 1924, Zenon Komissarenko, Iurii Merkulov, Nikolai Khodataev)

Ivan Tsarevich and the Grey Wolf 3 (*Ivan Tsarevich i seryi volk 3,* 2016, Darina Shmidt)

Ivanshko and Baba Yaga (*Ivashko i Baba Iaga,* 1938, Valentina Brumberg, Zinaida Brumberg)

Journal of Political Satire No. 2 (*Zhurnal politsatiry No. 2,* 1941, Valentina Brumberg, Zinaida Brumberg, Ol'ga Khodataeva, Ivan Ivanov-Vano, Aleksandr Ivanov)

Just You Wait (*Nu, pogodi!,* 1969–1993, Viacheslav Kotenochkin)

Kamilla (2008, Iuliia Aronova)

Kings and Cabbages (*Koroli i kapusta,* 1996, Mariia Muat)

Kinocircus (*Kinotsirk,* 1942, Ol'ga Khodataeva)

Know-Nothing 2: A Meeting with a Magician (*Neznaika 2: Vstrecha s volshebnikom*, 1976, Nina Shorina)

Larisa (*Larisa*, 1980, Elem Klimov)

Little Girl and the Bear (*Devochka i medved'*, 1980, Natal'ia Golovanova)

Little Humpbacked Horse (*Konek-gorbunok*, 1947, Ivan Ivanov-Vano)

Little Red Riding Hood (*Krasnaia shapochka*, 1937, Valentina Brumberg, Zinaida Brumberg)

Little Vasilisa (*Malen'kaia Vasilisa*, 2007, Darina Shmidt)

Lucanus Cervus (1910, Wladyslaw Starewicz)

Lucy Girl and Grandpa Krylov (*Devochka Liusia i dedushka Krylov*, 2003, Mariia Muat)

Luntik and his Friends (*Luntik i ego druz'ia*, 2004–present)

The Lost Letter (*Propavshaia gramota*, 1945, Valentina Brumberg, Zinaida Brumberg)

Masha and the Bear (*Masha i Medved'*, 2009–present)

Moomintroll and the Comet: A Way Home (*Mumi-troll' i kometa: put' domoi*, 1978, Nina Shorina)

Mother and Music (*Mat i muzyka*, 2006, Iuliia Aronova)

The Musicians of Bremen (*Bremenskie muzykanty*, 1969, Inessa Kovalevskaia)

My Mother is an Airplane (*Moia mama—samolet*, 2012, Iuliia Aronova)

The Night Before Christmas (*Noch' pered Rozhdestvom*, 1951, Valentina Brumberg, Zinaida Brumberg)

Not-a-kopek (*Nikopeika*, 2000, Anna Belonogova)

Only for You (*Tol'ko vam*, 1970, Inessa Kovalevskaia)

The Ornament of the Enamored Heart (*Das Ornament des verliebten Herzens*, 1919, Lotte Reiniger)

Peppermint Freedom (*Peppermint-Frieden*, 1983, Marianne Rosenbaum)

The Pied Piper of Hamelin (*Der Rattenfänger von Hameln*, 1918, Paul Wegener)

Poiga and the Fox (*Poiga i lisa*, 1978, Natal'ia Golovanova)

The Poodle (*Pudel'*, 1985, Nina Shorina)

Poor Liza (*Bednaia Liza*, 1972, Idea Garanina)

Prometheus (*Prometei*, 1974, Aleksandra Snezhko-Blotskaia)

Puss in Boots (*Kot v sapogakh*, 1938, Valentina Brumberg, Zinaida Brumberg)

The Returning Sun (*Vozvrashchennoe solntse*, 1936, Ol'ga Khodataeva)

Rescued by Rover (1905, Lewin Fitzhamon)

Rikki-Tikki-Tavi (*Rikki-Tikki-Tavi*, 1965, Aleksandra Snezhko-Blotskaia)

Sarmiko (*Sarmiko*, 1956, Ol'ga Khodatava)

Sesame Street (1969–)

Silly Symphonies (1929–1939)

Sinbad the Sailor (*Sindbad-morekhod*, 1944, Valentina Brumberg, Zinaida Brumberg)

Some Interviews on Personal Matters (*Ramdenime interviu pirad sakitkhebze*, 1977, Lana Gogoberidze)

Song about Chapaev (*Pesnia o Chapaeve*, 1944, Ol'ga Khodateava, Piotr Nosov)

Songs of the Inflamed Years (*Pesni ognennykh let*, 1971, Inessa Kovalevskaia)

Soviet Toys (*Sovetskie igrushki*, 1924, Dziga Vertov)

Snow Maiden (*Snegurochka*, 2006, Mariia Muat)

Start (*Start*, 1925, Nikolai Khodataev, no longer extant)

Stenka Razin (*Sten'ka Razin*, 1908, Aleksandr Drankov)

Story of a Crime (*Istoriia odnogo prestupleniia*, 1962, Fiodor Khitruk)

Tale of the Boy-Kibal'chish (*Skazka o mal'chishe-kibal'chishe, 1958,* Aleksandra Snezhko-Blotskaia)

The Tale of the Priest and his Worker Balda (*Skazka o pope i o rabotnike ego Balde*, 1940, Mikhail Tsekhanovskii)

Teremok (*Teremok*, 1945, Ol'ga Khodataeva)

Terrible Vavila and Little Auntie Arina (*Vavila groznyi i tetka Arina*, 1928, Ol'ga Khodataeva, Nikolai Khodataev)

The Tale of Tsar Durundai (*Skazka o tsare Durandae*, 1934, Valentina Brumberg, Zinaida Brumberg)

The Tale of Tsar Saltan (*Skazka o tsare Saltane*, 1943, Valentina Brumberg, Zinaida Brumberg)

The Three Little Pigs (1933, Burt Gillet)

Twelfth Night (*Dvenadtsataia noch'*, 1993, Mariia Muat)

Uncle Ahu in town (*Diadiushkia Au v gorode*, 1979, Mariia Muat)

Urfin Jus and His Wooden Soldiers (*Urfin Dzhius i ego dereviannye soldaty*, 2017, Vladimir Toropchin, Fedor Dmitriev, Darina Shmidt)

Winnie-the-Pooh (*Vinni-Pukh*, 1969, Fiodor Khitruk)

A Wonderful Garden (*Chudesnyi sad*, 1962, Aleksandra Snezhko-Blotskaia)

You Don't Joke with Me (*Ty ne shuti so mnoi*, 2017, Darina Smidt)

Zhikharka (*Zhikharka*, 1977, Natal'ia Golovanova)

Bibliography

Abol'chik, O. "Valentina i Zinaida Brumberg." In *Mastera sovetskoi mul'tiplikatsii*, edited by I. Lishchinskii, 55–78. Moscow: Isskustvo, 1972.

"About Luntik." Accessed December 12, 2018. https://www.youtube.com/user/luntik/about.

Anh, Ta. "Female Subjectivity in Animated Narrative Film." *Animatrix* 9 (1995/1996): 15–19.

"Aronova, Iuliia." Accessed December 16, 2018. http://www.animator.ru/db/?ver=eng&p=show_film&fid=6597.

Asenin, Sergei. *Volshebniki ekrana*. Moscow: Iskusstvo, 1974.

———. "Fantaziia i istina," in *Mudrost' vymysla*, edited by Sergei Asenin, 7–30. Moscow: Iskusstvo, 1983.

Attwood, Lynne, and Maiia Turovskaia. *Red Women on the Silver Screen: Soviet Women and Cinema from the Beginning to the End of the Communist Era*. London: Pandora, 1993.

Azarkh, Lana. "Mul'tiplikatory." *Iskusstvo Kino* 9 (2010): 136–146.

Balina, Marina. Introduction to *Politicizing Magic: An Anthology of Russian and Soviet Fairy-Tales*, edited by M. Balina, H. Goscilo, M. Lipovetsky, 105–121. Evanston, IL: Northwestern University Press, 2005.

Balmforth, Tom. "Barred from Hundreds of Occupations In Russia, A Few Women Fight Back." *RadioFreeEurope/RadioLiberty*, April 21, 2016. Accessed December 18, 2018. www.rferl.org/a/russia-womens-occupations-limited-soviet-law/27680005.html.

Bartlett, Djurdja. *Fashion East: The Spectre that Haunted Socialism*. Cambridge, MA: MIT Press, 2010.

"Battle over Russian Cartoons." *BBC News*, June 16, 2003. Accessed September 9, 2019. http://news.bbc.co.uk/2/hi/entertainment/2981688.stm.

Baum, L. F., and W. W. Denslow. *The Wonderful Wizard of Oz*. Chicago: G. M. Hill Co., 1900.

Beck, Ulrich, and Elisabeth Beck-Gernsheim. *Individualisation: Institutionalised Individualism and Its Social and Political Consequences*. London: Sage, 2002.

Beligzhanina, Anna. "S kogo risovali liubimykh geroev sovetskikh mul'tikov." *Komsomol'skaia pravda*, June 8, 2011. Accessed October 5, 2018. https://www.kp.ru/daily/25700.3/901496/.

Belonogova, Anna. "Gori, sverkhnovaia." Accessed August 2, 2017. http://www.vgik.info/college/history_of_animation/.

———. "Sbornyi rolik studentov-mul'tiplikatorov, take 5, pedagog Anna Belonogova." Accessed August 30, 2018. https://www.youtube.com/channel/UCbHcKQ6MyF7MI4wl6GESuMQ.

Bendazzi, Giannalberto. *Animation: A World History*. Boca Raton: CRC Press, Taylor & Francis Group, 2016.

Beumers, Birgit. "Comforting Creatures in Children's Cartoons." In *Russian Children's Literature and Culture*, edited by Marina Balina and Larissa Rudova, 153–173. New York: Routledge: 2007.

———. *A History of Russian Cinema*. New York: Berg, 2009.

Beumers, Birgit, Victor Bocharov, and David Robinson, eds. *Alexander Shiryaev: Master of Movement*. Pordenone: Le Giornate del Cinema Muto, 2009.

Bil'shai, Vera. *Reshenie zhenskogo voprosa v SSSR*. Moscow: Gospolitizdat, 1956.

Bobrova, Elena. "Pochemu my liubim Ivana-Duraka?" Accessed September 10, 2018. https://freetime.ru/lyubim-ivana-duraka/.

Bogdanova, S. L. "Ocherki o zhizni i tvorchestve Aleksandry Gavrilovny Snezhko-Blotskoi." *Kinograf* 19 (2008): 207–241.

Bol'shoi akademicheskii slovar' russkogo iazyka, edited by L. I. Balakhonova. Moscow: Nauka, 2004.

Borodin, Georgii. "Kinostudiia 'Soiuzmul'tfil'm': Kratkii istoricheskii obzor." https://web.archive.org/web/20160305111609/http://new.souzmult.ru/about/history/full-article/5.05.2016.

———. "Nikolai Erdman i animatsiia." *Kinovedcheskie zapiski* 61 (2002). http://www.kinozapiski.ru/ru/article/sendvalues/687.

———. "Obraz ded-moroza v rossiiskoi animatsii." *Prazdnik* (October 2001). http://www.animator.ru/articles/article_255.htm.

———. "Proshchai, 'Souizmul'tfil'm': Svidetel'skiie pokazaniia." http://animator.ru/articles/article.phtml?id=28.

———. "'Soiuzmul'tfil'm': Nenapisannaia istoriia." *Kinovedcheskie zapiski* 80 (2006): 149–152.

———. "V bor'be za malen'kiye mysli. Neadekvatnost' tsenzury." *Kinovedcheskie zapiski* 73 (2005): 261–272.

Brooks, Jeffrey. *When Russia Learned to Read: Literacy and Popular Literature, 1861–1917*. Princeton: Princeton University Press, 1985.

"Bremenskiie muzykanty. Nepridumannaia istoriia." Accessed February 2, 2018. http://2danimator.ru/showthread.php?p=62865.

Browning, Genia. "Soviet Politics: Where are the Women?" In *Soviet Sisterhood*, edited by B. Holland, 202–36. London: Fourth Estate, 1985.

"The Brumberg Sisters Against the Background of their Time." *Leading Figures in Russian Animation*. Film 6. MIR Studios, 2013. Accessed 11/1/2018, https://www.youtube.com/watch?v=pyds1GYc2LU&list=PLn5Aci4kkiv4FQaRr9Qsgx7_mWnj PM7h.

Brumberg, Valentina. "Zvukovaia mul'tiplika." *Proletarskoe kino* 2 (1931): 63.

Brumberg, Zinaida. "Liubimaia rabota." In *Zhizn' v kino. Vypusk 2*, edited by O. T. Nesterovich, 4–30. Moscow: Iskusstvo, 1979.

Buckley, Mary. *Women and Ideology in the Soviet Union*. Ann Arbor, MI: The University of Michigan Press, 1992.

———. "Soviet Interpretation of the Woman Question." In *Soviet Sisterhood*, edited by B. Holland. London: Fourth Estate, 1985.

Budgeon, Shelley. *Choosing a Self: Young Women and the Individualization of Identity*. Westport: Praegar, 2003.

Bulova, Elena. "Kak skazka prikhodit v dom." *Moskovskaia pravda*, November 25, 2014. https://dlib.eastview.com/browse/doc/42686639.

Butler, Alison. *Women's Cinema: The Contested Screen*. London: Wallflower Press, 2002.

Buxbaum, Gerda, ed. *Icons of Fashion: The 20th Century*. Munich: Prestel Publishing, 2005.

Chatterjee, Choi. *Celebrating Women: Gender, Festival Culture, and Bolshevik Ideology, 1910–1939*. Pittsburgh: University of Pittsburgh Press, 2002.

Chekhov, Anton Pavlovich. *The Essential Tales of Chekhov*. Hopewell, NJ: Ecco Press, 1998.

Cleave, Mary, for Walt Disney Productions Ltd, to Miss Mary V. Ford. June 7, 1938. Accessed June 19, 2018. http://www.openculture.com/2013/04/no_women_need_apply_a_disheartening_1938_rejection_letter_from_disney_animation.html.

Central Intelligence Agency. Soviet Postal Intelligence: May 1962. 78-02646R, Box 005, Folder 009. https://www.cia.gov/library/readingroom/docs/CIA-RDP78-02646R000600090001-2.pdf.

Colton, Timothy. *Russia*. New York: Oxford University Press, 2016.

Cowie, Elizabeth. *Representing the Woman: Cinema and Psychoanalysis*. Minneapolis: University of Minnesota Press, 1997.

"Darina Shmidt: Universitet dal pochvu dlia samorealizatsii i razvitiia." Accessed July 20, 2018. http://www.gup.ru/studlife/alumni-interview/multimedia/darina-shmidt/.

Davis, Katie. "Women at Work: New Exhibition Aims to Subvert the Feminine in Post-Soviet Russia." *The Calvert Journal*, July 10, 2018. Accessed December 7, 2018. https://www.calvertjournal.com/news/show/10476/women-at-work-new-exhibition-subverting-the-feminine-in-post-soviet-russia.

Deneroff, Harvey. "Lillian Friedman Astor: Pioneer Woman Animator." *ASIFA-East Program*. Accessed October 12, 2018, http://deneroff.com/docs/Lillian%20Friedman%20Astor%20Pioneer%20Woman%20Animator.pdf.

Desai, Padma. "Why Did the Ruble Collapse in August 1998?" *The American Economic Review* 90, no. 2 (2000): 48–52.

Dubogrei, Vilatii. Kak sozdalsia multfilm "Bremenskii musykanty." Accessed January 25, 2020. https://dubikvit.livejournal.com/16195.html.

Edele, Mark. "Strange Young Men in Stalin's Moscow: The Birth and Life of the Stiliagi, 1945–1953." *Jahrbücher für Geschichte Osteuropas* 50, no. 1 (2002): 33–61.

Eisenstein, Sergei, and Jay Leyda. *Eisenstein on Disney*. Calcutta: Seagull Books, 1986.

Eizenstein, Sergei. *Izbrannye proizvedeniia v shesti tomakh*. Moscow: Iskusstvo, 1964.

Engel, Barbara Alpert. "Women in Russia and the Soviet Union." *Signs* 12, no. 4 (1987): 781–796.

Entin, Iurii, and Elena Iakovleva. "A mne letat' okhota!" Kak sozdavalis' luchshie khity Iuriia Entina." Accessed January 31, 2018. http://www.aif.ru/culture/person/_a_mne_letat_ ohota_kak_sozdavalis_luchshie_hity_yuriya_entina.

Evans, Janet. "The Communist Party of the Soviet Union and the Women's Question: the Case of the 1936 Decree 'In Defense of Mother and Child.'" *Journal of Contemporary History* 16, no. 4 (1981): 757–775.

Faulconbridge, Guy. "Russian Stocks Shed over $1 Trillion in Crisis." *Reuters.com*, November 3, 2010. Accessed June 28, 2019. https://www.reuters.com/article/us-markets-russia-trillion /russian-stocks-shed-over-1-trillion-in-crisis-idUSTRE4AC5M020081113.

"Fakul'tet animatsii i mul'timediia—samyi molodoi vo VGIKe." Accessed 8/30/2018. http://www.vgik.info/teaching/animation/.

Feinberg, Chloe. "Articulating Interiors of longing and Desire: Asparagus (1979) by Suzan Pitt." *Animation Studies 2.0*, November 11, 2015. https://blog.animationstudies. org/?p=1303#comments.

"Feminism in Russia: On the Streets and Behind the Scenes." *Moscow Times*, February 21, 2018. https://themoscowtimes.com/photogalleries/feminism-in-russia-60586.

Filippov, Ivan, Iuliia Fedorinova, and Ekaterina Dolgosheeva. "Cheburashka luchshe Faberzhe." *Vedomosti*, April 11, 2007. Accessed September 9, 2019. https://www.vedomosti.ru/newspaper/article.shtml?2007%2F04%2F11%2F123914.

"Film Fay Animatsionnaia studiia." Accessed Feburary 28, 2020. http://filmfay.com/.

Fisher, Ralph. *Pattern for Soviet Youth: A Study of the Congresses of the Komsomol, 1918–1954*. New York: Columbia University Press, 1959.

Fitzpatrick, Sheila. "War and Society in Soviet Context: Soviet Labor before, during, and after World War II." *International Labor and Working-Class History* 35 (1989): 37–52. http://www.jstor.org/stable/27671803.

Flores, Terry. "*Frozen's* Jennifer Lee Melts Glass Ceilings." *Variety*, June 10, 2014. Accessed December 16, 2018. https://variety.com/2014/film/awards/frozens-jennifer-lee-melts-ceilings-1201216961/.

Forrester, Sibelan, and Jack Zipes. *Baba Yaga: The Wild Witch of the East in Russian Fairy-Tales*. Jackson, MS: University of Mississippi Press, 2013.

Frisby, Tanya. "Soviet Youth Culture." In *Soviet Youth Culture*, edited by Jim Riordan, 1–15. London: MacMillan, 1989.

Furniss, Maureen, ed. *Art and Industry*. New Barnet: John Libbey Publishing, 2009.

Gaidar, Arkadii. *Voennaia taina*. Moscow: Detizdat, 1935.

———. *Timur i ego komanda*. Moscow: Detskaia literatura, 1940.

Garin, V. "Novye raboty mul'tfil'ma." *Iskusstvo kino* 5 (1939): 34–36.

Ghez, Didier. *Walt's People: Talking Disney with the Artists Who Knew Him*, vol. 8. Bloomington: Xlibris Corporation, 2009.

Ginzburg, Semen S. *Risovannyi i kukol'nyi fil'm: Ocherki razvitiia sovietskoi mul'tiplikatsionnoi kinematografii.* Moscow: Iskusstvo, 1957.

Giroux, Henry A., and Grace Pollock. *The Mouse that Roared: Disney and the End of Innocence.* Lanham: Rowman & Littlefield Publishers, Inc, 2010.

Goldschmitt, Kariann. "Doing the Bossa Nova: The Curious Life of a Social Dance in 1960s' North America." *Luso-Brazilian Review* 48, no. 1 (2011): 61–78.

Goldman, Wendy Z. *Women at the Gates: Gender and Industry in Stalin's Russia.* Cambridge: Cambridge University Press, 2002.

"Golovanova, Nataliia Evgen'evna." Accessed December 16, 2018. http://animator.ru/db/?p=show_person&pid=1957&sp=1.

Gorsuch, Anne E. "'A Woman is Not a Man': The Culture of Gender and Generation in Soviet Russia, 1921–1928." *Slavic Review* 55, no. 3 (1996): 636–660. http://www.jstor.org/stable/2502004.

Gosfil'mofond. F. A, op. II d. b-2. Belye stolby, Russian Federation.

Goundortseva, Irina. "Animose and Russian Animation." Accessed July 21, 2018. http://www.liaf.org.uk/2011/04/animose-and-russian-animation-%E2%80%93-irina-goundortsev.

Grimm, Jacob, and Wilhelm Grimm. *The Complete Fairy Tales of the Brothers Grimm,* translation and introduction by Jack Zipes. New York: Bantam Books, 1987.

———. *The Original Folk and Fairy Tales of the Brothers Grimm: the Complete First Edition.* Princeton: Princeton University Press, 2014.

Hanicsh, Carol "The Personal is Political." http://www.carolhanisch.org/CHwritings/PIP.html.

Hayes, John. "Reconstruction of Reproduction? Mothers in the Great Soviet Family in Cinema after Stalin." In *Women in the Khrushchev Era,* edited by Melanie Ilič, Susan E. Reid, and Lynne Attwood, 114–130. Basingstoke: Palgrave Macmillan, 2004.

Hebdige, Dick. *Subculture: The Meaning of Style.* London: Methuen and Co., 1979.

Hellman, Ben. *Fairy Tales and True Stories: The History of Russian Literature for Children and Young People (1574–2010).* Leiden: Brill, 2010.

Herhuth, Eric. "Political Animation and Propaganda." In *The Animation Studies Reader,* edited by Nichola Dobson, Annabelle Honess Roe, Amy Ratelle, and Caroline Ruddell, 169–179. New York: Bloomsbury, 2018.

Hillman, Betty Luther. "'The Clothes I Wear Help Me to Know My Own Power': The Policitcs of Gender Presentation in the Era of Women's Liberation." *Frontiers: A Journal of Women Studies* 34, no. 2 (2013): 155–85.

Holmgren, Beth. "'The Blue Angel' and Blackface: Redeeming Entertainment in Aleksandrov's 'Circus.'" *The Russian Review* 66, no. 1 (2007): 5–22. http://www.jstor.org/stable/20620475.

———. "Bug Inspectors and Beauty Queens: The Problems of Translating Feminism into Russian." In *Postcommunism and the Body Politic,* edited by Ellen E. Berry, 15–31. New York: New York University Press, 1995.

———. "Toward an Understanding of Gendered Agency in Contemporary Russia." *Signs* 38, no. 3 (2013): 535–542.

Hutton, Marceline. *Incorporated Russian and Western European Women, 1860–1939: Dreams, Struggles and Nightmares.* Lantham: Rowman & Littlefield, 2001.

"Ideia Nikolaevna Garanina." Accessed March 05, 2018. http://www.animator.ru/db/?p=show_person&pid=1999.

"Ikar. Natsional'naia animatsionnaia 2016." Accessed December 13, 2018. http://animaprize.ru/laureati-2/.

Ilič, Melanie, Susan E. Reid, and Lynne Attwood, eds. *Women in the Khrushchev Era.* Basingstoke: Palgrave Macmillan, 2004.

Ince, Kate. *The Body and the Screen: Female Subjectivities in Contemporary Women's Cinema.* New York: Bloomsbury, 2017.

International Filmfestspiele 2012. Accessed November 2, 2018. https://www.berlinale.de/en/archiv/jahresarchive/2012/02_programm_2012/02_programm_2012.htm.

Isakava, Volha. "Reality of Excess Chernukha film in the Late 1980s." In *Ruptures and Continuities in Soviet/Russian Cinema: Styles, Characters and Genres before and after the Collapse of the USSR,* edited by Birgit Beumers and Eugenie Zvonkine, 147–165. New York: Routledge, 2017.

Ivanian, E. A. *Entsiklopedia rossiisko-amerikanskikh otnoshenii XVIII–XX veka.* Moscow: Mezhdunarodnye otnosheniia, 2001.

Ivanov-Vano, Ivan. "Graficheskaia mul'tiplikatsiia." In *Mul'tiplikatsionnyi fil'm,* 101–197. Moscow: Kinofotoizdat, 1936.

———. *Risovannyi fil'm.* Moscow: Goskinoizdat, 1950.

———. *Risovannyi fil'm. Osobyi vid kinoiskusstva.* Moscow: Goskinoizdat, 1956.

———. *Sovetskoe mul'tiplikatsionnoe kino.* Moscow: Znanie, 1962.

Iskusstvo kino (1936–).

Jagger, Gill. "Dancing with Derrida: Anti-essentialism and the Politics of Female Subjectivity." *Journal of Gender Studies* 5, no. 2 (1996): 191–199.

Jobling, Paul. *Advertising Menswear: Masculinity and Fashion in the British Media since 1945.* London: Bloomsbury, 2014.

Johnson, Mindy. *Ink & Paint: The Women of Walt Disney's Animation.* Los Angeles: Disney Corporation, 2017.

Johnson, Priscilla. *Khrushchev and the Arts: The Politics of Soviet Culture, 1962–1964.* Cambridge, MA: MIT Press, 1965.

Jones, Polly. *The Dilemmas of De-Stalinization: Negotiating Cultural and Social Change in the Khrushchev Era.* London: Routledge, 2006.

Jurkowski, Henryk, and Penny Francis. *A History of European Puppetry.* Vol. 2: *The Twentieth Century.* Lewiston, NY: Edwin Mellen, 1998.

Kaganovsky, Lilya. *How the Soviet Man Was Unmade: Cultural Fantasy and Male Subjectivity Under Stalin.* Pittsburgh: University of Pittsburgh Press, 2008.

———. "Ways of Seeing: On Kira Muratova's 'Brief Encounters' and Larisa Shepit'ko's 'Wings.'" *Russian Review* 71, no. 3 (July 2012): 482–499.

———. Voice of Technology: *Soviet Cinema's Transition to Sound, 19281935*. Bloomington: Indiana University Press, 2018.

Kapkov, Sergei. "Baba-iaga—moi liubimyi personazh." *Gazeta* 48 (March 17, 2018). Accessed July 20, 2018. http://www.animator.ru/articles/article.phtml?id=286.

———. "Valentina i Zinaida Brumberg." In *Nashi mul'tfil'my: litsa, kadry, eskizy, geroi, vospominaniia, interv'iu, stat'i, esse*, edited by M. Margolina and N. Lozinskaia, 28–33. Moscow: Interros, 2006.

Kapkov, Sergei, and Leonid Aristov. "Kinematografom ia zarazilsia, kak infektsiei." *Gazeta* 16 (August 16, 2004). http://www.animator.ru/articles/article.phtml?id=50.

Katz, Maya. *Drawing the Iron Curtain: Jews and the Golden Age of Soviet Animation*. New Brunswick, NJ: Rutgers University Press, 2016.

Kay, Karyn, and Gerald Peary, eds. *Women and the Cinema: A Critical Anthology*. New York: E. P. Dutton Press, 1977.

Kearney, Rachel. "The Joyous Reception: Animated Worlds and the Romantic Imagination." In *Animated 'Worlds,'* edited by Suzanne Buchan, David Surman, and Paul Ward, 1–14. Bloomington: Indiana University Press, 2006.

Kelly, Catriona. "Shaping the 'Future Race': Regulating the Daily Life of Children in Early Soviet Russia." In *Everyday Life in Early Soviet Russia: Taking the Revolution Inside*, edited by Christina Kiaer and Eric Naiman, 256–281. Bloomington: Indiana University Press, 2006.

Kharms, Daniil. "Kak Volodia bystro pod goru letel." *Chizh* 12 (1936): 11–12.

Khodataev, Nikolai. "Iskusstvo multiplikatsii." In *Mul'tiplikatsionnyi fil'm*, edited by Grigorii Roshal', 15–100. Moscow: Kinofotoizdat, 1936.

———. "Khudozhniki i mul'tipikatory." *Sovetskoe kino* 10 (1934): 28–34.

———. "Puti mul'tfil'ma." *Sovetskoe kino* 4 (1935): 46–48.

Kipling, Rudyard, and Daniel Karlin. *Rudyard Kipling*. Oxford: Oxford University Press, 1999.

Kipling, Rudyard. "The Cat that Walked by Himself." *Just So Stories*. Accessed March 05, 2018. http://etc.usf.edu/lit2go/79/just-so-stories/1296/the-cat-that-walked-by-himself/.

"Kitai v ogne (Ruki proch' ot Kitaia)." Accessed June 20, 2018. http://animator.ru/db/?p=show_film&fid=2318.

Kitson, Clare. *Yuri Norstein and Tale of Tales: An Animator's Journey*. Bloomington: Indiana University Press, 2005.

Kononenko, Natalie. "The Politics of Innocence: Soviet and Post-Soviet Animation on Folklore Topics." *Journal of American Folklore* 124, no. 494 (2011): 272–294.

Kondakov, I. B. "Nichego tut ne poimesh'! Diskurs detstva v poezii D. Kharmsa." *Obshchestvennye nauki i sovremennost'* 2 (2004): 154–165.

Konovalova, Elena. "Mariia Muat: 'Chuvstvuiu sebia Karabasom-Barabasom.'" Accessed November 7, 2017. http://newslab.ru/article/312607.

Kort-Butler, L. A. "Justice League?: Depictions of Justice in Children's Superhero Cartoons." *Criminal Justice Review* 38, no. 1 (2013): 50–69.

Kuhn, Annette. *Women's Pictures: Feminism and Cinema*. London: Routledge & K. Paul, 1982.

Kovalevskaia, Inessa. "Vospominaniia Inessy Alekseevny Kovalevskoi o sozdanii legendarnogo fil'ma 'Bremenskie muzykanty.'" *Kinograf* 20 (2009): 326–365.

"Kovalevskii, Aleksei Ivanovich." Accessed November 29, 2018. http://www.generals.dk/general/Kovalevskii/Aleksei_Ivanovich/Soviet_Union.html.

Kuvaev, Oleg. "Bremenskie muzykanty." Accessed February 2, 2018. http://www.mult.ru/trubadur.

LaPlace, Maria. "Producing and Consuming the Woman's Film: Discursive Struggle in *Now Voyager*." In *Home is where the Heart Is: Studies in Melodrama and the Woman's Film*, edited by Christine Gledhill London: British Film Institute, 1987.

Larsen, Susan. "Kira Muratova's *Brief Encounters*." In *The Cinema of Russia and the Former Soviet Union (24 Frames Series)*, edited by Birgit Beumers, 119–127. London: Wallflower Press, 2007.

———. "National Identity, Cultural Authority and the Post-Soviet Blockbuster: Nikita Mikhalkov and Aleksei Balabanov." *Slavic Review* 62, no 3 (2003): 491–511.

Lavrov, Sergei. "Mul'tfil'm studii 'Mel'nitsa' preodolel otmetku $10 mln." Kinodata.pro, January 20, 2016. Accessed December 13, 2018. http://kinodata.pro/vse-o-kino/obzor-kassovyh-sborov-v-rossii/9979-multfilm-studii-melnica-preodolel-otmetku-10-mln.html.

Leigh, Michele. "Dangerous Beauty: Representation and Reception of Women in the Films of Evgenii Bauer, 1913–1917." PhD diss., University of Southern California, 2007.

———. "Reading between the Lines: History and the Studio Owner's Wife." In *Doing Women's Film History: Reframing Cinemas, Past and Future*, edited by Julia Knight and Christine Gledhill, 42–52. Urbana, IL: University of Illinois Press, 2015.

———. "A laughing matter: El'dar Riazanov and the Subversion of Soviet Gender in Russian Comedy." In *Women in Soviet Film: The Thaw and Post-Thaw Periods*, edited by Marina Rojavin and Tim Harte, 112–133. Abingdon: Routledge, 2018.

Levinson, Rosalie B. "The Meaning of Sexual Equality: A Comparison of the Soviet and American Definitions." *New York Law School Journal of International & Comparative Law* 10 (1989): 151–182.

Leyda, Jay. *Kino: A History of the Russian and Soviet Film*. Princeton: Princeton University Press, 1983.

Liu, Yin. "Text as Image in Kipling's *Just So Stories*." *Papers on Language & Literature* 44, no. 3 (2008): 227–249.

Livanov, Vitalii. "Kak sozdavalsia mul'tfil'm 'Bremenskie muzykanty.'" *Pozitiv iz Goroda Solntsa*. Accessed January 31, 2018. http://dubikvit.livejournal.com/16195.htm.

———. *Pomni o beloi vorone. Zapiski Shherloka Kholmsa*. Moscow: Eksimo, 2007.

Lukinykh, Natal'ia. "Soiuzmul'tfil'm: traditsii i ambitsii." *Iskusstvo kino* 2 (1991): 56–67.

Lutz, Wolfgang, Sergei Scherbov, and Andrei Volkov. *Demographic Trends and Patterns in the Soviet Union before 1991*. London: Taylor and Francis, 2002.

MacFadyen, David Ward. *Yellow Crocodiles and Blue Oranges: Russian Animated Film Since World War II*. Montréal: McGill-Queen's University Press, 2005.

Maliantovich, Kirill. "Kak borolis' s 'kosmopolitami' na 'Soizmul'tfil'm' (rasskaz-vospominanie)." *Kinovedcheskie zapiski* 52 (2001): 191–196.

Maliukova, Larisa. "Igrushechnye istorii Marii Muat." *Iskusstvo kino* 6 (2003): 69–75.

———. "Kino. Uolt-strit—doroga v detstvo im. U. Disneia." *Novaia gazeta*, December 6, 2001. https://dlib.eastview.com/browse/doc/3468307.

———. *Sverkh: Sovremennaia Rossiiskaia Animatsiia, Devianostye/Nulevye*. Moscow: Umnaia Masha, 2012.

———. "The State of the Art: Russian Animation Today." *Kinokultura* 23 (2009). Accessed November 2, 2018. http://www.kinokultura.com/2009/23-maliukova.shtml.

Mally, Lynn. *Culture of the Future: The Proletkult Movement in Revolutionary Russia*. Berkeley, CA: University of California Press, 1990.

Margolina, Irina, and Mark Liakhovetskii, dirs. *Kollektsiia Animatsiia ot A do Ia*. Episode 47: "Brumberg, Valentina i Zinaida." Moscow: Ren TV, 1996.

Margolina, Irina, and Natal'ia Lozinskaia, eds. *Nashi mul'tfil'my: litsa, kadry, eskizy, geroi, vospominaniia, interv'iu, stat'i, esse*. Moscow: Interros, 2006.

Marshak, Samuil. *Stikhi dlia detei*. Moscow: Sovetskaia Rossiia, 1977.

"Masha and the Bear." *Socialblade*. Accessed February 26, 2020. https://socialblade.com/youtube/user/mashabearen.

Mayne, Judith. *Kino and the Woman Question: Feminism and Soviet Silent Film*. Columbus: Ohio State University Press, 1989.

———. "The Woman at the Keyhole: Women's Cinema and Feminist Criticism." *New German Critique* 23 (1981): 27–43.

———. *The Woman at the Keyhole: Feminism and Women's Cinema*. Bloomington: Indiana University Press, 1990.

Mazzarino, Andrea. "Entrepreneurial Women and the Business of Self-Development in Global Russia." *Signs* 38, no. 3 (Spring 2013): 623–645. Accessed December 07, 2017. http://www.jstor.org/stable/10.1086/668550.

McLean, Malcolm D. "O. Henry in Honduras." *American Literary Realism, 1870–1910* 1, no. 3 (1968): 39–46.

Menchikova, N. N. *Viatskie narodye promysly i remesla: istoriia i sovermennost'*. Kirov: O-kratkoe, 2010.

Merinov, Sergei. "Pobedonosnoe umershchvlenie . . ." Livejournal.com, July 3, 2010. Accessed December 12, 2018. https://sergey-merinov.livejournal.com/131015.html.

Merkulov, Iurii. "Sovetskaia mul'tiplikatsiia nachinalas' tak." In *Zhizn' v kino: Veterany o sebe i svoikh tovarishchakh*, vol. 2, edited by O. T. Nesterovich, 122–140. Moscow: Iskusstvo, 1971.

Mikolchak, Maria. "Misogyny in Alexander Pushkin." In *Misogynism in Literature*, edited by Britta Zangen, 99–110. Frankfurt: Peter Lang, 2004.

Milne, A. A. *When We Were Very Young*. London: Egmont, 2007.

Mjolsness, Lora. "Vertov's *Soviet Toys*: Commerce, Commercialization and Cartoons." *Studies in Russian & Soviet Cinema* 2, no. 3 (2008): 247–267.

———. "Under the Hypnosis of Disney: Ivan Ivanov-Vano and Soviet Animation for Children after World War II." In *Brill Companion to Soviet Children's Literature and Film*, edited by Ol'ga Voronina, 393–420. Leiden: Brill, 2019.

Molyneux, Maxine. "The 'Woman Question' in the Age of Perestroika." *Agenda: Empowering Women for Gender Equity* 10 (1991): 89–108.

Moore, Jennifer Grayer. *Street Style in America: An Exploration*. Santa Barbara: ABC-CLO, 2017.

Morely, Rachel. *Performing Femininity: Woman as Performer in Early Russian Cinema*. London: I. B. Tauris & Co. Ltd., 2017.

Mulvey, Laura, and Rachel Rose. *Laura Mulvey, "Visual Pleasure and Narrative Cinema," 1975*. London: Afterall Books, 2016.

Murasheva, Aleksandra. "Mul'timaniia Inessy Kovalevskoi." *Moskovskaia pravda*, August 13, 2012. https://dlib.eastview.com/browse/doc/27529944.

Naiman, Eric. "The Case of Chubarov Alley: Collective Rape, Utopian Desire, and the Mentality of NEP." *Russian History / Histoire Russe* 17 (Spring 1990): iii–30.

Nevafilm. *The Film Industry in the Russian Federation*, edited by André Lange. Strasbourgh: European Audiovisual Observatory, 2010.

Noake, Roger. "Nina Shorina: the State of Narration." In *Women and Animation: A Compendium*, edited by Jayne Pilling, 104–108. London: British Film Institute, 1992.

"Nominanty premii 'Zolotoi Orel' za 2017 god." Accessed December 13, 2018. https://www.kinoacademy.ru/category/nominees-award.

Norell, Norman, Louise Nevelson, Irene Sharaff, Alwin Nikolais, Andre Courreges, and Priscilla Tucker. "Is Fashion an Art?" *The Metropolitan Museum of Art Bulletin* 26, no. 3 (1967): 129–140.

Norstein, Yuri Leonid Shvartsman, Andrei Khrzhanovskii and Edvard Nazarov. "Kogo pozdravliat' s 75-letiem, esli Souizmul'tfil'ma uzhe net?." *Novaia gazeta*, no. 6, June 8, 2011. Accessed November 19, 2019. https://novayagazeta.ru/articles/2011/06/07/45255-kogo-pozdravlyat-s-75-letiem-esli-soyuzmultfilma-uzhe-net.

"Novosti 28 fevralia 2015." Accessed December 12, 2018. http://www.animator.ru/?p=show_news&nid=2101.

Obraztsov, Sergei. "Chto takoe kukol'nyi teatr?" In *Chto i kak v teatre kukol*, edited by E. F. Denisov. Moscow: Iskusstvo, 1969.

———. *Moia professiia*. Moscow: AST, 2009.

Ofer, Gur, and Vinokur, Aaron. *The Soviet Household under the Old Regime: Economic Conditions and Behaviour in the 1970*. Cambridge: Cambridge University Press, 1992.

O. Henry. *Cabbages and Kings*. New York: Start Classics, 2014.

Olsen, Laura, and Svetlana Adonyeva. *The Worlds of Russian Village Women*. Madison: University of Wisconsin Press, 2012.

"O rabote komsomola sredi devushek." In *KPSS o komsomole i molodezhi, 1917–1961*, 50. Moscow, 1962.

"O rabote sredi molodezhi." In *KPSS o komsomole i molodezhi, 1917–1961*, 77. Moscow, 1962.

"O studii." Pilot Film Studio. Accessed November 2, 2018. http://www.pilot-film.com/index.php?id=3.

"O studii Mel′nitsa." Mel′nitsa.com. Accessed December 12, 2018. http://melnitsa.com/about/.

Orlov, Aleksei. "Tri prekrasnye damy." *Isskustvo Kino* 9 (2000): 117–119. Accessed August 30, 2018. http://kinoart.ru/archive/2000/09/n9-article22.

Ostrovskii, Aleksandr Nikolaevich. *Plays*, 2004. http://www.gutenberg.org/ebooks/10722.

Parfitt, Tom. "Former teacher Tatyana Bakalchuk is Russia's richest woman." The Times. (February 21 2020). Accessed February 29, 2020. https://www.thetimes.co.uk/article/former-teacher-tatyana-bakalchuk-is-russias-richest-woman-02cbh8nxq.

Perera, Loretta Marie. "Russia's Feminists Work to Smash the Taboo." *Moscow Times*. Accessed February 21, 2018. https://themoscowtimes.com/articles/smashing-the-taboo-60587.

Perrault, Charles. *Little Red Riding Hood, The Fairy, and Blue Beard; with Morals*. Philadelphia: John M'Culloch, 1797.

Peterson, Monique. *The Little Big Book of Disney*. New York: Disney, 2001.

Pikkov, Ülo. "On the Topics and Style of Soviet Animated Films." *Baltic Screen Media Review* 4, no. 1 (2016): 16–37.

Pilkington, Hilary. *Russia's Youth and Its Culture: A Nation's Constructors and Its Constructed*. London: Routledge, 1994.

Pilling, Jayne, ed. *Women and Animation: A Compendium*. London: British Film Institute, 1984.

Pontieri, Laura. *Soviet Animation and the Thaw of the 1960s: Not Only for Children*. Bloomington: John Libbey Pub. Ltd., 2012.

Posner, Dassia N. "Life-Death and Disobedient Obedience: Russian Modernist Redefinitions of the Puppet." In *The Routledge Companion to Puppetry and Material Performance*, edited by Dassia N. Posner, Claudia Orenstein, and John Bell, 130–143. London: Routledge, 2014.

———. "Material Performance." In *The Routledge Companion to Puppetry and Material Performance*, edited by Dassia N. Posner, Claudia Orenstein, and John Bell, 5–7. London: Routledge, 2014.

"Postanovlenie TsK VKP(b) ot 9 sentiabria 19233 g. 'Ob izdatel′stve detskoi literatury.'" In *Resheniia partii o pechati*, 158–159. Moscow: Politizdat, 1941.

Prokhorov, Alexander. "Arresting Development: A Brief History of Soviet Cinema for Children and Adolescents." In *Russian Children's Literature and Culture*, edited by Marina Balina and Larissa Rudova, 129–152. New York: Routledge, 2008.

———. "The Cinema of the Thaw, 1953–1967." In *The Russian Cinema Reader*, vol 2, edited by Rimgaila Salys, 14–31. Boston: Academic Studies Press, 2013.

———. "Revisioning Aleksandrov's 'Circus': Seventy Years of the Great Family." *The Russian Review* 66, no. 1 (2007): 1–4. http://www.jstor.org/stable/20620474.

———. "The Unknown New Wave: Soviet Cinema of the 1960s." In *Springtime for Soviet Cinema: Re/Viewing the 1960s*, 7–29. Pittsburgh: University of Pittsburgh, 2001.

Proletarskoe kino (1931–1932).

Pushkin, Aleksandr Sergeevich. *Izbrannye Proizvedeniia*. Khudozhestvennia literatura: Moscow, 1968

———. *Stikhotvorenia, skazki, Ruslan i Luidmila*. Moscow: Khudozhestvennaia literatura, 1985.

———. *The Tale of Tsar Saltan*. Transated by Louis Zellikoff. Moscow: Progress Publishers, 1978.

Razlogov, Kirill. "Nina Shorina." In *Nashi mul'tfil'my: litsa, kadry, eskizy, geroi, vospominaniia, interv'iu, stat'i, esse*, edited by Irina Margolina and Natal'ia Lozinskaia, 252–255. Moscow: Interros, 2006.

Razumovskaia, Olga. "Studio Renews Fight for Soviet Cartoons." *Moscow Times*, August 17, 2010. Accessed September 9, 2019. https://www.themoscowtimes.com/2010/08/17/studio-renews-fight-for-soviet-cartoons-a715.

Retrospective at the Deutsche Kinemathek 2012. Accessed November 2, 2018. https://www.deutsche-kinemathek.de/en/retrospective/2012/films.

RGALI. f. 2469, op. 1, ed. khr. 122, Moscow, Russian Federation.

RGALI. f. 2469, op. 1, ed. khr. 661, Moscow, Russian Federation.RGALI. Stsenarnyi otdel. "Perepiska s avtorami o predlagaemykh zaiavkakh i literaturnykh stsenariiakh" (1958), 21. Moscow, Russian Federation.

Rimskii-Korsakov, Nikolai, and Ostrovskii, Aleksandr Nikolaevich. "Snegurochka." Moscow: Muzyka, 1967.

Riordan, Jim. "Soviet Youth: Pioneers of Change." *Soviet Studies* 40, no. 4 (1988): 556–572.

Risch, William Jay. "Soviet 'Flower Children'. Hippies and the Youth Counter-Culture in 1970s' L'viv." *Journal of Contemporary History* 40, no. 3 (2005): 565–584.

Rogan, Frances, and Shelley Budgeon. "The Personal is Political: Assessing Feminist Fundamentals in the Digital Age." *Social Sciences* 7, no. 8 (2018): 1–8.

Rubanova, Irina. "Golos chelovecheskii." *Iskusstvo Kino* 6 (1985): 130–134.

"Russian Dance Film Selections 2004." *St. Petersburg Dance Film Festival "Kinodance."* Accessed June 27, 2018. http://www.kinodance.com/russia/films_russian_selection.html.

Salys, Rimgaila. "Life into Art: Laying Bare the Theme in 'Bed and Sofa.'" *Russian Language Journal / Russkii iazyk* 52, no. 171/173 (1998): 291–303. www.jstor.org/stable/43669091.

———. "Three-Rib Circus: Women and Historical Discourse in 'Rebro Adama.'" In *The Russian Review* 60, no. 4 (2001): 614–630. http://www.jstor.org/stable/2679370.

Saidasheva, Iana. "Rezhisser 'Luntika' Darina Shmidt: Sovremennym mul'tfil'mam ne khvataet dramatizma." *Sergievskie kuranty*. Accessed August 29, 2018. http://s-kuranty.ru/2016/10/28/098765434567890/.

Sekundov, N., ed. *Amerikanskie fil'my*. Leningrad, 1935.

Semenov, Andrei. *Gennadii Gladkov: Kniga o veselom kompozitore*. Moscow: Muzyka, 2009.

Shogren, Elizabeth. "Russia's Equality Erosion." *Los Angeles Times*, February 11, 1993, 1. Accessed December 18, 2019. https://www.latimes.com/archives/la-xpm-1993-02-11-mn-1479-story.html.

"Shorina, Nina Ivanovna." Accessed December 5, 2018. http://animator.ru/db/?p=show_person&pid=1968&sp=1.

Simonovich-Efimova, Nina. "O Petrushke." *Vestnik teatra* 34 (September 23–28, 1919): 6–8.

Sifer, Dana Tyrkich. "Chto takoe zhenskoe kino?" *Iskusstvo Kino* 6 (1991): 42–49.

Slonimskaia, Iuliia. "Marionetka." *Apollon*, March 3, 1916, 1–42.

Sokolianskii, Ivan, and Aleksandr Zaluzhnyi, eds. *My protiv skazki*. Kharkov, 1928.

Sokolov, Stanislav. Interview with Ekaterina Vyskokovskaia. "Kak seichas zhivet studiia Souizmul'tfil'm? Nad chem rabotaiut ee mastera? Kakova sud'ba otechestvennoi mul'tiplikatsii?." Radio Maiak. June 27, 2013. Accessed April 10, 2020. https://radiomayak.ru/shows/episode/id/1122612/.

Stamp, Shelley. *Lois Weber in Early Hollywood*. Oakland: University of California Press, 2015.

Steel, Valerie. "Anti-Fashion: The 1970s." *Fashion Theory: The Journal of Dress, Body & Culture* 1, no. 3 (1997): 279–295.

———. *Fifty Years of Fashion: New Look to Now*. New Haven: Yale University Press, 2000.

Strazzoni, Andrea. "Subjectivity and individuality: Two strands in early modern philosophy: Introduction." *Societate si Politica* 9, no. 1 (2015): 5–9.

"Soiuzmultfilm—Russia." CLG Wiki, The Motion Graphics Museum. Accessed August 12, 2018. http://www.closinglogos.com/page/Soyuzmultfilm+(Russia).

Sovetskoe kino (1932–1936).

"Studii 'Pchela' ispolnilos' 10 let." *Animalife*, July 28, 2016. Accessed July 22, 2018. http://animalife.ru/2016/07/28/studii-pchela-ispolnilos-10-let/.

Taylor, Richard. "Soviet Cinema as Popular Culture: Or the Extraordinary Adventures of Mr Nepman in the Land of the Silver Screen." *Revolutionary Russia* 1, no. 1 (June 1, 1988): 36–56.

Taylor, Richard, and Ian Christie. *The Film Factory and Soviet Cinema in Documents, 1896–1939*. New York: Routledge, 1994.

Teicher, Jordan. "Why a Russian cartoon bear is more popular than Taylor Swift on YouTube" *IBM*. March 19, 2018. Accessed on February 26, 2020. https://www.ibm.com/blogs/industries/youtube-loves-russian-cartoon-bear-biggest-global-pop-stars/.

Tirado, Isabel A. "Komsomol and the Krest'ianka: The Political Mobilization of Young Women in the Russian Village, 1921–1927." *Russian History* 23, no. 1 (1996): 345–366.

Tizard, Will. "Russian Animation Proves to Be an International Draw." Accessed December 10, 2018. https://variety.com/2018/film/global/russia-animation-international-1202800414/.

Tolstaya, Tatyana, and Maryniak, Irena. "The Human Spirit is Androgynous." *Index on Censorship* 19, no. 9 (2007): 29–30.

Tolz, Vera. "'Cultural Bosses' as Patrons and Clients: The Functioning of the Soviet Creative Unions in the Postwar Period." *Contemporary European History* 11, no. 1 (2002): 87–105. http://www.jstor.org/stable/20081818.

Treml, Vladimir G. "Soviet and Russian Statistics on Alcohol Consumption and Abuse." In *Premature Death in the New Independent States*, edited by J. L. Bobadilla, C. A. Costello, and F. Mitchell for National Research Council (US) Committee on Population. Washington D. C.: National Academies Press, 1997. https://www.ncbi.nlm.nih.gov/books/NBK233387/.

Trotsky, Leon. *The Revolution Betrayed*. New York: Pathfinder Press, 1972.

Tsivian, Yuri. "The Case of the Bioscope Beetle: Starewicz's Answer to Genetics." *Discourse: Theoretical Studies in Media and Culture* 17, no. 3 (Spring 1995): 119–125.

TsKhDMO, f. 1, op. 23, d. 391, 11. 1, 8, 69. Moscow, Russian Federation.

TsKhDMO, f. 1, op. 23, d. 864a, 11. 2, 5. Moscow, Russian Federation.

TsKhDMO, f. 1, op. 23, d. 864a, 1. 6. Moscow, Russian Federation.

Turovskaia, Maiia. "Mentolovyi mir." In "Ekran Festivalia." *Iskusstvo Kino* 12 (1983): 69–166.

———. "Zhenshchina i kino." *Iskusstvo kino* 6 (1991): 131–137.

———. "'Zhenskii fil'm'—chto eto takoe?" *Iskusstvo Kino* 5 (1981): 28–35.

Urbanora. "Daily Archives: October 22, 2008." *The Bioscope*. Accessed June 27, 2018. https://thebioscope.net/2008/10/22/.

"*V iarange gorit ogon'*." Accessed November 23, 2018. http://animator.ru/db/?p=show_film&fid=3071.

Vasil'kova, Aleksandra. "Ideia Garanina." In *Nashi mul'tfil'my: litsa, kadry, eskizy, geroi, vospominaniia, interviu, stat'i, ésse*, edited by Irina Margolina and Natal'ia Lozinskaia, 224–227. Moscow: Interros, 2006.

Vaté, Virginie. "Maintaining Cohesion through Rituals: Chukchi Herders and Hunters, a People of the Siberian Arctic." *Senri Ethnological Studies* 69 (2005): 45–68.

Vereykina, Elizaveta. "Russian Animation Rises From Ashes of 1990s." *The Moscow Times*. May 25, 2015. Accessed on February 26, 2020. https://www.themoscowtimes.com/2015/05/25/russian-animation-rises-from-ashes-of-1990s-a46842.

Volkov, Aleksandr. *Volshebnik izumrudnogo goroda*. Moscow: Detizdat, 1939.

Volkov, A. *Mul'tiplikatsionnyi fil'm*. Moscow: Znanie, 1974.

Voronina, Ol'ga. "Mythology of Women's Emancipation in the USSR as the Foundation for a Policy in Discrimination." In *Women in Russia: A New Era in Russian Feminism*, edited by Anastasia Posadskaya, 37–56. London: Verso, 1994.

"Vstrecha s rossiiskimi mul'tiplikatorami." Accessed September 15, 2018. http://kremlin. ru/events/president/news/54644.

Vukvukai, Nadezhda I. "Chukchi Traditional Clothing as Historical Source of Cultural Transformation." *Études/Inuit/Studies* 31, no. 1/2 (2007): 311–315.

Walker, Andrew. "World War II and Modern Russia at the Philadelphia Museum of Art: The Christian Brinton Collection, 1941–1945." *Archives of American Art Journal* 41, no. 1/4 (2001): 34–42.

Walker, Shaun. "Putin approves legal change that decriminalises some domestic violence." *The Guardian*, February 7, 2017. Accessed December 18, 2018. www.theguardian.com / world/2017/feb/07/putin-approves-change-to-law-decriminalising-domestic-violence.

Wells, Paul. *Animation and America*. New Brunswick, NJ: Rutgers University Press, 2002.

———. *Animation: Genre and Authorship*. London: Wallflower Press, 2002.

———. *The Animated Bestiary: Animals, Cartoons and Culture*. New Brunswick, NJ: Rutgers University Press, 2009.

———. *Understanding Animation*. London; New York: Routledge, 1998.

White, Patricia. *Women's Cinema, World Cinema: Projecting Contemporary Feminisms*. Durham, NC: Duke University Press, 2015.

"Women at Work: Subverting the Feminine in Post-Soviet Russia." *White Space Gallery*. Accessed December 19, 2018. www.whitespacegallery.co.uk/exhibition/ women-at-work-subverting-the-feminine-in-post-soviet-russia.

The Women Film Pioneers Project. Accessed June 18, 2018. https://wfpp.cdrs.columbia.edu/.

Zabrodin, V. *Eizenshtein o Meierkhol'de*. Moscow: Novoe izdatel'stvo, 2005.

Zehnder, S. M., and Calvert, S. L. "Between the Hero and the Shadow: Developmental Differences in Adolescents' Perceptions and Understanding of Mythic Themes in Film." *Journal of Communication Inquiry* 28 (2004): 122–137.

"Zhurnal politsatiry, No. 2, 1941." Accessed December 17, 2018. http://animator.ru/ db/?p=show_film&fid=2928.

Zipes, Jack. "A Second Gaze at Little Red Riding Hood's Trials and Tribulations." In *Don't Bet on the Prince: Contemporary Feminist Fairy Tales in North America and England*, edited by Jack Zipes, 227–260. New York: Taylor and Francis, 2014.

———. *The Enchanted Screen: The Unknown History of Fairy Tales Films*. London: Routledge, 2011.

———. *The Trials and Tribulations of Little Red Riding Hood*. London: Routledge, 1993.

Index

"Who knew that animation would shine such a bright light on the 'woman question' and reveal so many artistically expressed answers by women themselves? The female workforce in Soviet and Russian animation represented themselves and their struggle to represent as nothing less than the future of the nation. How right they were. Delving into national discourses often expressed as binary world views, a century of women animators helped forge new cultural pathways between and through tradition and individuality, family and selfhood, authority and the authorial."

—Maya Balakirsky Katz, Author of *Drawing the Iron Curtain: Jews and the Golden Age of Soviet Animation*

"*She Animates* offers an enlightening insight into the central role of women in Russian animation. The rich industrial, aesthetic, and social history it presents will be equally accessible to students and scholars working in animation, gender or Slavic studies. Encompassing films from the silent era to contemporary works, this book traces the cultural specificity of changing female aesthetics and subjectivity in Russian animation, while speaking to timely concerns beyond the immediate subject. It is a valuable and much needed addition to the scholarship on animation history."

—Malcolm Cook, Associate Professor in Film Studies, University of Southampton; Author of *Early British Animation: From Page and Stage to Cinema Screens*

"Unlocking the remarkable contributions of women within our animated past is no easy feat. Due to unconscious biases, research challenges, prevailing myths, and sweeping assumptions, the ground-breaking work of women within this universal artform is generally overlooked and largely lost to time. *She Animates: Soviet Female Subjectivity in Russian Animation* brings to light twelve landmark directors who would have likely gone unrecognized. In this exploration of feminism, gender equality and the impact of women within Russian animation, Michele Leigh and Lora Mjolsness provide thoughtful analysis and critical approaches which help to challenge the outdated norms of our collective past."

—Mindy Johnson, author of *Ink & Paint: The Women of Walt Disney's Animation*

"In their book *She Animates: Soviet Female Subjectivity in Russian Animation*, Michele Leigh and Lora Mjolsness accomplish a superb job of refocusing the study of Soviet and Russian animation on women. They single out twelve female directors of animation across a hundred years of film history, which enables them to trace developments of individual animation directors across several decades without landing the reader in a jungle of names and titles. Instead, they provide an elegant and focused reading of the way in which women in animation have carved a niche for their views on such themes as motherhood, womanhood and femininity at different times and through different tales.

Leigh and Mjolsness provide a solid framework for their study of women in Soviet and post-Soviet animation by engaging with such terms such as 'women's cinema' and 'feminism' in the historical, political and social context of different times and regimes. They succinctly demonstrate the divergence in the understanding of second wave of feminism in the late 1960s, when Soviet animators display difference rather than equality, and in this context they offer a refreshing analysis of the youth and dress culture in *The Musicians of Bremen*—often neglected as a 'woman's' work.

This is an informed and thoroughly researched study which, through the focus on twelve careers, never overburdens the reader who can look forward to an enjoyable read."

—Birgit Beumers, Professor Emerita in Film Studies,
Aberystwyth University, Wales

"This impeccably researched historical account of women's involvement in Russian and Soviet animation encourages the reader to rethink the interaction between women's labour, animation, and ideology in the Russian and Soviet context. Leigh and Mjolsness explore the work of women animation directors from the 1920s to the present day and make the case that an evolving female subjectivity can be traced in their work, one that often questioned and pushed back against women's perceived role in society. In doing so, *She Animates* actively resists the frequent pigeon-holing of animation as 'just for children' and offers a vibrant contribution to the ongoing discourses in animation studies, women's cinema, and Slavic film. Rich with detailed analyses of individual films and filmmakers that are read against the context of women's position in Soviet and Russian society, this is an illuminating addition to the growing literature that reconsiders women's role in the history of animation."

—Bella Honess Roe, Senior Lecturer in Film Studies,
University of Surrey

CPSIA information can be obtained
at www.ICGtesting.com
Printed in the USA
LVHW020935250421
685457LV00010B/679